Cultivating the
Human Faculties

Cultivating the Human Faculties

James Barry (1741–1806)
and the Society of Arts

Edited by
Susan Bennett

Lehigh
University
Press

Bethelehem: Lehigh University Press

Associated University Presses
2010 Eastpark Boulevard
Cranbury, NJ 08512

The paper used in this publication meets the requirements of the American National Standard for Permanence of Paper for Printed Library Materials Z39.48-1984.

Library of Congress Cataloging-in-Publication Data

Cultivating the human faculties : James Barry (1741–1806) and the Society of Arts / edited by Susan Bennett.
 p. cm.
 Includes bibliographical references and index.
 ISBN 978-0-934-223-96-6 (alk. paper)
 1. Barry, James, 1741–1806—Criticism and interpretation. 2. Mural painting and decoration—England—London. 3. Royal Society of Arts (Great Britain) I. Bennett, Susan, 1951–
 ND497.B27C85 2008
 759.2—dc22
 2008030644

These studies are presented to Dr. David G. C. Allan

as a tribute to his work as a writer and teacher

on RSA history for over half a century.

"I have endeavoured to illustrate one great maxim, or moral truth, that the obtaining of happiness, as well individual as public, depends on cultivating the human faculties"

—James Barry, *An Account of a Series of Pictures in the "Great Room" of the Society of Arts, Manufactures and Commerce at the Adelphi* (1783)

Contents

List of Illustrations 9

Prologue 11
 Susan Bennett

Acknowledgments 13

Chronology 15

Introduction 19
 Helen Clifford

James Barry (1741–1806): A Biographical Outline 23
 David G. C. Allan

The Society and the "Polite Arts" 1754–1778: "best drawings,"
"High" Art and Designs for the Manufactures 26
 Anne Puetz

Patriotism, Virtue, and the Problem of the Hero: The Society's
Promotion of High Art in the 1760s 50
 Martin Myrone

Arts and Commerce Promoted: "female excellence" and the
Society of Arts' "patriotic and truly noble purposes" 64
 Charlotte Grant

Making a Place for Ornament: The Social Spaces of the
Society of Arts 76
 Andrea MacKean

The Olympic Victors: The Third Painting in Barry's Series,
The Progress of Human Knowledge and Culture 88
 David G.C. Allan

Elysium's Elite: Barry's Continuing Meditations on the
Society of Arts Murals 98
 William L. Pressly

"This Slip of Copper": Barry's Engraved Detail of
Queen Isabella, Las Casas and Magellan 110
 John Manning

A Preparatory Drawing for Barry's *Glorious Sextumvirate*
Rediscovered: The Search for the Seventh Man 119
 William L. Pressly

Barry's Medal for the Society of Arts: A Celebration of the
Three Kingdoms 131
 William L. Pressly

Epilogue: Barry's Death and Funeral 142
 David G. C. Allan

Appendix 145

Bibliography 151

Contributors 157

Index 159

Illustrations

1. James Barry, *Self-portrait*, 1802. 24

2. James Barry, *Design for a tea kettle*, 1801. 33

3. Joachim Smith, *Design for a mirror frame*, 1759. 35

4. William Herbert, *Design for a table clock*, 1760. 36

5. John Edwards, *Flower design*. 37

6. Lewis Pingo, *Design for silk*. 38

7. Peter Sayer, *Flower design*. 39

8. Robert Edge Pine, *Surrender of Calais to Edward III*. 57

9. Thomas Banks, *"Priam pleading with Achilles for Hector's Body,"* 1765. 59

10. James Barry, *Mrs Montagu*, detail from *The Distribution of Premiums*. 65

11. Hannah Chambers, *Flowers in a vase*, 1759. 71

12. Hannah Chambers, *Design for a candelabra*, 1757. 72

13. William Bailey, *Flyer for election of a Register*. 78

14. James Barry, *The Triumph of the Thames or Commerce*, 1792. 84

15. F. R. Roffe, *Entrance to the Society's "Great Room,"* 1839. 89

16. Isaac Taylor, *"Great Room" of the Society of Arts*, 1804. 90

17. A. C. Pugin and T. Rowlandson, *The "Great Room" of the Society of Arts*, 1809. 91

18. James Barry, left-hand panel of *Crowning the Victors at Olympia*, 1777–84. 94

19. Key to left-hand panel. 94

20. James Barry, middle panel of *Crowning the Victors at Olympia*, 1777–84. 95

21. Key to middle panel. 95

22. James Barry, right-hand panel of *Crowning the Victors at Olympia*, 1777–84. 96

23. Key to right-hand panel. 96

24. James Barry, *Lord Baltimore and the Group
 of Legislators*, 1793. 99

25. James Barry, *Scientists and Philosophers*, c. 1800–1805. 100

26. James Barry, *Pensive Sages*, c. 1800. 101

27. James Barry, *Self-Portrait*, c. 1800–1805. 102

28. James Barry, *The Phoenix or the Resurrection
 of Freedom*, 1776. 103

29. James Barry, *Blessed Exegesis*, c. 1800. 104

30. James Barry, *The Education of Achilles*, c. 1772. 108

31. James Barry, *Queen Isabella, Las Casas and Magellan*, 1800. 111

32. James Barry, *Reserved Knowledge*, c. 1800. 120

33. James Barry, *Glorious Sextumvirate*, third state, c. 1800. 121

34. James Barry, *Sketch for Glorious Sextumvirate*, c. 1795. 122

35. James Barry, detail of *Elysium and Tartarus*, 1777–84. 123

36. James Barry, *Glorious Sextumvirate*, first state, c. 1795. 125

37. James Barry, *Glorious Sextumvirate*, second state, 1798. 127

38. James Stuart, *Design for medal for the Society of Arts*, 1757. 132

39. James Barry, detail from *The Distribution of Premiums*
 showing 1801 additions. 133

40. Warner after Barry, *Heads of Minerva and Mercury for a
 new medal of the Society of Arts*, 1809. 135

41. James Barry, Sketch for *Design for medal of the
 Society of Arts*, 1801. 136

42. James Barry, *Design for medal for Society of Arts*, 1801. 137

43. James Barry, Study for *The Act of Union between
 Great Britain and Ireland*, 1801. 138

44. James Barry, *King George and Queen Charlotte*, 1791. 139

45. James Barry, *Orpheus*, 1777–84. 146

46. James Barry, *Grecian Harvest Home*, 1777–84. 147

47. James Barry, *Olympic Victors*, 1777–84. 147

48. James Barry, *The Triumph of the Thames
 or Commerce*, 1777–84. 148

49. James Barry, *The Distribution of Premiums*, 1777–84. 149

50. James Barry, *Elysium*, 1777–84. 149

Prologue

Susan Bennett

IN 1983 THE RSA ESTABLISHED A SERIES OF ANNUAL HISTORICAL SYMPOSIA BEGINNING, as was appropriate for that year, with one designed to commemorate the bicentenary of the first exhibition of James Barry's paintings in the Society's "Great Room" and to coincide with the first comprehensive modern exhibition of his works, The Artist as Hero, held at the Tate Gallery in London. The proceedings of this symposium were not published, though some of the papers read appeared as separate contributions to the *RSA Journal*.[1] Barry also figured in two later symposia: "Samuel Johnson" (1987), with a paper on "Barry and Johnson," and "Armada Themes" (1988) with a paper on "James Barry and British History."[2] Then in 2000 another Barry-oriented symposium was staged entitled "The Ornament of Nations." However, on account of changes in the format of the *RSA Journal*, its proceedings remained unpublished until the present time. This volume will form a companion to the 2005/6 exhibition catalogue and conference proceedings: *James Barry (1741–1806) the Great Historical Painter*, sponsored by the Crawford Municipal Art Gallery at Cork, and the new edition of Barry's own *Account of his paintings in the RSA's "Great Room."*[3]

A recently discovered letter written by Susan Burney describing a visit to the Society of Arts with Barry on October 26, 1779, to see his work in progress, has been included as an appendix to this collection of papers.

NOTES

1. D. G. C. Allan, "The Chronology of James Barry's work for the Society's "Great Room," *Journal of RSA* 131 (1983): 214–21, 283–89; William J. Pressly, "A Chapel of Natural and Revealed Religion: James Barry's Series for the Society's Great Room Reinterpreted," *Journal of RSA*, 132 (1984): 543–47, 634–37, 693–95. See also Pressly, *The Artist as Hero* (1983). London: Tate Gallery, 1983.

2. D. G. C. Allan, "Barry and Johnson," *Journal of Royal Society of Arts*, 133 (1985): 628–32; "James Barry and British History." *RSA Jnl* 136 (1988): 727–31.

3. Ibid, *The Progress of Human Knowledge and Culture. A description of the paintings by James Barry in the Lecture Hall or "Great Room" of the RSA in London*, (2005); Tom Dunne, ed., *James Barry 1741–1806, "The Great Historical Painter"* (2005). Cork: Crawford Art Gallery, 2005.

Acknowledgments

The editor wishes to thank all the contributors, as well as the helpful advice of Dr. David Allan and Dr. Helen Clifford. Also thanks are due to Rob Baker, RSA Archivist and Records Manager, for his help with illustrations for this volume and to The Paul Mellon Centre for Studies in British Art for their generous grant towards the cost of photography.

Charlotte Grant would like to thank Markman Ellis, Elizabeth Eger, and Helen Clifford for commenting on versions of this article, also Susan Bennett and Helen L. Bing for funding her fellowship at the Huntington Library.

David Allan wishes to thank Nicola Allen, former RSA Archivist and Records Manager; Susan Bennett, Honorary Secretary of the William Shipley Group; Dr Ann Saunders, Chairman of the London Topographical Society; David Bradbury, Librarian, the Guildhall Library; J. Wisdom, Librarian, St Paul's Cathedral; and to other scholars acknowledged in my earlier writings on James Barry.

In 1986 the *Journal of RSA* changed its name to *RSA Journal*. For the sake of clarity each citation to that journal will use the name that was correct at the time it was published.

Chronology

1731	Foundation of Dublin Society.
1741	James Barry is born in Cork on October 11.
1745	Foundation of the Anti-Gallican Association.
1754	Foundation of the Society of Arts at Rawthmell's Coffee House, Covent Garden.
1758	Premiums divided into classes.
1759	Society moves into premises designed by William Chambers in Denmark Court (Strand).
1760	First exhibition of the works of living artists.
1762	Shipley's Proposal for a Repository of Arts.
1763	Barry wins a prize from the Dublin Society for his painting of the *Baptism of the King of Cashel*.
1765	Incorporation of the Society of Artists.
1765–71	Barry studies in France and Italy under the patronage of Edmund Burke. He exhibits his *Temptation of Adam* at the Royal Academy of Arts (founded 1768) on his return and settles in London.
1772–	The House of Society of Arts is built according to the design of Robert and James Adam as part of their newly developed "Adelphi" estate. Barry becomes ARA (1772) and RA (1773). He and nine other artists are invited by the Society to paint pictures for its new Great Room. The invitation is declined.
1777	March: Barry proposes to the Society that he should undertake the entire decoration of the Great Room without fee (the Society providing canvas, paints, and models). His offer is accepted and in April he begins painting.
1782	Barry is appointed Professor of Painting at the Royal Academy.
1783–84	Two exhibitions of the paintings in the Great Room are held, Barry receiving the proceeds. Society of Arts begins publication of *Transactions* (1783–).
1787	Annual ceremony for presentation of awards established by the Society of Arts.
1790	Barry completes the portrait of the Prince of Wales for the fifth picture in the Great Room.

1791–95 Barry publishes etchings of the paintings.

1793 Duke of Norfolk becomes President of Society of Arts.

1798–1801 Barry adds certain details to the fourth, fifth, and sixth pictures in the Society's Great Room. The Society votes him two hundred guineas and a gold medal in January 1799, and in April of that year he quarrels with the Royal Academy and is expelled.

1805 An annuity is raised for Barry by certain prominent members of the Society. Barry is asked to add Nelson's portrait to his sixth picture in the Great Room.

1806 Barry dies on February 22. His body rests in the Great Room on the eve of its internment in the Crypt of St Paul's Cathedral.

Cultivating the
Human Faculties

Introduction

Helen Clifford

Dᴜʀɪɴɢ ᴛʜᴇ ꜰɪʀꜱᴛ ʜᴀʟꜰ ᴏꜰ ᴛʜᴇ ᴇɪɢʜᴛᴇᴇɴᴛʜ ᴄᴇɴᴛᴜʀʏ ᴛʜᴇ ʙʀɪᴛɪꜱʜ ᴡᴇʀᴇ ꜱᴛᴇʀᴇᴏᴛʏᴘᴇᴅ as being a manual and "mechanick" nation, lacking the artistic imagination and flair of their French counterparts. In response, from the 1730s there was growing debate about improving the training of designers connected with the economic role of luxury commodities in the context of foreign competition. These debates were aired publicly through print, and were part of an explosion of interest in design, not only academic but also popular, which gained momentum in the 1750s. Charles Saumarez Smith has attributed this phenomenon to three distinct yet interconnected factors: a growing sense of nationalism, expressed in the fear that the increasing volume of imported foreign luxuries was endangering native British prosperity; an intellectual environment in which political economy was conceptualized in terms of improvement; and a boom in print culture, made possible by the expansion of publication and circulation, providing hitherto unimagined opportunities for publicity.

In 1751 Malachy Postlethwayt, in his *Universal Directory of Trade and Commerce*, repeated John Gwynn's call for the training of "ingenious workmen," this time for the ornamental as well as the fine arts, "to improve the perfection and delicacy of our Old Manufactures, and to discover such New Trades and Manufactures, as will enable us, at least, to keep pace in wealth and power with our rival nations, if we cannot go beyond them." In 1754 action was finally taken by William Shipley, who founded the Society for the encouragement of Arts, Manufactures and Commerce. Shipley ran a drawing school in rooms adjoining their meeting rooms, and many of his students entered the Society of Arts drawing competitions.

Yet the boundaries between, and methods of, training for the fine and applied arts were hotly debated. Sir Joshua Reynolds among others believed that training in the fine arts would percolate down to the mechanic arts. In his seventh *Discourse* to the Royal Academicians he was to argue that, "As our art is not a divine gift, so neither is it a mechanical trade," and he warned against "sacrificing to fashion," which was the fault of the "mechanick and ornamental arts," while upholding the primacy of "history" painting, which he believed would "improve" English painting. Yet artists and designers were united in this aim of improvement, even if attained by different routes and with different moral implications. One of the most enthusiastic purveyors of this idea was James Barry, who in 1774 published *An Inquiry into the Real and Imaginary Obstructions to the Acquisition of the Arts in England*, a powerful polemic in favor of the kind of patronage which would allow the development of what he saw as a higher type of art. In 1777 he undertook to put these beliefs into practice, beginning work on a cycle of six paintings, known as *The Progress of Human Culture and Knowledge*, for the "Great Room" of the Society of Arts, illustrating "one great maxim of moral truth, viz. that the obtaining of happiness, individual as well as public depends upon cultivating the human faculties." Barry offered these without any fee other than the

admission payments to two exhibitions of the work in 1783 and 1784, together with the profits from the prints made from them.

It is Barry's relationship with the Royal Society of Arts via this project which formed the focus for a symposium held in June 2000 at the Society, in the "Great Room" itself. The papers given at the event form the basis of this book, centering on Barry's "attempts to unite" his art "more closely with the utility," in the "improvement of mankind, in manners, in understanding and in private and public virtue." Each of the seven contributors have taken different aspects of the "Great Room" cycle to illustrate the relationships between Barry's work and ideals with the wider contemporary art and design debates focusing on nationalism and improvement, publicity and patronage. The resulting publication is both innovative and fruitful, creating new connections between theory (political, social, and cultural) and practice; and revealing the wealth of documentary and visual sources that the Royal Society of Arts possesses. In a sense this book offers the "novelty full of comprehension and importance" that Barry himself was aiming for in his historical art. While Barry advised those who "had no part in the question of superior art . . . to content themselves with those greater profits which in this commercial country must ever follow from the practice of the lower branches," the aims and meaning of his work, as investigated in this book, reveal more complex relationships between the arts of painting and design than has hitherto been understood or appreciated.

David Allan introduces us to Barry, "a challenging and controversial" figure. While his training and his ambitions neatly fitted the potential offered by the Society's commission for the "Great Room" frieze, he was rewarded with critical but not financial success. Barry's powerful character dominates the story of the conception, execution, and reception of the frieze.

Anne Puetz's contribution charts the development of the Society's "polite arts" premiums from an initial focus on designs for the manufactures—reflecting the urgency of the contemporary design debate—to an increasingly ambitious, and contentious, program that tended toward the establishment of a British school of "high" art. The Society's changing policies give insight into wider contemporary disagreements over the best course of artisanal training, while an analysis of the drawings submitted, and of the numbers, gender, and future occupations of competitors, attempts to gauge the actual effectiveness (if any) of the Society's efforts in this field.

The next step is to connect the eighteenth-century understanding of design to the developing aims of high art. Martin Myrone examines the Society's promotion of "high" art in the 1760s, arguing that Barry was concerned to find an alternative language to express civic virtue in an age when its traditional symbolism had been hijacked by radical and revolutionary forces. This struggle, exemplified in Barry's design for the "Great Room," was set in the context of a Society dominated not by an artistic but a polite elite, who were keen to distance themselves from charges of effeminate luxuriousness. Barry's work, Myrone suggests, was intended to bind commerce and virtue together in the fight against both the French and the economic peril.

Charlotte Grant adroitly turns from macho classical patriotism to the feminization of virtue, as exemplified in the act of prize giving, represented in Barry's panel entitled *The Distribution of Premiums in the Society of Arts*. She focuses on the exemplary figure of Elizabeth Montagu, whose wealth derived from industry, and reveals how Barry promoted the importance of female occupation over idleness, turning the tables on the association of luxury with effeminacy. The discussion of Barry's rather radical iconography is set against the Society's practical encouragement of girls and women to participate in the premium competitions.

Who then saw Barry's paintings in the "Great Room," and how did their audience interpret their position, scale, and content? Turning to the architectural space of the Society's rooms, Andrea MacKean investigates the relationship between the public

and private, and the permanent and transient in the architectural setting of high art. Taking the Society's rooms, the Adelphi, and Barry's frieze, she explores the self-conscious manipulation of these social spaces through the orchestration of interior with exterior, the seen and the hidden, revealing the stage-like quality of the setting for the promotion of commerce.

Having set a variety of wider contextual backdrops to Barry's relationship with the Society of Arts, the second half of the book examines Barry's frieze in detail, the grand narrative sequence masterfully interpreted by David Allan. He argues that the third painting in the series, *Crowning the Victors at Olympia*, incorporating the figures of Minerva and Hercules, is symbolic of the virtues of Wisdom and Strength, upon which the Society was based, justifying its central position upon entry into the "Great Room." Having gained a panoramic perspective of the frieze the next two contributions move to a more detailed scale of analysis, which shed light on how Barry sought to realize his ideas through his art.

W. L. Pressly examines two recently discovered engravings by Barry, which he argues reveal the innermost thoughts, intentions, and practice of the artist and are more about process than end product. Pressly explores Barry's constant reworking of the Society's murals via these engravings and the publication of prints, which enabled him to access a wider audience for his ideas.

The next contribution examines Barry's engraved detail of *Queen Isabella*. John Manning speculates how this twenty-eight-inch "slip of copper," dedicated to Charles James Fox and dated July 25, 1800, fits into the frieze of *Elysium and Tartarus or the State of Final Retribution* in the "Great Room," yet another example of his constant reworking of themes. Manning argues that, far from being a dislocated image, although made seventeen years after the panels were completed, its retrospective incorporation into the panorama is essential to an understanding of both Barry and the work. It connects Barry to his patron, both persecuted Irish Catholics, and the three sixteenth-century figures in the engraving, all of whom made sacrifices to the benefit of mankind. Present and past are linked within the narrative, a fitting leitmotiv for this book of the symposium, the contributors and organizers of which join with Barry in believing that "art and artists play a fundamental role in the advancement of society."

In his last two contributions, Pressly examines the importance of Barry's additional engravings to the Society's murals and his design for the Society's medal. These works in media other than paint deepen our understanding of the scope of Barry's abilities, and the range of his ambitions. Pressly reveals how Barry continued to develop his frieze in the "Great Room," long after the paint on the wall had dried. Via the conception and execution of additional prints he reworked earlier themes, according to a changing personal artistic and political agenda. Barry's enthusiasm for the medal as an art form, and as a means of communicating a message, are revealed in his strong bold designs for both obverse and reverse, showing a talent for powerful symbolism. David Allan's contribution returns to the broader and personal context of Barry in his time, and closes the book with reflections on the circumstances of his death and funeral. As in life, so in death, Barry's fate was closely linked to the frieze and the Society—his body was placed in the "Great Room" the night before his funeral.

James Barry (1741–1806):
A Biographical Outline

David G. C. Allan

JAMES BARRY, SOMETIME ROYAL ACADEMICIAN AND PROFESSOR OF PAINTING AT THE
Academy, and perpetual member of the Society for the encouragement of Arts, Manufactures and Commerce, was born at Cork in Southern Ireland on October 11, 1741.
His father intended him to be trained in his coastal trading business, but seeing that
James was determined on the career of an artist sent him to a school in Cork where
some drawing instruction was available. Copying illustrations of the works of Raphael and other masters led to the production of original paintings of classical and biblical subjects. In 1763 Barry went to Dublin where his painting of the *Baptism of the
King of Cashel by St Patrick* received a prize from the Dublin Society for promoting
Husbandry and other Useful Arts. For seven or eight months he studied in the Dublin
Society's Drawing School before being sent by Edmund Burke to London, where he
worked as an assistant to James "Athenian" Stuart, the architect and classicist, who
with Nicholas Revett had recently published the first volume of *The Antiquities of
Athens.*

In October 1765, financed by Edmund and William Burke, Barry set off for an artistic
tour of France and Italy which would last over five years. His time on the Continent
confirmed his ambition to succeed as a "history painter" and to teach moral truths to
mankind by painting in the grand manner, disdaining portraiture and genre subjects as
useful but secondary pursuits for the artists to follow. This was the doctrine enunciated by Reynolds, and Barry heard with enthusiasm of the foundation of a Royal Academy of Arts in London with Reynolds as its president in 1768. He foresaw a glorious
future for himself in the capital of the British Isles and in 1771, a year after his return
from Italy, he exhibited his *Temptation of Adam* at the Royal Academy's annual exhibition. His work was greatly admired, as were the three paintings he exhibited in
1772. In November of that year he was elected ARA, in February 1773 he became a
full Academician, and soon after was active in the abortive scheme for the decoration
of the interior of St Paul's Cathedral. He exhibited regularly at the Academy until
1776 but he was a difficult colleague, jealous of his brother artists, and beginning to
believe that neither the king, the nobility, nor the Academy appreciated his genius.
His book *An Inquiry into the Real and Imaginary Obstructions to the Acquisition of
the Arts in England* (1775) was a diatribe on this theme.

In 1777 Barry found an institution which was prepared to give him an opportunity
to display his skills to the nation and to the world. The Society for the encouragement
of Arts, Manufactures and Commerce had been founded in 1754 and had recruited
many persons of high social standing and learning in science and the arts into its
membership and had rewarded a whole generation of artists and inventions. In 1774 it
moved to the house built for it in the Adelphi by Robert and James Adam, where the

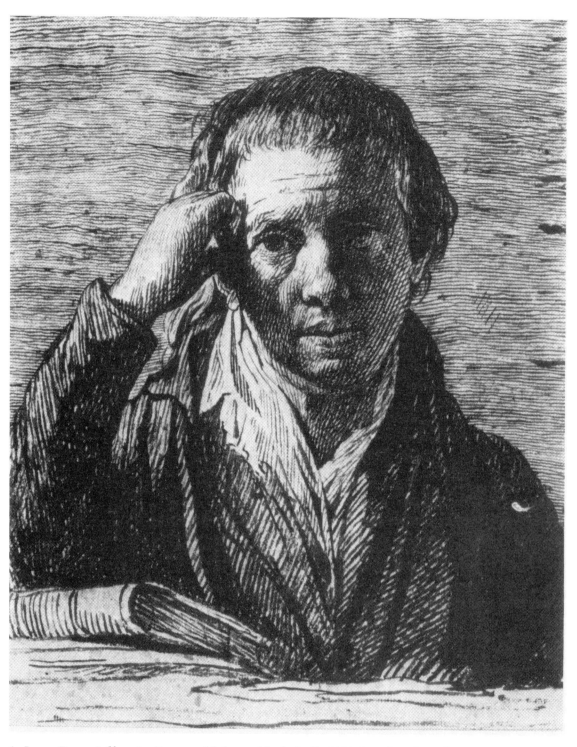

1. James Barry, *Self-portrait*, pen and ink over black chalk, 1802. Royal Society of Arts, London.

walls in its new meeting or "Great Room" were considered ripe for embellishment. Ten artists, including Barry, were invited to paint pictures for the Society, but they voted to reject the invitation. In 1777 Barry arranged to undertake the whole work of decorating the Society's "Great Room" with paintings "analogous to the views of the Institution" and for five years he worked without pay on the gigantic task of producing six canvases illustrating *The Progress of Human Knowledge and Culture.*

By 1783 the pictures were ready for exhibition and Barry was voted the formal thanks of the Society. The exhibition of 1783 was a moderate success and that of 1784 a complete failure. Barry had hoped for both financial and critical reward. He obtained the latter but was still forced to live a life of relative penury. In 1786 he received a down payment of £100 for a painting of *King Lear* to form part of Boydell's projected Shakespeare Gallery and a further £200 when the painting was finished in 1787. In 1789 he obtained a sitting from the Prince of Wales and was thus able to complete the fifth picture in the Adelphi series. But although he had published a descriptive book, a catalogue, and a series of engravings relating to the paintings, he felt that his efforts were unappreciated. In his writings, in the captions to his engravings, and in his lectures as professor of painting at the Royal Academy—he had been appointed to the post in 1782—he was challenging and controversial. A partisan approach to the American War of Independence, a natural sympathy for Irish grievances, and an association with radical Protestant dissenters on the one hand, and an enthusiasm for the papacy and Catholicism on the other, made him a suspect figure. Although the Society of Arts voted him a gold medal, two hundred guineas, and life membership in January 1799, he was expelled from the Royal Academy in the following April. A series of illustrations to Milton's *Paradise Lost* had already been completed and Barry remained active as a painter and engraver. In 1801 he added certain details to his Adelphi cycle and was working on a vast canvas of his own, ten × eighteen inches, called *The Birth of Pandora.* By 1804 he had finished his *Jupiter and Juno on Mount Ida.* He was struggling to live on £60 a year out of which £40 went in rent for a nearly ruinous house in Castle Street, Leicester Square. A thousand pounds was subscribed by his friends at the Society of Arts to purchase an annuity of £120 p.a. on his behalf. He died before he could receive the first payment.

Barry died, aged sixty-five, from pleurisy on February 22, 1806. On the night of March 13 his coffin lay in the Society of Arts' "Great Room." The next day it was taken to St Paul's Cathedral and interred in the Crypt, near the tombs of Reynolds and Wren. James Barry was unmarried and died intestate. His sister, Mary Ann Bulkeley, inherited his collections.[1]

NOTE

1. The fullest modern biography is W. L. Pressly's *The Life and Art of James Barry* (New Haven: Yale University Press, 1981) which he summarizes in *The Oxford Dictionary of National Biography* (Oxford: Oxford University Press, 2004).

The Society and the "Polite Arts" 1754–1778: "best drawings," "High" Art and Designs for the Manufactures

Anne Puetz

In MAY 1782, THE WRITER OF AN ARTICLE IN *THE MORNING CHRONICLE AND LONDON Advertiser* noted with approval that the forthcoming public exhibition *in situ* of James Barry's "elaborate, magnificent, historical and allegorical Pictures" for the Society's "Great Room" was highly likely to restore the institution "to its former splendour." The Society's association with Barry's ambitious project was, he implied, bound to reverse the trend of falling membership and financial difficulty that had come to a head in the late 1770s: "Some respectable Noblemen and Gentlemen, were so pleased on this occasion, as to double their subscriptions."[1]

A year later, the same paper eulogized the Society of Arts not only as the instigator of London's public art exhibitions—then most notably embodied in the Royal Academy's splendid proceedings at Somerset House—but also, apparently without irony, as the creative force behind the institution of the Academy itself.[2] The Society had already portrayed its activities in much the same light in its first published list of premiums of 1778, and was to do so again in 1797, when its secretary, Samuel More, further characterized the body's interests in the field of the "Polite Arts" as tending to the early encouragement of promising young artists and of potential patrons.[3]

In this context of the Society's apparent involvement with the most prestigious efforts toward the establishment of a British school of "high" art by the late 1770s, it is worth remembering that its premiums for the "polite arts" had originally been conceived and publicised as a key strategy in its broader concern for the improvement of commerce and of the national manufactures.[4] At the Society's first meeting in Rawthmell's Coffee House in Covent Garden on March 22, 1754, it was proposed to give monetary awards not only for the native production of important dye-stuffs for the textile industry, but also for the (unspecified) "best drawings" by a number of boys and girls under the ages respectively of fourteen and seventeen: "It being the Opinion of all present, that the Art of Drawing is absolutely Necessary in many Employments Trades, & Manufactures, and the Encouragement thereof may prove of great Utility to the Public."[5] The institution of premiums for drawing (which were to multiply rapidly in the succeeding years) constituted one of the most material contributions to a long-standing public debate on the state of indigenous "design" and its effects on the national production of luxury consumer goods.[6] From at least the 1730s onward, it had seemed to many contemporary observers an urgent economic requirement—though based on perception rather than fact—that native industries counterbalance a slump in Britain's traditional woollen trade in semifinished goods by a diversification

of production and increased competition in the luxury sector of the international and domestic markets. The superiority in particular of French luxury goods was attributed to fashionable appearance and ornamentation—to "design" in other words—and it was in this area, it was believed, that native manufactures needed to be improved.[7] The fostering of draftsmanship at artisanal level was the key solution—proposed by all contributors to the design debate—to the problem of this national "design deficit," to use Matthew Craske's phrase. Skill and constant exercise in freehand, rather than merely technical (compass, protractor, and ruler-bound) drawing was believed to stimulate inventive and creative abilities—the abilities, in other words, to come up with ever new and fashionable "designs"—on which the competitiveness and success of the luxury trades were seen to depend.[8]

The Society's "polite arts" program was originally intended to have a twofold effect: the incentive of monetary awards for drawing was to help raise design awareness among the wider population and encourage children and young adults to acquire and practice drawing skills in preparation for the competitions. The latter were to bring forward gifted and design-literate candidates who could then be channeled into the various trades appropriate to their gender.[9] With hindsight, we know that the Society did not in the main produce "ingenious Mechanics" and "good Workwomen," but, as it later proudly and repeatedly acknowledged, gave first encouragement to a number of eminent British artists.[10] Unfortunately, after its first fulsome dedication to the cause of design improvement, the Society made no further pronouncements on the course of its project for the "polite arts"; no statements, in the minutes, for instance, on the reasons why certain premiums were initiated or discontinued and in particular why awards for the applied arts were abolished altogether after 1778. For any sense of the institution's evolving policy with regard to the "arts of design," we can only turn to the numbers and wording of the premiums themselves. This essay attempts to shed some light not only on the Society's intentions, but also on its influence (if any) on the actual world of contemporary work. Extant prizewinning drawings in the Society's archives and such evidence as we have on the identity, age, gender, and future employment of the competitors may help us gauge something of the effectiveness of the Society's awards and their relations to conditions of training and workshop practice. Lastly, I should like to embed the Society's design policy in the wider context of contemporary thoughts on artisanal education and their far-reaching effects.

The initial award offer to boys and girls for "best drawings" solicited the substantial number of thirty-six submissions of work, of which ten (five for candidates under fourteen and the same number for those under seventeen) were awarded premiums. The subject matter of the prizewinning drawings gives us some idea of the general nature of submissions: assorted "heads" and *têtes d'expression*, an Academy figure, a drawing of *Boaz and the Servant set over the Reapers*, a landscape, and a "horse from the life."[11] Of all ten, only a single work, a floral and animal composition "ornamentally disposed" that won Elias Durnford third prize among the under seventeen-year-olds, could be said to have had any direct utilitarian value to manufactures.[12]

The overall "academic" bias of those first submissions cannot have been accidental, given that at least the younger of the first award-winning candidates had been prepared for the competition by the Society's founder, the drawing master and major instigator of the premiums for drawing, William Shipley himself.[13] In the following year of 1755, it appears likely that one or several of the Society's members associated with manufactures—silk weavers or calico printers perhaps—suggested that the sponsorship of a more industry-related category of drawings than those produced in the year before would befit the institution's original intentions.[14] The first premium offer of "best drawings" was extended by two more specialized categories: a premium for drawings, plans, and designs of military installations, by somewhat older candidates

(under twenty) and, more importantly, an award for "The best fancied & most useful Designs proper for Weavers, Embroiderers, or Callico printers, drawn by Boys and Girls under seventeen, and of their own Invention."[15]

In what appears to be another concession to the requirements of the manufactures, the Society decided in the same year to appoint, alongside the group of artists and drawing masters who judged the submissions of general "best drawings," a second panel of adjudicators. This consisted of trades- and craftsmen with appropriate experience, who were invited to pronounce on the quality of the designs for the textile industry.[16] The latter was, in fact, at the heart of the Society's mercantilist encouragement culture in general and its design awards program in particular. This was not surprising, since, most powerfully embodied in the Spitalfields silk manufacture, the textile industry held a quasi-symbolic position in the design debate. As a key metropolitan industry characterized by a high turnover in fashions that were expensive to produce, it was the object of much anxiety over the vulnerability of native products to French imports and the dependence of British manufacturers on French patterns and designers.[17]

Over the years, premium offers were adjusted on several further occasions, to bring them closer to contemporary working practices, or to reflect changes in demand for the products of different industries. In 1756, the premiums for designs for the textile industries were for the first time divided by gender (now given to boys or girls under the age of seventeen), thus doubling their number. This division—thereafter established for all "polite arts" awards in which girls were allowed to take part—was allegedly the result of a petition by "several young Ladies and Girls" who had declared themselves "intimidated" by the necessity to compete directly with boys.[18] While in 1756 the remaining two "classes" of "best drawings" were exclusively open to boys—respectively under fourteen and under seventeen—in successive years girls were readmitted to what one might call the "lesser" general arts competitions, calling for flora and fauna, "after nature" or based on specified print models. Not surprisingly, in view of contemporary notions of decorum and intellectual ability relating to female artistic activity, girls were not admitted to any of the subsequent competitions involving figure drawing from life, historical compositions, or architecture. In the field of designs for manufactures, their contribution was largely limited to pattern-making for the production of embroidered, woven, and printed textiles, and of wallpapers. In contrast, the (much less numerous) drawing competitions for "mechanick" trades and manufactures involving greater physical strength, but also a greater degree of material outlay in tools and materials—such as cabinetmaking and metalwork—were exclusively addressed to young men. The only award for three-dimensional models "for any Trade or Manufacture" open to girls was a premium for wax ornaments of "Birds, Beasts, Fruit, Flowers or Foliage" introduced in 1762 (boys had been invited to model in wax from 1758), while the presumably more "sculptural" modeling of ornaments in clay was reserved for male candidates.[19]

In 1757, awards for the textile industries still amounted to half the number of the now eight "polite arts" premiums, calling for "Drawings or Compositions of Ornaments (taken from various prints) fit for Weavers, Callico-Printers, Embroiderers, or any Art or Manufactory" by boys and girls respectively under eighteen and under fifteen. The addition "or any Art or Manufactory" to the wording of the design awards marked a notional extension of the Society's encouragement to manufactures other than the textile industries. However, although the 1757 offer produced a number of designs of rococo cartouches, leaf studies, candelabra, and similar widely applicable "ornament" based on French print series dedicated to artisanal drawing practice, the same award thereafter predominantly attracted submissions of the previous patterns for weavers and calico printers.[20]

An additional note in the minutes for 1757 specifically permitted "Apprentices, as

well as others" to compete for all the "polite arts" premiums in that year, and the upper age limit of eighteen appears to have been introduced accordingly.[21] The offer of awards addressed to apprentices, which became a feature of the premium list from that year onward, probably reflected an awareness on the Society's part that competent, workable submissions, particularly for the manufactures, depended to a certain extent on a candidate's familiarity with basic industry practices. This would constitute a change in the institution's policy, a scaling-down of its original ambition of channeling considerable numbers of children into appropriate arts and manufactures to the more modest aim of improving, by competition, those young people already in a chosen field of activity.

A different, more ambitious change in the Society's project was indicated by the massive and steady increase in the number of overall "polite arts" awards from 1758 onward, culminating in an all-time peak of 108 in 1763. Numbers of premiums for designs for the manufactures also rose, but far from proportionately, and there was consequently a rapid decline in the relationship between awards for "designs" and "fine" art productions: in 1758 "designs" made up 27 percent of all arts awards, in 1759 15 percent, in the following year 14 percent, in 1761 and 1762 respectively 9.6 percent and 9.1 percent and, showing a small increase, 10.8 percent in 1763. The year 1758 marked the beginning of the Society's switch from the encouragement of juvenile drawings to a highly ambitious, albeit relatively short-lived, program for the encouragement of the arts at the highest level, which included from 1759 to 1769 variously awards for oil paintings and works in sculpture of a historical subject.[22] In 1758 the Society introduced the unprecedentedly high premium of thirty guineas for a life drawing by young artists under twenty-four at the St Martin's Lane Academy or a drawing of any example from the third Duke of Richmond's collection of plaster casts of antique statuary.[23]

Significantly, the premium for life drawing at St Martin's Lane was worded so as to suggest that this most academic of activities was of direct, material value to the manufactures, and is worth quoting in full:

> Fancy, Design and Taste, being greatly assisted by the Art of Drawing, and absolutely necessary to all Persons concerned in *Building, Furniture, Dress, Toys, or any other Matters where Elegance and Ornament is required*; it is judged proper to encourage the same, by giving for the best Drawings of an human Figure after Life, drawn at the Academy for Painting, &c. in St Martin's Lane, by Youths under the Age of Twenty-four . . . thirty guineas.[24]

This notion was based on the widespread belief, originating in architectural discourse, that exercises in freehand drawing of the most complex form in nature—the human body—equipped students with the necessary skills to master any other "design."[25] Of the Society's influential members in matters of art, William Shipley certainly shared that opinion, and his own school, which was based on a broadly "academic" curriculum—progressive copying from prints, drawings, and casts, (and which had a separate provision of a class for lady amateurs)—was repeatedly advertised as tending to the instruction of future apprentices.[26] However, it is clear that not all the Society's members supported the notion that "high" art exercises held any real value for the improvement of "design" in the manufactures. Shipley, whose drawing school shared the Society's premises in its earliest years, even appears to have been the occasional target of suspicions that his real concern was not for the public good, but that he used the Society's munificence to the end of furthering his own interests in the more profitable and prestigious education of "fine" artists.[27] Certainly, as early as 1756, Shipley, in conjunction with one of the cofounders of the Society, the scientist Henry Baker, thought it necessary publicly to dispel the notion that money spent on awards for the "polite arts" may have been "misemployed." They reiterated the well-worn argument that "Drawing is necessary in so many Trades that the gen-

eral Knowledge of it must conduce greatly to the Improvement of our Manufactures"
and emphasized the Society's intention to prepare young boys and girls for a variety
of trades and crafts, specifically denying that its aim was to educate "what are usu-
ally called Painters."[28] Notwithstanding these assurances, however, another member,
John Ellis, complained in 1759 that the Society's "polite arts" prizes aimed precisely
at the education of "fine" artists, and submitted in evidence the premium list for that
year, which contained, among others, the newly introduced, considerable awards of
one hundred, fifty, and twenty guineas for large-scale oil paintings of subjects from
British or Irish history.[29]

The Society's program in the field of the arts was undeniably increasingly ambi-
tious. However, whether or not Shipley and his friends acted on motives other than
pure public-spiritedness—and the Society's effective encouragement of the manufac-
tures in areas other than design is well documented—evident here is that there were
real disagreements within the Society as to the appropriate course of its "polite arts"
awards. As we shall see, these disagreements neither originated with the Society, nor
were they exclusive to the British situation, and they should be seen in the context of
broader eighteenth-century contentions about the nature of artisanal design training.

In the period from 1758 to 1765 numerous awards for the "polite arts" were offered.
Against the background of the Society's then current "high art" project, which in-
cluded not only the premiums for historical subjects in different media, but also the
hosting of the first public exhibition by the Society of Artists at its "Great Room"
in Denmark Court in 1760, the institution retained a small, but stable number of
premiums for industrial design proper. To the awards for the textile industries and
"any other manufactory," which made up between two and six of the overall "design"
prizes in every year, and most of which were addressed to apprentices, the Society
added in 1758 a short-lived premium to older male candidates for designs for "cabi-
net-makers, coach-makers, manufacturers of iron, brass, china, earthenware, or any
other Mechanic Trade that requires Taste."[30] In spite of a reasonable take-up rate this
specific award was dropped as early as the following year. It produced, as we shall see,
a few reasonably competent designs in the manner of leading rococo carvers and it is
possible that the Society realized the redundancy of its award in the face of the print
market's already ample provision of such designs.

From 1763, the institution extended its award for designs for embroiderers and calico
printers to include the field of wallpaper manufacture ("Paper-Stainers"), a thriving
London industry since the end of the seventeenth century, which had seen a consider-
able upturn in demand from about 1760.[31] In terms of designing for wallpapers, there
was much affinity to that of a variety of textiles, such as printed calicoes, damasks,
and cut velvets, while the industrial process—the cutting of the woodblock and the
printing of papers—was obviously closest to that for the printing of calicoes.[32] Thus,
when the Society offered premiums for designs for calico printers and paper stain-
ers—but not for silk weavers in the same award—it evidently emphasized experience
in the process of production over the skill of inventing appropriate motifs. In other
words, it sought a certain specialization among its candidates and the ability to see
a design through from its conception to its eventual application in the workshop. A
greater desire for specialization is also evident in the Society's detachment, from the
same year, of its premiums for designs for weavers from those for the above textile
and wallpaper industries. It began to institute awards for designs for "weavers only"
and stipulated that such drawings be colored. This seems to indicate an awareness of
the fact that designing for silk weavers in particular required distinct skills, based on
experience with the industrial processes, over and above that of draftsmanship. These
skills included, among others, the ability to indicate precise nuances in coloring (so
that differently colored threads could be grouped together accurately), to clarify the
pattern repeat (this was, of course, a general requirement in the designing of textiles

and printed papers), and the ability to think of the freehand design in terms of its transfer to point paper, which illustrated the translation of the design onto the loom.[33] It is perhaps not coincidental that the Society encouraged specialist knowledge at precisely the moment, from 1763, in which the silk industry entered a period of economic crisis after the prosperous and successful 1750s.[34] In addition, the preeminent freelance designer, Anna Maria Garthwaite, who had contributed so much to the success of Spitalfields silks from the late 1720s onward, had ceased her activities in 1756, and no obvious successor had yet come forward.[35] The unprecedented incentive, from 1765 to 1767, for (shares in) the large sum of fifty guineas for "the best pattern for Weavers, by Persons of either Sex, of any Age under thirty"—premiums clearly directed at experienced craftsmen and women, rather than at young apprentices—may therefore be interpreted as an attempt to bring to the fore one or several new designers of the caliber of a Garthwaite.

However, this greater munificence in a small number of specialist sectors had to go hand in hand with a considerable limitation in the overall number of "polite arts" awards. Reflecting the Society's decline in popularity, in (subscription-paying) membership, and its resulting financial crisis from the beginning of its second decade, arts premiums dropped sharply from ninety-three in 1765 to only forty-one in 1766.[36] Cheaper gold medals, gold, silver, and silver-gilt "pallets"—previously honorary awards to young amateurs—were increasingly given in place of monetary prizes, and for the first time in 1767 also offered to candidates submitting designs for weavers in two categories "for any age" and "for Youths." In that year, only two awards offered shares of the substantial sums of fifty guineas in each category, respectively, for "original patterns for Weavers . . . under thirty" and for a set of designs for the newly introduced sector of "Useful and Ornamental Furniture." Between 1768 and 1770, the only remaining awards for the manufactures were honorific prizes of gold and silver pallets to young silk designers, and the monetary award of fifty guineas for furniture designs. The introduction of the latter underlines the Society's policy of concentrating its encouragement on sectors of the luxury industries with a promising market profile. In Dossie's words, the premium for furniture designs was offered in the hope that, if taken up, it be "of very great consequence to one of the most improving of our manufactures."[37] The institution's decision to discontinue its awards for embroidery designs in the same year of 1767 may also have been motivated by commercial considerations. Although embroidery continued to be important, and became even more important in the embellishment of certain high-quality garments such as fashionable waistcoats, on the whole it seems to have declined as an independent industry and become more evident as a domestic pastime from about 1760.[38] Under those circumstances, it may be that its continued support would have been seen to contradict the Society's original mandate to encourage activities with a real, economic value or its later concentration on the "ideal" value of the "fine" arts. A number of factors also combined to diminish both the economic importance of, and the requirement of, specialized designs for the Society's original core concern, the silk-weaving industry. The American War of Independence cut off the industry's main overseas market until 1783, while the great intrinsic expense of silk as a raw material had already rendered the industry increasingly uncompetitive in the sector of furnishing materials, which was usurped by cheaper printed cottons, wallpapers, and worsteds. Furthermore, original "design" added to the cost of what was already a highly exclusive material, and silk weavers increasingly resorted to French design formulae, to patterns developed for printed cottons, and most importantly, to plainer motifs, thus diminishing the requirement for much in the way of novel, indigenous, silk design. The change from rococo to neoclassical fashions in dress affected materials and patterns of garments and further limited the scope for large and complex designs.[39] In this context, it is not surprising that the Society first reduced premiums for patterns for woven silks to one

honorific award from 1771 (two in 1773), and finally abolished awards altogether in 1776.

In contrast, the reintroduction in 1771 of two monetary awards for patterns for calico printers "of light or dark-ground Chintz" and those for "Copper plates . . . for furniture and garments" reflected the triumph of printed cottons over woven silk and the huge demand, both at home and abroad, for such materials. The industry was given an added boost in 1774 when the Calico Acts were repealed, and the printing of all cotton cloth (imported and home-produced) was permitted.[40] After the abandonment of prizes for woven silks, those for calico printing alone represented the textile industries from 1776 to 1777. When awards for printed calicoes were dropped in 1778—preceding the abandonment of all industrial arts premiums from 1779—this was not the reflection of an industry in crisis, or a waning fashion, but of a manufacture so successful "technically, commercially, and aesthetically" that it needed no outside encouragement.[41] The Society's various award committees had always been anxious to justify spending sums drawn from its members' annual subscriptions by reference to perceived economic need, and had a policy of rejecting proposals for awards, and dropping existing premiums, in areas encouraged elsewhere or where the Society's original objectives appeared to have been fulfilled.[42] However, that policy was somewhat inconsistent, as we have seen in the cases of furniture designs and particularly of printed cottons, where premiums were reintroduced at a time when the industries were already well-established and thriving.

During the last years of our period, from 1772 to 1775, the Society briefly seemed to return to an encouragement predominantly of "design." It was perhaps due to the particularly straitened financial situation following the construction of its new home in the Adelphi that the Society considered it wise to concentrate its awards on the more obviously useful applications of the "arts of design." Consequently, premiums for history and landscape painting were discontinued in favor of areas such as the engraving of frontispieces and the drawing of machines. To the usual designs for weavers and calico printers, the Society added, from 1771 to 1775, offers of awards for models (rather than drawings) of a "table chandelier, on a new design," of "an elegant ornamented vase," and of "any piece of ornamental Household Furniture," all of which were to be "of a size fit for use."[43] The models particularly for chandeliers (candelabra) and vases, for which premiums continued to be offered respectively until 1776 and 1778—the furniture award was first abandoned, in 1776—were obviously intended to suit the manufacture of consumer goods in the then current neoclassical taste.[44] In addition, however, because of their eminently classical pedigree and proximity to architectural decoration and sculpture, such objects were also able to appeal to potential "high" art candidates and their supporters in the Society's "polite arts" committee.[45] For an evocative illustration of the Society's marriage of "polite" and commercial concerns in that period, we need only turn to James Barry's fifth painting for the "Great Room," *The Distribution of Premiums in the Society of Arts*. It includes as the only object of what Alexander Beresford Hope was later to term "art manufacture" a highly vase-like tea kettle "of a classical design" (added in 1801), while elsewhere allusion to the premiums for the "arts of design" is made exclusively with reference to works of a historical and academic character.[46] Shortly after the discontinuation of the last "design" award, for the model of a vase, in 1779, the Society appears to have fundamentally rethought its premiums for the arts. Relinquishing the encouragement of ambitious historical art in oil painting and sculpture, which was clearly seen to have been taken on by the Royal Academy, it returned to the sponsorship of draftsmanship in a preparatory function, but now addressed solely to the promising young "fine" artist and the future patron.[47]

The chronological development of the Society's "polite arts" program thus gives evidence of a rapid expansion of the "fine" arts premiums to the detriment of those for

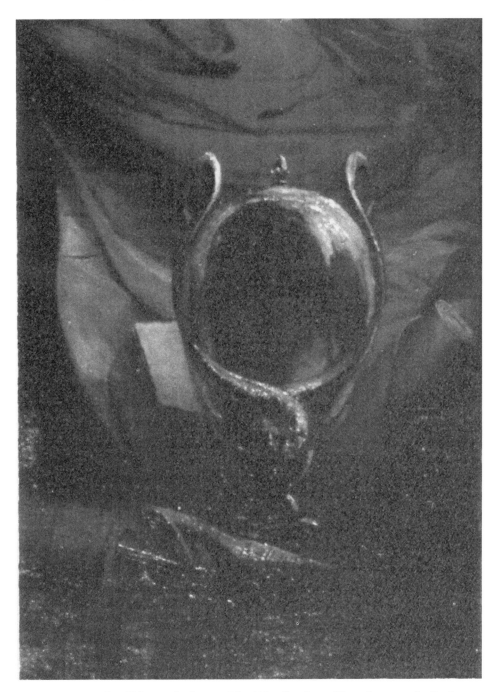

2. James Barry, detail from 5ᵗʰ picture, *The Distribution of Premiums at the Society of Arts* showing a tea kettle designed by Barry (added 1801). Royal Society of Arts, London.

the applied arts, culminating in a relatively brief, but intense period of encouragement for works in different media in the highest genre of history painting. In the field of "design," the Society's project concentrated largely on the textile industries, in which its award offers reflected, to a certain extent, changing fashions and the requirements of the market. The increasing emphasis on the contributions of older candidates—of apprentices and in the later period of established artisans—narrowed the Society's original intention of raising design literacy among the capital's youth in preparation for a wide variety of design-dependent crafts and trades.

Thus far, we have been concerned with the Society's broad intentions toward the encouragement of design for the manufactures through an analysis of the awards it offered. For an evaluation of the efficacy of its program, we must turn to the quality and practicality of the extant drawings themselves and to the numbers, and recipients, of awards made.

The majority of the drawings deposited in the RSA archives are by younger candidates, and only a very few are by those who can be identified, with some degree of certainty, as apprentices or future craftsmen in specific areas of the manufactures. That is not surprising, since most masters would have been reluctant to put on public record, as it were, designs that were based on intimate knowledge of their workshop practices and that might reveal trade secrets, or fashions developed in-house. Indeed, some manufacturers, such as the calico printer William Kilburn, held their own prize-giving annual design competitions to encourage, and reward, artistic efforts among their workforce.[48] On initial investigation, the majority of the extant RSA designs reveal considerable common ground with contemporary artisanal practice. Firstly, in methodology of instruction, they were based on the idea of "invention through imitation," a phrase Maxine Berg has coined with regard to wider economic phenomena, but which equally applies to the contemporary notion of fostering indigenous design (as well as, of course, the skills of the "fine" artist) through the continued and progressive copying and adaptation of approved master models.[49]

A scrapbook put together in the 1760s by the wood-carver Gideon Saint, containing cuttings of appropriate models (largely contemporary engraved ornament) and drawings of imitations and increasingly "free" adaptations by Saint himself, exemplifies this method in contemporary artisanal practice.[50] Many of the RSA's drawings are likewise based on identifiable models, and moreover, often on the same models by all or most of the candidates in a specific year, suggesting that at least the younger competitors were prepared for the awards by the same drawing master and copied from a single example, or a coherent series of models. This can be seen, for instance, in the case of the assorted "ornaments" based on the French print series mentioned in note 20, and produced by Shipley's students for the 1758 competition for patterns for silk weavers or "any art or manufactory" by girls and boys under eighteen.

In terms of content, many of the prizewinning designs were clearly copied, and adapted, from patterns that were reasonably up-to-date at the time of the competitions. The award offered in 1758 for patterns for "cabinet-makers, coach-makers, manufacturers of iron, brass, china, earthenware, or any other Mechanic Trade that requires Taste" produced a small number of rococo designs for three-dimensional objects, such as carved mirror frames and candelabra. Although a design like Joachim Smith's mirror frame, which was awarded a prize in that competition in 1759, cannot be traced back to a single source—after all, the premium offer specified originality in conception—it is nonetheless reminiscent in overall appearance and decorative detail of the rococo carver Thomas Johnson's influential untitled collection of designs, which had come on the market in 1758.[51] Another (watered-down) pattern with elements derived from Johnson's interpretation of the rococo was submitted by William Hebert in the following year.[52] In this design for a table clock, typically Johnsonian motifs—the representation of "Father Time," the very English hunting scene, the stridently patriotic elements ("Quebeck taken 1759"), and the spiky rococo scroll-work—were clearly derived from close study of the carver's print publications, but somewhat incongruously married to the much less fashionable bulky shape and the baroque framing of the dial face.

Textile patterns were, of course, much closer to the heart of the Society's project than these occasional designs for three-dimensional objects, and not surprisingly make up the majority of the extant drawings in the archives. At a cursory glance, a number of these patterns appear fairly accomplished and not dissimilar to contemporary

3. Joachim Smith, prize-winning design for a mirror frame, 1759. Royal Society of Arts, London.

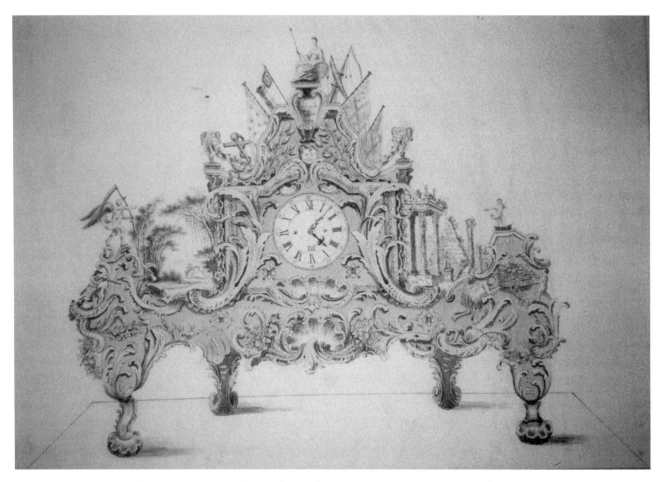

4. **William Herbert, prize-winning design for a table clock, 1760. Royal Society of Arts, London.**

executed fabrics or the patterns by known designers on which they were based. John Edwards's silk design, which won a second share of three guineas in 1759, for instance, aims at a *points rentrés* execution, pictorially indicated by the elaborately hatched areas of the floral elements.[53] Edwards, in fact, was probably no "lay" designer, but by 1759 already an apprentice in the silk industry. As late as 1771, he reappeared at the Society with an accomplished pattern for a tobine striped and brocaded silk closely resembling actual fashions of the late 1760s and early 1770s, for which he won first prize in the specialist competition for original patterns for weavers only. There is, not surprisingly, a difference in feasibility and state of fashion between the very few "professional" designs, such as Edwards's, and those executed by young candidates without experience of the industrial processes. For all its apparent similarity to actual contemporary patterns, Lewis Pingo's design for a silk brocade, for instance, which won him a first share of four guineas in the same competition in which Edwards had also been awarded, was, in fact, already somewhat old-fashioned. More importantly, although it is squared up, it fails to indicate the crucial pattern-repeat, without which a design would be of little use to the weaver attempting to translate it onto the loom. The overall appearance, and particularly the stenciled yellow blossoms—to indicate the use of gold thread in the weaving—appeared in designs produced by Anna Maria Garthwaite some four years earlier, and thus a considerable time in the fast-lived world of silk fashions, before Pingo's competition drawing.[54] Not surprisingly, such obvious defects as the failure to indicate an exact, or any, repeat is not to be found in the designs of the (future) pattern drawers Peter Sayer and Richard Sissell discussed

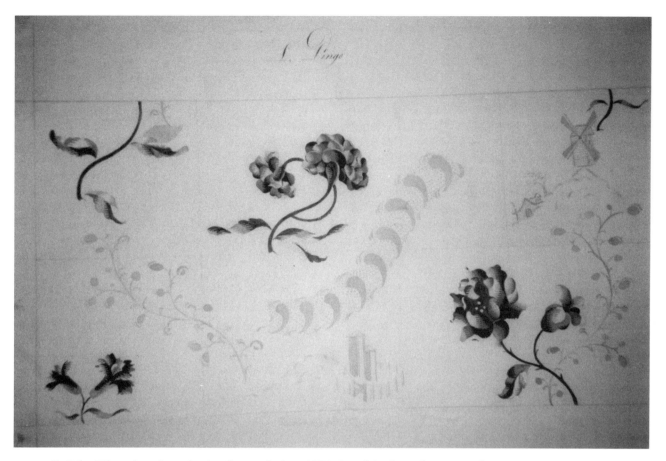

5. **John Edwards, prize-winning flower design, 1771. Royal Society of Arts, London.**

below. They won premiums respectively in 1770 and 1771 for patterns for silks with tobine stripes, wreathed with stylized flowers and interspersed with small blossoms and sprays of flowers, which appear both more stylish and up-to-date than the designs of the younger and/or "nonprofessional" candidates.

Interestingly, all the silk designs in the Society's archives suppress the technical information of precisely indicating the sequences of colors to be used. Garthwaite, among others, did this by way of an intricate numbering system that we can find on extant designs. Such numbering would be required for translation of the patterns onto point paper and then onto the loom, and its absence may be due to the fact that the "lay" candidates were ignorant of the technical procedures, while the apprenticed draftsmen were probably reluctant to disclose information that would turn a mere drawing into a usable design.[55]

In conclusion, it therefore appears that the children and youths without direct experience of the silk industry—in contrast to the fewer known apprentices—depended for models on somewhat outdated patterns and were also not entirely *au fait* with some of the essential aspects of the design process. It is perhaps in response to such problems that an anonymous "Mercer" wrote to the "polite arts" committee in 1757, urging the Society to employ a master weaver to attend the adjudication of the designs, "for no one Else can be a Proper Judge whether their designs can be worked or not" and emphasizing the "intricate" nature of designing for this industry.[56] In that context, it may be significant that a considerable number of drawings—of isolated bunches of flowers and flowers in vases—are not easily identifiable with designs for a given manufacture, or at least not for the textile industry, which, as we have seen,

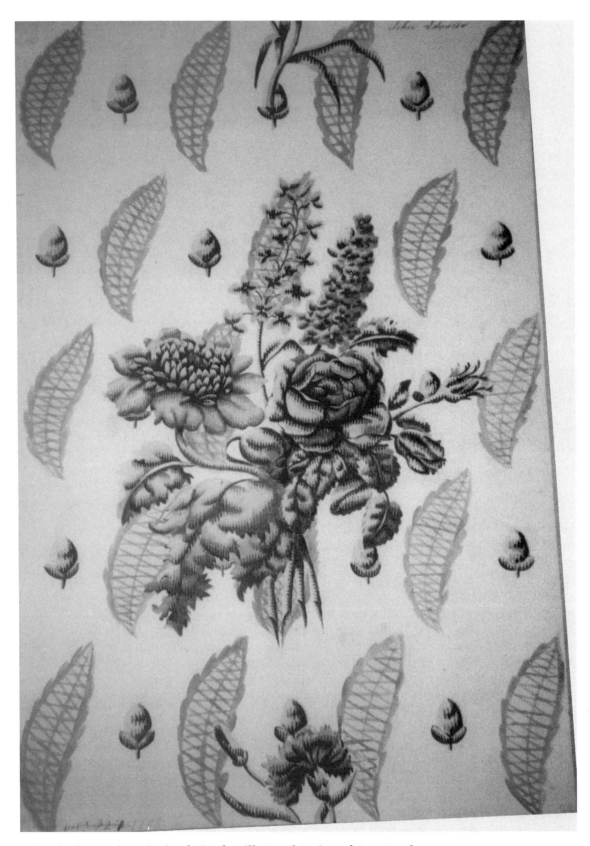

6. Lewis Pingo, prize-winning design for silk. Royal Society of Arts, London.

7. **Peter Sayer, prize-winning flower design. Royal Society of Arts, London.**

required a considerable understanding of, and sensitivity to, the production process. Hannah Chambers's composition of flowers, for instance, which was awarded a third share of three guineas in 1759 for designs for "weavers, embroiderers or any art or manufactory," would at best be useful as a single motif within a silk design—perhaps a damask—which would then have to be developed, particularly in terms of the pattern repeat. Such individual flower motifs were, in fact, much more useful to the painting of porcelain, or to those occupations, such as *découpage* and japanning, that occupied the gray area between art, craft, and domestic pastime and that were deemed particularly suitable for women "artists." In addition, their isolated motifs lent themselves much better than a technically complex silk design to the process of copying and adaptation from the profusion of source material contained in drawing and pattern books.

Much more research into artisanal design and workshop practice needs to be undertaken before we can fully evaluate these juvenile drawings. An investigation into the Society's quantitative contribution to the formation of actual contemporary "designers," too, is hampered by the fact that we still know, and often care, so little about the majority of the men and women working in the applied arts in the period. While the subsequent careers of the institution's "fine" arts protégés—the likes of Richard

Cosway, Mary Moser, John Flaxman, William Mulready, Edwin Landseer, John Everett Millais, and various others—are well documented, many of the other names in the Society's "premium received" lists remain meaningless to us. This anonymity is particularly marked in the case of the female candidates in Robert Dossie's summary of the prizewinners.[57] Dossie, who gives information on many of the male candidates' apprenticeships and subsequent careers, identified the young women at best in relation to their (better-known) fathers and brothers—such as Mary Vivares, daughter of the engraver and printseller Francis Vivares—or to their future husbands. Since girls and young women made an overwhelming contribution to the applied arts competitions—while young men concentrated on the "fine" arts—this lack of information further limits our evaluation of the Society's success in turning out competent designers for the manufactures.[58]

Among the male candidates, Dossie named two future Spitalfields silk weavers, one Isaac Martell, who had won first share of the premium for designs "for weavers, embroiderers or calico-printers" for boys under seventeen in 1757, and one George Hebert, who received first share of a prize for "Drawings of any kind, human figures and heads excepted" in 1760.[59] Although only these two weaver-designers are known with certainty to have emerged from its competitions, the Society would have been justified in taking pride in the encouragement of a combination of skills, the general lack of which was considered as a grave detriment to the competitiveness of the native silk industry. Godfrey Smith's influential craft treatise, *The Laboratory, or School of Arts*, which went through numerous editions and was reprinted well into the nineteenth century, attributed the superiority of French designs, especially "in the flowered way" to the fact that every Lyons silk manufacturer, "though he employs several hands in drawing of patterns, is a pattern-drawer himself; and qualified as such by his judgment, he has the whole management under his own care and direction." In England, Smith complained, only a minority of manufacturers were thus qualified.[60] In addition, the Society's premiums appear to have encouraged at least four apprentice pattern drawers for Spitalfields, named as Samuel Paris (prizes in 1763 and 1764), Abraham Mondet (1768), Richard Sissell (1770), and Peter Sayer (1771), and the three young designers, John Dew (1772), William Naylor (1768), and John Philpot (1771) working for Robert Jones's calico printworks at Old Ford, Middlesex.[61] While these youths competed in categories consistent with their then current apprenticeships—excepting Naylor, who won his premium for a pattern for weavers, and Philpot, who was awarded for a drawing in the nonspecific "class" of compositions of "fruit, flowers and plants"—there was, on the whole, little correlation between the type of competition entered and the candidates' future employment. The example of the several children of Thomas Pingo, Society member, and engraver to the Mint, is a case in point. The adolescent Lewis Pingo, his brothers Henry and Benjamin, and sister Mary, were among the most prolific producers of apparently competent designs for woven silks, embroidery, and calico printing in the period mainly from 1755 to 1762. Indeed, in 1769 the youngest son, Benjamin, won an honorary gold pallet in the same competition for silk designs, in which the "professional" Abraham Mondet, mentioned above, only came second, with a "silver pallet gilt." Nonetheless, it seems that none of them actually made a career in the silk industry. Lewis and Mary Pingo, and their elder brother John, were also repeatedly successful in the Society's awards for medals, and it may well be that the family tradition of die-sinking and gem and medal engraving held out more highly reputed and financially rewarding employment.[62] While the Pingos, among others, thus competed on several occasions for awards for textile designs and turned to professions more akin to "high" art practices, a number of prizewinners in the more general "fine" art categories had future careers in the crafts and trades. William Gastrell, for instance, who became a chaser and was also mentioned as a jeweler, won fourth prize in the category "Drawings of a Human Figure or of Heads in Chalks" in 1760, and

again in 1761, in which the future jewelers Charles Whitton and James Ainsworth were also awarded premiums.[63]

Indeed, the instances in which future crafts- and tradesmen were first encouraged by way of such "heads," figures, and compositions drawn from approved master models—see also Hebert and Philpot above—appears to give a certain credence to the notion of the universal usefulness of academic drawing, to which a considerable part of the Society's membership subscribed. There were, of course, even more high-profile examples of artist-designers, who had been encouraged by the Society, and had subsequently developed lucrative *and* honorific ways of applying "high" art skills and subject matters to the requirements of the manufactures. Josiah Wedgwood certainly drew on talent encouraged by the Society for the employment of his designers and modelers, among whom were the sculptors John Flaxman and John Lochée. The latter, who was active in the Wedgwood factory from 1774 to at least 1787 and played a considerable part in the creation of the famous series of contemporary portraits, *Heads of illustrious models*, in jasper ware, had been the only recipient of the Society's awards for the models of "table chandeliers" mentioned above, winning shares of seven guineas in 1773 and 1774.[64] He was also employed by the entrepreneurial Scottish glass and gemstone engraver James Tassie, who in turn collaborated with (rather than worked for) Wedgwood and who was himself one of the successes of the Society's encouragement of the "polite arts," having won a premium for portrait medallions and gems in 1766.[65] Gem engravers and modelers like Tassie, Flaxman, and Lochée, of course, depended on the academic apparatus of two-dimensional representations, and casts of classical statuary in a variety of media as models. However, there is plenty of evidence that such "high" art tools were widely employed in the training grounds of a number of humbler potential crafts- and tradesmen, among which William Shipley's own school and its academic curriculum has already been mentioned. Another pertinent example is Robert and Andrew Foulis's ambitious "Academy" at Glasgow, where Tassie had received his first training, and which had been founded in the same year as the Society with the aim, at least in part, to supply designers for the manufactures. In 1754 the school was advertised not only as offering an ambitious academic curriculum with an emphasis on life drawing, but even of intending to hold regular exhibitions of "old master" paintings, drawings, and prints and of bestowing travel scholarships to Rome.[66]

Thus, there seems to have been some vindication for the widely held notion of the automatic benefits of a "high" art training to the "arts of design" in the widest sense. This notion Joshua Reynolds advanced in 1769 as a justification for the disassociation of the newly established Royal Academy of Arts from the direct training of crafts- and tradespeople that had been so apparently dominant a requirement in the majority of early to mid-eighteenth-century appeals for a national academy of arts.[67] However, a closer look at some of the latter, such as the influential *Essay on Design* (1749) by John Gwynn, and the "plan" for an Academy submitted to the Society in 1755 by Henry Cheere, reveals a bias from the very beginning toward an academic solution to the problem of the nation's "design deficit."[68] These writers vision of a national school of design was largely based on the model, no less, of the most prestigious of the European academies of art, the French Académie Royale. As a logical consequence of the academic idea, according to which instruction tended to the formation of the history painter, such a vision, of course, implied an inbuilt inferiority, and marginalization, of the artist designing for the manufactures. It is surely not insignificant for the development of the Society's "polite arts" program, and its increasing "fine" art bias, as we have outlined it above, that Gwynn, Cheere, and leading members of the Dilettanti had close associations with and/or membership in the Society in its early years.[69]

In this context of the efforts of eighteenth-century painters and architects to attain professional status and to gain acceptance as "liberal" artists, the Society's deviation

from an original emphasis on the "polite arts" as a means of improving the national manufactures was a characteristic, rather than exceptional, feature in the development of design schools and of contemporary encouragement societies at large. This was particularly true, of course, in countries or regions with a nascent, or weak, academic tradition. The evolution, over the course of a few decades of the Trustees' Academy in Edinburgh, from a sophisticated training ground of crafts- and tradesmen founded in 1760 to a more ambitious school for "fine" artists, is a typical example.[70] It is a significant confirmation of the increasing bias toward the "fine" arts as a wider eighteenth-century trend that the Société pour l'avancement des Arts of Geneva should have mirrored the development of the London Society so closely. Founded in 1776 by a very similar confluence of patrician and commercial forces with a common interest in the development of local industries—in particular clock- and jewelery-manufactures—it turned within the space of two years to the provision of life classes also, and increasingly, for artists and by 1786 had essentially become a "fine" art society, which was to hold several "Salon" exhibitions of the work of Genevan painters before the end of the century.[71] At a time when social respectability and upward mobility were increasingly defined by a process of distinction, particularly of "high" culture from its "mechanick," and overtly artisanal manifestations, it is not surprising that the London Society, too, should have turned to the more honorific encouragement of the "fine" arts. The Society's membership, although heterogeneous, was certainly distinctly "polite," and one of which crafts- and tradesmen, who were not entitled to serve as chairmen of the arts committees, appear to have made up less than 2 percent. In a telling conclusion to its "Observations on the Effects of Rewards bestowed in the Class of Polite Arts," having dwelled at length on the Society's contributions to the cause of "high" art, it mentions what had once been its key concern merely as an afterthought:

> The encouragement also that has been given by the Society, to invention or improvement, *even in the lower branches of the Polite Arts,* such as Drawings of Patterns for Silk-Weavers and Callico-Printers, has been attended with evident benefit to these manufactures, which now may fairly vie in beauty with those of any other country.[72]

The increasing bias toward the "fine" arts did not, of course, only affect the Society's policy and "polite arts" committees, but did presumably also influence many of the potential recipients of its bounties. The social, economic, and cultural devaluation of the "mechanick" crafts and trades—at least below the level of upholder or manufacturer—and the growing viability from the second half of the century of a lucrative career in the "fine" arts must have acted as a disincentive for many young people to consider an occupation in the "lower branches" of the "polite arts."[73] The number, at any rate, of (future) crafts- and tradesmen encouraged by the Society was small, not only, as we have seen, in the textile industries, but in other sectors of the manufactures as well. Of Shipley's twenty-one known students—there may, of course, have been many more—only one subsequently emerged as an artisan: William Willis, who won a premium for a textile design in 1760, was later known as a glass ornament cutter.[74] More typically among Shipley's pupils, awards for textile patterns were also made, for instance, in 1757 to Richard Cosway (later a miniature painter), a year later to James Gandon (a future architect), and in 1759 to Simon Taylor and William Pars (respectively a future botanical draftsman, and a portrait painter and successor in the management of Shipley's drawing school).[75] Not only did many applicants for the "design" awards later turn to the "fine" arts or professions, but a considerable number of these competitions, especially in the later years of our period, brought forth few, or no, prizewinners at all. In 1764 and 1765, for instance, one Alice Morrison was the only recipient of a share in the premium for colored patterns for weavers by girls under the

age of eighteen; having already won part of a prize, alongside another girl, for the same award in 1763. The return, year after year, of the same few candidates for particular competitions, especially for those of a relatively specialized nature, gives evidence of the somewhat narrow appeal of the Society's award offers. In 1768, and again in 1770, even the incentive of (a share in the sum of) fifty guineas for furniture design did not bring forward a single successful applicant. We do not know whether, as the Society's secretary Sir Henry Trueman Wood suggested in the early 1920s, the response to "design" competitions—in contrast to those for the "fine" arts—was unsatisfactory, or whether the inadequacy of submitted drawings account for the low rate of awards made in that sector.[76] Most likely, both these and other factors combined to make the Society's efforts toward the improvement of "design" for the manufactures a relative failure. Not least among these was a certain amateurish, top-down approach—typical of patron-led encouragement societies—which, for all its well-meaning efforts, disregarded, to an extent, the realities and requirements of the contemporary market. Matthew Craske dismisses the notion that the encouragement of "design" by way of efforts toward the establishment of academies and through prize-giving societies was responsible for the elimination of the "design deficit" from the mid-eighteenth century onward.[77] Indeed, we know that the "market"— in the form of enterprising craft-designers, drawing masters, print- and book publishers—provided both new "design" models and materials relating to design instruction in profusion from at least the 1750s onward.[78] Important luxury manufactures, including that of the silk industry, which continued to feature so prominently in contributions to the design debate, were, by all accounts, already thriving and competitive—in the case of silks even internationally—by the time the Society's premium offers properly got under way.[79]

Moreover, there was the Society's "academic" bias, which was based in part, as we have seen, on the institution's desire to align itself with the polite cause of "high" art, but which also informed the dominant opinion of its "polite arts" committees with regard to the proper course of artisanal instruction. On the basis of the notion that a (modified) academic approach, with an emphasis on draftsmanship and the copying of approved master models—whether human figures or flowers—alone was to serve the "fine" and the applied arts alike, the Society failed sufficiently to take into account the necessity of specialist industrial training to supplement drawing. Again, this was not exclusive to the Society, and disagreements over the most efficient way of training designers for the manufactures were evident even in major centers of Continental luxury production.

Sarah Richards has, for instance, charted the contentions between the Dresden Academy and the Meissen Porcelain Manufactory, whose drawing school was under the former's control, over the best way of instilling good "taste" in the workforce of Meissen's painting division from 1763 to 1836. There, the Academy's emphasis on an unmitigated, "high" art training for designers and its vision of porcelain as a branch of the "fine" arts, collided with the manufacture's requirement to suit designs to complex production processes and with its commercial need to supply an expanding public with the popular and fashionable objects it demanded.[80] Even in France—the long-established leader of European luxury production—disagreements arose over the best training for the artisans employed in its important manufactures. At Lyon, for instance, provision of drawing instruction for the silk industry was certainly varied and plentiful, from teaching led by established, even Academy-trained painters, to elementary "écoles gratuites" and those attached to workshops.[81] Its theoretical framework, however, was contested by the advocates of an "academic" training based on figure drawing on the one hand—generally painters, amateurs, and painter-designers—and of those in favor of a less ambitious, but more focused concentration on flower painting and "technical" drawing on the other hand (manufacturers and designers in the workshop).[82] The reality of silk production at Lyon appeared to show the important

necessity at least of adding technical and commercial design aspects to those of "pure" draftsmanship.[83]

Crucially, as far as the London Society was concerned, its premiums in themselves did not, of course, teach anything—notwithstanding the early close relation of Shipley's school with the Society—but only brought forward, by the incentive of competition, those relatively few apprentices and would-be apprentices already possessed of certain artistic skills. The awards therefore relied on a more elementary level of training, which, as we know, was largely restricted to private drawing masters, such as Shipley himself, who prepared the younger applicants for the Society's competitions. Such instruction was probably too expensive for the majority of the girls and boys whom the Society originally intended to channel into appropriate crafts and trades, and who had to rely, at best, on the more vicarious process of learning from cheap drawing and pattern books.[84] There was thus a deficit of elementary drawing skills among the lower artisanal class which the Society's premiums could not remedy, and a more successful course of action might have been—as it increasingly became during the institution's nineteenth-century efforts—to sponsor that element for the many, rather than giving prizes for already rather accomplished drawings by the few. Rival approaches to the improvement of design, such as Jean-Jacques Bachelier's influential Ecole Royale Gratuite in Paris (founded 1767, and precursor of the still existing Ecole nationale supérieure des arts décoratifs) and the several drawing schools established in Birmingham by the late 1750s, in fact, demonstrated the importance of a combination of scale (of numbers of students taught) and industry-related specificity of training to the success of the enterprise.[85] Bachelier himself came from an artisanal background and, as former directeur artistique at the Vincennes porcelain works, had personal experience of manufacturing. Rather than providing the same, "academic" teaching for all students, he divided apprentices and would-be apprentices into three classes appropriate to their chosen occupation, giving instruction either in geometry and architecture, in human figures and animals, or in flower painting and "ornament."[86] His rationalized timetable proved capable of educating fifteen hundred [!] pupils per week, and the resulting achievement was not so much the encouragement of a handful of original designers, but the wholesale provision of elementary drawing instruction to future artisans.[87] Importantly, by way of a royal charter and of handsome support from philanthropic aristocrats and professionals, the Ecole Royale Gratuite, as the name implies, was able to provide this training free of charge, as well as offering honorific and hugely valuable material prizes, the latter especially in the form of "prepaid" apprenticeships in the award-winning students' preferred occupations.[88]

In conclusion, the Society of Arts' program for the encouragement of design for the manufactures was certainly flawed, but some of the underlying reasons—particularly an inherent bias toward the "fine" arts, and a belief that (more or less academic) draftsmanship was in itself capable of stimulating "design"—are interesting in what they reveal about more widespread, and influential contemporary notions about the training of artists and artisans in the "lower branches" of the "polite arts."

Following the revival of the design debate in the 1830s, when the alleged shoddiness and artistic poverty of British luxury goods caused widespread concern, the Society finally recovered its original concern for the improvement of national manufactures in terms of design. Although its efforts were late in coming (lumbering into action in 1843), and not always to the point or efficiently managed, the Society's series of exhibitions of industrial goods ultimately contributed to the Great Exhibition of 1851 and to the establishment of what is now the Victoria and Albert Museum. In particular, and no doubt based on recollections of its eighteenth-century experiences, the Society for the first time resolved to engage with, and invested in, the important issue of elementary drawing instruction.[89] Finally, from the 1920s, the now Royal Society of Arts contributed, by way of its Student Design Awards, which seconds prizewinning

applicants to work placements within appropriate industries, one important means of bridging the gap between design training and the actual application of design in the processes of manufacturing.

Notes

1. *The Morning Chronicle, and London Advertiser*, Saturday, May 11, 1787. It is, of course, entirely possible that this article was a "puff" placed by the Society, or indeed by Barry himself.

2. *The Morning Chronicle, and London Advertiser*, May 5, 1783. See also Robert Dossie, *Memoirs of Agriculture, and other Oeconomical Arts*, 3 vols. (1767–82), 32–33 for an evaluation of public exhibitions as "owing entirely to the example set by the Society."

3. *A Register of the Premiums and Bounties given by the Society of Arts 1754–1776* (London: n.p., 1778), see "Observations on the Effects of Rewards bestowed in the Class of Polite Arts," 54. On Samuel More's address at the distribution of awards in 1797, see D. G. C Allan, "Artists and the Society in the Eighteenth Century," in *The Virtuoso Tribe of Arts and Sciences: Studies in the Eighteenth-Century Work and Membership of the London Society of Arts* (Athens, Ga.: University of Georgia Press, 1992), 114.

4. In the following, I shall make the distinction, according to modern usage, between the "high" or "fine" and the "applied" or "industrial" arts. In contrast, the Society's own terminology, according to Dossie, made no such distinction: "By the Polite Arts, according to the sense in which the expression is used by the Society, are meant, those which depend on design and taste; and are called by others the Fine Arts." Dossie, *Memoirs*, 32.

5. RSA Minutes, January 22, 1754.

6. On earlier "encouragement societies," who had preceded the Society of Arts in giving premiums for drawing, such as the Dublin Society, founded in 1739—or for the native production of examples of woven brocade and bone lace, the Antigallican Society's prizes in 1751—see Jules Lubbock, *The Tyranny of Taste: The Politics of Architecture and Design in Britain 1550–1960*. (New Haven: Yale University Press, 1995), 219.

7. For a comprehensive discussion of the eighteenth-century design debate, see for instance Matthew Craske, "Plan and Control: Design and the Competitive Spirit in Early and Mid-Eighteenth-Century England," *Journal of Design History* 12, no. 3 (1999): 187–216, particularly 196–205.

8. See for instance Robert Campbell's advice to the prospective cabinetmaker: "A Youth who designs to make a Figure in this Branch must learn to draw; for upon this depends the Invention of new Fashions, and on that the Success of his Business: He who first hits upon any new Whim is sure to make by the Invention before it becomes common in the Trade; but he that must always wait for a new Fashion till it comes from Paris, or is hit upon by his Neighbour, is never likely to grow rich or eminent in his Way." Robert Campbell, *The London Tradesman* (London, T. Gardner, 1747), 171.

9. Henry Baker, "Advantages arising from the Society for encouraging Arts," *Gentleman's Magazine* 26 (1756): 62, original MS written by "Mr. H. Baker signed Wm Shipley" is in Society's Guard Books, I, 83. Baker names for instance carving, cabinetmaking, coach-painting, weaving, metalwork, sculpture, engraving, and calico printing as destinations for the boys, and millinery, dressmaking, embroidery, and pattern drawing for the girls.

10. Ibid. For the Society's proud association with leading British artists, see Allan, *Virtuoso Tribe*, 1992: 114.

11. Dossie, *Memoirs*, 392–96.

12. Ibid., 395. The drawing—in pencil, gray wash, and red chalk on blue paper of an arrangement of leaves, fruit, a bird, and a dragonfly, is extant in the RSA archives, location PR.AR/103/19/125.

13. Ibid., 394. The older candidates were apparently trained by the drawing master Jacob Bonneau. Ibid., 396.

14. The Minutes only record, though perhaps suggestively, that on consideration of the drawing premiums "after Debate it was judg'd most convenient *for the public Good,* . . . that the praemia be distinguish'd under the three following Heads" (my emphasis).

15. RSA Minutes, March 5, 1755. The award for military drawing was proposed, but not implemented as such exercises were found to be sufficiently encouraged by the Woolwich Naval Academy.

16. The first drawing submissions had been adjudicated by the architect and sculptor Henry Cheere, the drawing masters Jacob Bonneau and Richard Dalton, and the engravers Robert Strange and Francis Vivares. Minutes, January 15, 1755, 11. The panel for textile designs for the following year included the calico printer John Arbuthnot and in 1757, another calico printer, Henry Clare, was added to the existing panel. RSA Minutes, December 31, 1755, and January 19, 1757.

17. See for instance Daniel Defoe, *The Complete English Tradesman*. London (London: C. Rivington, 1738), posthumous ed., 262, Robert Campbell, (Tradesman), 259; Joseph Collyer, *The Parent's and*

Guardian's Directory. (London: R Griffiths, 1761), 79, and John Gwynn, *An Essay on design: Including Proposals for Erecting a Public Academy to be supported by voluntary subscription for Educating the British Young in Drawing and the Several Arts depending thereon.* London: n.p., 1749.

18. RSA Minutes, January 21, 1756.

19. This was, of course, entirely in keeping with contemporary prescriptions of what were appropriate occupations for men and women—see for instance, Campbell and Collyer above,—although in practice, women occasionally participated in "male" trades. On women in furniture making, see for instance Pat Kirkham, "If you have no sons": Furniture Making in Britain," in Judy Attfield and Pat Kirkham, eds., *A View from the Interior: Feminism, Women and Design* (London: Women's Press, 1989), 109–30.

20. The print series in question were Gabriel Huquier's etched suite after Alexis Peyrotte, *Divers Ornements Dédiés à Monsieur Tanevot, Architecte du Roy*, and Gilles Demarteau's etchings after Girard, *Second Livre de Leçons d'Ornements dans le Goût du crayon*. See Michael Snodin, ed., *Rococo: Art and Design in Hogarth's England*, exhibition catalogue, Victoria and Albert Museum, 1984, 73.

21. RSA Minutes, April 13, 1757. Extended in 1760 to include "Students to different Artists."

22. For an overview of the Society's premiums for paintings, drawings and bas-reliefs of historical subjects, see "A survey of Premiums Offered for Historical Art by the Society for the Encouragement of Arts, Manufactures and Commerce, 1760–1799" by Martin Myrone (1997), deposited in the RSA's archives. For a discussion of the Society's "fine" art program, see also Martin Myrone's essay in this volume.

23. On the duke's close relations to the Society—particularly as vice president from 1761—and the description of his "Academy" as an "extension of the Society of Arts" see Joan Coutu, "'A Very Grand and Seigneurial Design': The Duke of Richmond's Academy in Whitehall," *The British Art Journal* 1, no. 2 (Spring 2000), 52.

24. *Register*, 13. My emphasis.

25. This is expressed, for instance, in William Chambers's influential *A Treatise on Civil Architecture* (London: printer for the author, 1759), 11. I am grateful to Martin Myrone for drawing my attention to this passage.

26. Evidence of Shipley's curriculum is contained, for instance, in the letters of his pupil Ozias Humphrey (later a well-known miniature painter and Royal Academician), who entered the school for the purpose of learning to draw lace patterns for the family business. See D. G. C. Allan, *William Shipley, Founder of the Royal Society of Arts*, 2nd rev. ed. (London: Scolar Press, 1979), 81. For the advertisements of the school, see for instance the *Public Advertiser* of June 25, 1757: "it will be Mr. Shipley's endeavour to introduce Boys and Girls of Genius to Masters and Mistresses in *such Manufactures* as require Fancy and Ornament," quoted by D. G. C. Allan, *William Shipley*, 80; my emphasis.

27. Sir Henry Trueman Wood, Secretary of the Society in the early twentieth century, still felt compelled to refute that notion. "The Society and the Fine Arts (1755–1851)," *Journal of Royal Society of Arts*, no. 3 (1912): 108, 60.

28. Baker, "Advantages arising," 62.

29. Ibid., 77.

30. In 1758 the Society further introduced a premium for models in wax for metalworkers, addressed to young men (nonspecific wax models were invited from 1762 also by girls) and dropped in 1765, and two awards to male candidates for "models or compositions of ornaments in clay" that were retained until 1764.

31. Treve Rosomon, *London Wallpapers: Their Manufacture and Use 1690–1840*, exhibition catalogue (London: RIBA, 1992), 2.

32. Ibid., 5, 9, 13.

33. Lesley Ellis Miller, "Drawing: The Lynchpin in the Success of Lyonnais Patterned Silks of the Eighteenth Century," a paper given to "The Future of Drawing in Design," a conference at the Department of Design, University of Huddersfield, September 18, 1997, 5. I am grateful to Dr. Ellis Miller for an offprint of her talk. For the difficulty of designing for the silk industry, see also Natalie Rothstein, *Silk Designs of the Eighteenth Century in the Collection of the Victoria and Albert Museum* (London: Thames and Hudson, 1990), 27.

34. Rothstein attributes this predominantly to the recession at the end of the Seven Years' War. Natalie Rothstein, *Woven Textile Design in Britain from 1750–1850.* (London: Victoria and Albert Museum, 1994), 7

35. Ibid., 7.

36. Allan, *Virtuoso Tribe*, 104.

37. Dossie, *Memoirs*, 34.

38. On the development of embroidery in the later decades of the eighteenth century, see Patricia Wardle, *Guide to English Embroidery.* (London: H.M.S.O., 1970), 20-21.

39. Rothstein, *Silk Designs*, 7–10.

40. Lubbock, *Tyranny of Taste*, 212.

41. Rothstein, in Snodin, ed., *Rococo*, 219.

42. The rejection of a premium for military drawings has been mentioned above. In 1756, a premium

for "making the finest and best piece of Tapestry after the Manner of that at the Goblins" [sic] was proposed, referred to the Manufactures Committee and its implementation declined on the grounds that native tapestry making was already "of perfection." Minutes, March 24, 1756, 110, March 31, 1756, 113, April 7, 1756, 116.

43. Society of Arts, Register, 1778, 27, 31.

44. For the importance of the publication of William Hamilton's antique vases to manufacturers and craftsmen in the early 1770s, see Viccy Coltman, "Sir William Hamilton's Vase Publications (1766–1776)," Journal of Design History 14, no. 1 (2001): 1–16.

45. From the 1780s, figures for candelabra, chimney-pieces, and vases, and models of candelabra, were exhibited at the Royal Academy, under the heading of "sculpture" by artists such as F. Hardenberg, Peter Rouw, J. T. and W. J. Coffee, Peter Francis Chenu, and J. B. Papworth. See Algernon Graves, The Royal Academy: A Complete Dictionary of Contributors and their work, 1769–1904 (1905), reprint (East Ardsley: S. R. Publishers, 1970). Much earlier, in 1770, Sir William Chambers had already exhibited designs for vases for the king and queen, to be made in ormolu by Matthew Boulton at the Royal Academy. See Hilary Young, "Silver, Ormolu and Ceramics," in J. Harris and M. Snodin, eds., Sir William Chambers: Architect to George III (New Haven: Yale University Press, 1996), 149–62 at 155.

46. Beresford Hope coined the term in reference to his father Thomas Hope's application of "the beauty of forms to the wants and productions of common life." See David Watkin, Thomas Hope and the Neoclassical Idea (London: Murray, 1968), 54.

47. See Allan, Virtuoso Tribe, 110–11 on the "Polite Arts" committee's rejection in December 1783 as "not a proper Object of the further attention of the Society" of Valentine Green's plans for a new award for ambitious oil paintings by students of the Royal Academy, in whose exhibition the prizewinning painting was to feature.

48. Wendy Hefford, Design for Printed Textiles in England 1750–1850 (London: V&A Publications, 1992, reprint 1999). 10.

49. Maxine Berg, "New Commodities, Luxuries and their Consumers in Eighteenth-Century England," in Maxine Berg and Helen Clifford, eds., Consumers and Luxury: Consumer Culture in Europe 1650–1850 (Manchester: Manchester University Press, 1999), 76–82.

50. See Morrison Heckscher, "Gideon Saint, an Eighteenth-Century Carver and his Scrapbook," Metropolitan Museum of Art Bulletin, February 1969: 299-311.

51. Republished under the misleading title One Hundred and Fifty New Designs by Robert Sayer in 1761.

52. The award for cabinet- and coach-makers and other "mechanick" trades no longer existed, and Hebert submitted his design under the niche of "any art or manufactory" contained in the usual awards for the textile industry.

53. Miller's definition of the term is particularly concise, and further implies the ambitious nature of this device: points rentrés, a method of interlocking dark and light colored threads in the weave structure in order to create intermediate shades, and hence some kind of perspective [in contrast to the "two-dimensionality of many silk patterns"]; Miller, Drawing, 3. I am grateful to Moira Thunder of the Victoria and Albert Museum for pointing out the relation of points rentrés with the hatching of the designs.

54. I am grateful to Moira Thunder for drawing my attention to Garthwaite's earlier designs.

55. The silk industry was notoriously vulnerable to, and anxious about, the theft of designs. For the French situation. See for instance Lesley Ellis Miller, "Innovation and Industrial Espionage in Eighteenth-Century France: An Investigation of the Selling of Silks through Samples," Journal of Design History 12, no. 3 (1999): 271–91.

56. It may be that the specialist panel of trade judges introduced in 1755 and mentioned above had not been continued. The silk mercer's letter is dated December 12, 1757, and archived at the RSA under PR/AR/103/10/937. I am grateful to Moira Thunder for drawing this document to my attention.

57. Dossie, Memoirs, III.

58. On the percentages of male and female candidates see Helen Clifford, "Key Document from the Archives: The Award of Premiums and Bounties by the Society of Arts," RSA Journal 145 (August/September 1997): 78–80. I further refer the reader to Moira Thunder of the Victoria and Albert Museum. At the time of writing this essay she was engaged in welcome research into the identities of some of the many prizewinners in the field of textiles, who have remained unknown so far. She was also comparing extant silk designs at the RSA to known examples by leading contemporary designers to determine the ways in which young candidates were trained, and to gauge the effectiveness and fashionability of prizewinning designs.

59. Dossie, Memoirs, III. George Hebert may have been related to William Hebert, whose design for an ornamented clock was awarded five guineas in the same year. The latter drawing is illustrated in Snodin, Rococo, 150, K4, where the surname is mistakenly given as Herbert.

60. Godfrey Smith, The Laboratory, or School of Arts containing a large Collection of valuable Secrets, Experiments and Manual operations in Arts and Manufactures, 6th ed., 2 vols. (London, n.p. 1799), I, 40.

61. It is possible that Samuel Paris is identical with the "Mr Paris" with whom Peter Sayer was later apprenticed according to an inscription on the verso of his award-winning drawing in 1771. For a brief entry on Jones, see Hefford, *Design for printed textiles*, 157.

62. On the Pingos and their involvement with the Society see Christopher Eimer *The Pingo Family and Medal Making in 18ᵗʰ Century England*. London: British Art Medal Trust, 1999.

63. See Dossie, *Memoirs*, III for further examples. One of the most notable instances of a "design" premium awarded to an artist subsequently better known for his adherence to academic theory and honors is that of the young Thomas Banks, the future sculptor who in 1769 was the only candidate ever to win a share of the fifty guineas briefly offered for "Designs for Useful and Ornamental Furniture."

64. See Terence Hodgkinson, "John Lochée, Portrait Sculptor," *Victoria and Albert Museum Yearbook 1969*, 1:152–54.

65. See James Holloway, *James Tassie 1735–1799*. Exhibition catalogue, Edinburgh National Gallery of Scotland, 1986, 6

66. The academy indeed had an impressive range of "professors" and sent a number of students to Rome where they studied under Gavin Hamilton, one of the pioneering neoclassical artists of his time. Ibid., 5–6.

67. Sir Joshua Reynolds, *Discourses on Art*, ed. Robert R. Wark, 3ʳᵈ ed. (New Haven: Yale University Press, 1988), Discourse I, 13.

68. John Gwynn, *Essay on Design*. Henry Cheere's "Plan" has been copied in manuscript in Dr. Templeman's *Transactions*, vol. I, 1754–58, 32–48, and has been transcribed in typescript, n.p., by Susan Bennett to whom I am grateful for a copy. Craske notes that a version was also published under the title *The Plan of an Academy for the Better Cultivation, Improvement and Encouragement of Painting, Sculpture and Architecture and the Arts of Design in General* (London: n.p., 1755). Craske, *Plan and Control*, 215, n.76. The plan was submitted on behalf of leading artists from the from the St Martin's Lane Academy, and was probably based on a scheme earlier put forward by the Society of Dilettanti. See D. G. C. Allan, *Virtuoso Tribe*, 1992: 93.

69. On the connections of these campaigners with the Society, see for instance Ilaria Bignamini, "The Accompaniment to Patronage: A Study of the Origins, Rise and Development of the Institutional System for the Arts in Britain 1692–1768" (PhD thesis, University of London, 1988), 432—34, 438.

70. See Timothy Clifford, *Designs of Desire: Architecture and Ornament Prints and Drawings 1500–1850*, exhibition catalogue, Scottish National Galleries, 13.

71. See *Jacques-Laurent Agasse 1767–1849 ou la séduction de l'Angleterre*, exhibition catalogue, Musée d'art et d'histoire, Geneva; Tate Gallery, London, 1988, 24–25.

72. *Register*, 54, my emphasis.

73. The career of William Shipley's pupil Ozias Humphrey is a prime example of a switch from the manufactures to the "fine" arts; see note 26.

74. Dossie, *Memoirs*, vol. 3.

75. Ibid., Dossie, *Memoirs*, vol. 3, 399, 408.

76. Sir Henry Trueman Wood, "The Society and the Fine Arts (1755–1851)," *Journal of Royal Society of Arts* 60 (1912): 733. The latter suggestion was made by Robert Dossie with regard to the awards of fifty guineas for the best patterns for weavers, Dossie, *Memoirs*, 34.

77. Craske, *Plan and Control*, 205.

78. See my article, "Design Instruction for Artisans in Eighteenth-Century Britain," *Journal of Design History* 12, no. 3 (1999): 220–32.

79. For the competitiveness of the silk industry in the 1750s, see for instance Rothstein, *Silk Designs*, 7. In view of the success of Thomas Chippendale's *The Gentleman and Cabinet-Maker's Director* 1st ed. (London: printed for the author, 1754) to name but one of the period's important furniture pattern books, the Society's efforts with regard to furniture-making were late in coming, to say the least.

80. Sarah Richards, "A True Siberia: Art in service to Commerce in the Dresden Academy and the Meissen Drawing School 1764–1836," *Journal of Design History* 11, no. 2 (1998): 109–26.

81. Miller, *Drawing*, 1997: 3–4.

82. Ibid., 4.

83. Ibid., 6.

84. Ozias Humphrey's mother, for instance, paid the (to her considerable) sum of half a guinea entrance and a guinea a month for two days teaching per week to Shipley. Allan, *Shipley*, 1979, 81.

85. For Bachelier, see Ulrich Leben, "Jean -Jacques Bachelier et L'Ecole royale gratuite de dessin de Paris," *Jean-Jacques Bachelier (1724–1806): Peintre du Roi et de Madame de Pompadour*, exhibition catalogue, Musée Lambinet, Paris, Versailles, 1999, 75–85. For the Birmingham schools, see for instance Hilary Young, "Manufacturing outside the Capital: The British Porcelain Factories, 1745–1795," *Journal of Design History* 12, no. 3 (1999): 266.

86. Jean-Jacques Bachelier, *Mémoire concernant L'Ecole Gratuite de Dessin* (Paris: lumprimerie Royale, 1774), 6–7.

87. Leben, *Memoire*, 75.

88. Ibid., 79-80.

89. For the Society's renewed engagement with the design debate, see David Jeremiah, "The Society of Arts and the National Drawing Education Campaign," *Journal of RSA* 117 (1969): 292–94, 365–67, 440–42, 508–10, 582–84.

Patriotism, Virtue, and the Problem of the Hero: The Society's Promotion of High Art in the 1760s

Martin Myrone

THE COMPLETION OF JAMES BARRY'S EXTENSIVE DECORATIVE SCHEME FOR THE "GREAT Room" of the Society of Arts in 1783 should have been a moment of triumph for British history painting, as well as a triumph for him personally, and for the Society. In the event, Barry's work on the "Great Room" cost him dearly in every sense, and the general indifference of the public to the scheme aggravated his bitterly pessimistic view of his status as an artist, and of the state of the arts in general, to the point of vicious, self-destructive paranoia. His heroic efforts were interpreted by many contemporaries as eccentric, ill-guided, and willfully obscure. In historical perspective, the "Great Room" stands as a quite singular monument, testifying at once to the artist's grandiose ambitions, ambitions encouraged by the recurrent calls to reform and advance high art in Britain over the previous decades, and, in its uniqueness, to the failure of either public or private institutions to effectively support this sort of art to any meaningful extent. The great irony of the scheme is that it presents a commemoration of the role of the arts in advancing the civilizing process. There were those in the late eighteenth century who argued in one way or another that high art, based on Classical and Renaissance examples, should have such a role, refining and improving public taste until this nation became the equal of ancient Greece or sixteenth-century Italy. With his extensive writings on art and culture Barry stands prominent in this company; he stands almost alone, though, in seeking to match such high-minded rhetoric with action.

The purpose of this essay is to provide a sense of historical perspective on Barry's efforts in the "Great Room." My focus is on the 1760s, when the Society sought directly to promote high art as part of their greater effort to renew and advance the British economy. The hollowness of Barry's claims about the central place of high art in Britain's cultural life, was though, underscored by the failure of two proposals presented to the Society's Committee of Polite Arts around the time he was completing the scheme. The first in 1780 was an elaborately worked-out scheme to reward large-scale religious paintings and distribute the winning works among the churches and chapels of London and the Southeast.[1] The second in 1783 was the suggestion that the Society should give prizes for historical paintings executed by students of the Royal Academy.[2] The Committee of Polite Arts rejected both. The author of the latter scheme, and almost certainly the former as well, was the engraver Valentine Green. An active member of the Society since 1772 and from 1780 to 1786 chairman of the Committee of Polite Arts, Green was acutely aware of the obstacles faced by modern artists and the potential role of the Society. As Barry was completing the "Great Room," Green published his *Review of the Polite Arts* (1782), where he detailed at considerable length the failures of the modern state to promote high art.

This, he claimed, had moral implications inasmuch as Britain had failed to produce an exemplary body of heroic imagery that could illustrate proper virtues for the public and thus encourage virtue among them. For Green, the annual art exhibitions organized by the Royal Academy ensured that British artists had public exposure as never before, but:

> To what public exertion have they ever been called, or in what instance have they been invited to a trial that could put them on a scale of comparison with those of other nations? What Churches, Palaces, or other Public Edifices, have been opened to them?
>
> What King's, or Hero's Actions have they recorded, to which the Public can be referred to contemplate? What monuments of the Worth, or the Wisdom, the Patriotism, or the Virtues of Individuals, or Communities, have they been called forth to give to our imitation, or our notice? Is it the want of Subjects in the history of our country deserving to be perpetuated? Is it that we have had neither Patriot Kings, Princes, or Heroes to celebrate?[3]

Green's questions were evidently intended as rhetorical, for the engraver argued that it was only a want of a "national policy" for the arts that prevented the production of heroic imagery. But in the years around the publication of the *Review*, these issues took on an added relevance. In 1782 the wars with America were ended, with Britain ceding independence to the colonists. The conflict had demonstrated that what had tenuously been defined as the citizenry could erupt into violence and divide with traumatic effect. Furthermore, the political discourse of the American revolutionaries and their supporters had effectively appropriated and radicalized traditional notions of civic virtue that had underwritten high-minded cultural activity in recent times. These years saw a profound crisis of political and cultural identity, which the religious unrest at home (notably with the Gordon Riots of 1780), the growing claims to political independence among the Irish, and the revelations concerning corruption within Britain's eastern empire only aggravated.[4] If high art, as presented by Barry and Green, was meant to unify a "public," if it was meant to draw the nation together around a clearly defined set of aspirational cultural values, and if it was meant to exemplify through narrative and the presentation of idealized bodies commonly understood ideals of political and moral action, then all the terms of their arguments were by this time definitely in question.

The interventions of Barry and Green did not come out of the blue. What Green was proposing in the early 1780s was a resuscitation of the Society's earlier promotional activities in the field of high art. From the outset the Society offered premiums for drawings by children, with the emphasis on work connected with industrial design. But even in these early years some figurative studies were also awarded prizes.[5] The introduction of art premiums was explained by referring to the supposition that as "the Art of Drawing is absolutely necessary in many Employments Trades, & Manufactures . . . , the Encouragem[ent] thereof may prove of great Utility to the public."[6] For a relatively brief period, the promotion of high, narrative art was accommodated to that larger project, and the Society ran a series of competitions for historical painting and sculpture. From 1760 prizes of up to one hundred guineas were offered for historical paintings, including at least three life-size figures on themes drawn from the national past. The premium was proposed at the beginning of 1759. Premiums of one hundred guineas and fifty guineas were to be offered for the:

> best Original Piece of History Painting containing not less than 3 Human Figures as big as Life . . . That one Subject only for the said Premiums be pitch'd upon by the society; & that the six following Subjects be proposed to them to chuse one thereof, if they think fit
>
> Boadica telling her Distresses to Cassibelan and Paulinus in the presence of her two Daughters

Queen Eleanora sucking the Poison out of K. Edward's Wound after he was shot with a
Poisoned arrow

Regulus taking Leave of his Friends when he departed from Carthage

The Death of Socrates

The Death of Epaminondas

The Birth of Commerce as described by Mr Glover in his Poem called London[7]

However, at a Society Meeting of February 28 it was determined that "the Claims
shall chuse their subjects out of the English History only." The specifications, the
scale of the work, and the premium remained.[8] The premium was offered in 1760–65,
and on different terms in 1768–72 and 1779. Also from 1760 premiums of up to thirty
guineas were available for bas-reliefs in clay showing Classical subjects;[9] these were
soon complemented by competitions for Classical bas-reliefs in marble[10] and Portland
or Purbeck stone,[11] and drawings[12] and chiaroscuro paintings similarly based on an-
cient literature or history. [13]

In the remainder of this essay I would like to reconsider these early efforts of the So-
ciety to promote high art, and situate them in a complex historical moment in which
notions of political and personal virtue, gender identity, and cultural value were being
overhauled.[14] The competitions will be considered as a highly significant episode in
the longer history of the contest over cultural authority between the old aristocracy,
the monarchy, the newly articulate professional classes, and artists themselves. The
Society's activities of the 1760s can be interpreted as a momentary and ultimately
uneasy alliance of some of the most vocal of these competing groups in an effort to
forge a consensual, public language of heroic high art. If by the early 1780s the alien-
ation of high art from public life seemed a self-evident problem, highlighted rather
than resolved by Barry's "Great Room," we can look back to this earlier phase of the
Society to see that the pessimism expressed by Barry and Green was not a historical
inevitability.

The Society's temporary engagement with history painting and sculpture, that is,
art based on elevated literary sources traditionally associated with the conservative,
authoritarian values of a centralized monarchy and aristocracy, or a powerful church,
requires some explanation. The traditional paucity of high art in England was a com-
monplace of earlier eighteenth-century accounts of Britain's culture. The Abbé Jean-
Bernard Le Blanc had curtly damned the arts in England in their totality in his *Lettres
d'un François* (1745, with an English edition in 1747): "Painting, sculpture and other
arts that depend on drawing, are as yet either unknown here, or in their infancy at
most."[15] The combination of Protestant Reformation, limited monarchy, the rise of
commercial enterprise, and a climate that quite literally dampened any effort to in-
dulge in visual pleasures supposedly served to stymie any national engagement with
the arts. Writers in English had, too, been forced to acknowledge that, even while
portrait painting thrived, there were simply no or at best few history painters. In
one of the first English-language expositions of academic art theory, *Three Dialogues
Concerning Art* (1685), William Aglionby lamented the demise of the Stuart courts
which had once sustained high culture, and pointed to Puritanism and religious re-
form as destructive forces in the arts: "had not the *Bloody-Principled Zealots*, who
are Enemies to all the Innocent *Pleasures* of Life, under the pretext of a *Reformed
Sanctity*, destroyed both the Best of Kinds and the Noblest of Courts, we might to this
day have seen these *Arts* flourish amongst us." Instead, despite a brief flourishing of
hope in the time of Charles II, the encouragement of the arts was for Aglionby left in
the hands of enterprising gentlemen and landowners who, Whiggish as they are, can
only be distasteful to this Tory author: "our *Nobility* and *Gentry*, except some few,

who had eminently showed their Kindness for this noble Art . . . are generally speaking, no *Judges,* and therefore can be no Promoters of an *Art* that lies all in nice Observations."[16] Subsequent authors were agreed, even if they were from quite another political persuasion: high art in the continental model had no natural place in modern Britain, and Britons lacked the temperament or intellectual resources for high art on the continental model.

By the 1750s, the absence of a national school of history painting was in the process of being converted into a virtue by the proponents of a distinctly national school of painting. For William Hogarth and the circles of craftsmen and artists associated with the drawing school in St Martin's Lane, the most authentic kinds of contemporary British art would be founded on a democratic notion of the everyday rather than the elevated themes favored by the continental aristocracy, absolutist monarchy, and the Catholic Church; it would be expressive and individual, as was British society, rather than hierarchical and rigidly rule-bound.[17] Yet the Society's competitions were aimed at promoting exactly the ambitious and high-minded kinds of art which had been neglected in Britain, and which were traditionally associated with autocracy and Catholic superstition, in the process reforming the image of the gentry and middle class as patrons of art, and contesting and reworking ideal art to fit a modern, Protestant, and commercial nation.

The competitions of the 1760s have been seen as the result of a small but influential group of artist-members effectively "hijacking" the Society and turning it to their self-interest.[18] On this point, it is especially significant that the Society's premiums for historical painting and sculpture did not originate in a simple way from within the artistic community. Although professional artists were active in the Society, including prominent figures as Joshua Reynolds, Allan Ramsay, and Henry Cheere, they formed a small constituency within the Society's membership, as the figures drawn together by D. G. C. Allan have demonstrated.[19] Though artists were brought into the Committee of Polite Arts to oversee the distribution of prizes and acted as judges for the premiums, they had no special control over the competitions in the fine arts. Professionals were, in fact, excluded from chairing committees (the case of Green in the early 1780s being an exception). The dominant force in the Society was, rather, what we can call the polite classes—the professionals, forward-thinking aristocrats, men of letters, and businessmen brought together by a common patriotic concern with the economic and cultural well-being of the nation. Why should these men have become concerned in 1759 with the promotion of high art? The prime mover behind the foundation of the Society, William Shipley, was of course a drawing master, and from the outset there were prizes for drawings by youths, testifying to the commonly understood belief that good "design" was essential to what we would call the "industrial arts."[20] But the kind of art promoted by the competitions of the 1760s was of a quite different order: finished paintings and sculptures referring to the rarefied field of Classical history and pictorial traditions associated with autocratic rule and superstition.

The appearance of the high-art competitions from 1759 testifies to the way that the idea of a specifically British high art evidently connected to continental traditions took on a new force, and secondly, that the ideological positions such works conventionally represented were in a position to be overhauled. The conditions for both these emerged during the Seven Years' War, with political discourse that pressed for an urgent reform of modern British culture, including its fine arts, so that Britain could more effectively compete economically with its Continental enemies, and a shift in the idea of political responsibility and virtue. Earlier in the century, the ideas of political virtue and of economically productive cultural enterprise were kept distinct. The political opposition of Country Whigs and Tories critiqued modern society as absorbed by the feminizing effects of material luxuries (whose accumulation was overseen by the Government Whigs). The "Classical" citizen of aristocratic discourse

was, in contrast, self-sacrificing in his commitment to public values and independent of central authority. [21] Such criticism had been largely a matter of rhetoric without direct influence in the political and social realm. By force of the stigma of rebellious Jacobitism, statements of political independence were curbed. [22] But in the 1750s and most particularly in the years after 1756 the luxury debate was revived with an unprecedented vigor and sense of urgency.[23] The early years of the war were marked by dramatic failures on the part of the British forces, culminating in the serious threat of an invasion in 1759. During that period cultural debate focused on the corrupting and feminizing effects of commercial wealth. According to John Brown, in his best-selling *Estimate of the Manners and Principles of the Times* (1757–58), the nation's present decline was directly a result of the faulty character of modern British manhood.[24] Only a return to the values of Classical citizenship, as defined within Country and Tory political discourse, would save Britain from imminent disaster. The revival (referred to by Brown and others as a "reformation") could be effected firstly by the appearance of a severely masculine "Patriot" who would lead the nation by example, and secondly by the raising of a militia.[25] This second line of argument is of crucial significance with regard to the Society. While virtuous citizenship was previously considered the preserve of property-owning gentlemen, in the course of debates calling for the militia necessary to expand Britain's military forces, the idea was expanded to encompass the full range of the polite or literate classes and even potentially plebeians.[26] The critical idea in the progressive cultural discourse of the early 1760s was that the renewal of British culture was not the responsibility of the king and his courtiers, or of them alone, but of the citizenry as a whole, who could, by their participation in cultural change, claim to possess virtue.[27] The contentious spirit required in the "arts of war" was, many commentators agreed, also now to be applied among the "arts of peace" if Britain's imperial conquests were to be secured and maintained, and if the newly founded empire was to be a civilizing force rather than corrupt and corrupting.[28] The threat of national debt was an enemy as great as France, and to fight such an enemy might be as virtuous, as patriotic, and as heroic; the danger of empire collapsing into tyranny terrible, and so finding ways of refining and improving Britain's citizens and colonial subjects was a matter of great significance.

Across a range of textual matter produced from the end of the 1750s, cultural production was implicated in the very real economic and imperial challenges facing Britain in this new era. For the gentlemen of the Society, the competitions were a means of clearly expressing their patriotic commitment at a moment of national crisis. For the artists who competed, the premiums provided the opportunity for producing ambitious works of art that, given the general indifference of the state, church, or private individuals toward modern high art, they would not otherwise have a reason to produce. Yet what kinds of subject matter would fulfill the demands of both groups? The status of history painting and Classical sculpture as the most elevated kind of art was well-established in principle by a tradition of academic art writing, stretching back to the Renaissance. But while historical paintings and sculpture were conventionally designed for specific settings—for a church, a palace, a government building, an aristocratic household—in Britain modern high art for public settings was much more rarely encouraged. The rare examples of high art in public places, notably Francis Hayman's patriotic decorations for Vauxhall Gardens, and the religious pictures for the Foundling Hospital, were created for specific social and spatial contexts that legislated for particular kinds of interpretation.[29] But the works that were produced for the competitions did not have such a clearly defined destination; they were not created for a specific place, but only, instead, for the judgmental gaze of the Committee on the Society's premises (at this date still a former upholder's factory). This is particularly evident in the case of the bas-reliefs created for competition. Bas-reliefs would normally be created for a particular architectural setting, and the Society went so far as

to specify Portland or Purbeck stone as the material for one of the competitions, relatively crude materials that were meant to be used for architectural exteriors, rather than "art" sculpture.[30] That the works were in fact exhibited publicly was largely fortuitous—the Society of Artists taking the opportunity to collaborate with the Society of Arts to set up annual exhibitions from 1760 which regularly featured paintings and sculptures from the competitions. Although entrenched in a sense of art-historical tradition, the high-art competitions led to the creation of works set loose from the social and physical settings that could maintain that tradition, and which, arguably, had to search in new imaginative territories for a sense of meaning. What emerged were works based on themes that expressed ideas of virtue that could exist outside of elitist cultural settings, and in so doing destabilized some of the conventions of high art. Perversely, in striving to formulate a heroic art relevant to modern Britons, the competitions contributed to the reworking of the relations between masculinity, virtue, and political authority which were assumed to be indivisible within academic art theory.

Generalizations about the character of the works produced for the institution are virtually impossible, as but a handful survive. In fact the largest body of extant images produced for the premium competitions derives only from the class of history paintings on themes drawn from the national past, the subject matter being an important innovation in itself. These have been, consequently, the only group to receive extensive art-historical attention. In a series of important essays, John Sunderland has identified an inclination toward antimonarchical themes among these premium-winning works. [31] According to Sunderland this bias was directed by the Society's executives who were committed to the cause of True Whiggery and opposed to the apparent autocratic ambitions of the new king. The idea that the committee were biased toward themes that were legible as provocatively critical of the institution of kingship has its limitations. The committee did not, first of all, have a great deal of latitude in their selection of winning pictures, as in each year very few candidates actually came forward. For instance, Casali's *Gunhilda*, certainly legible as an antimonarchical statement, appears to be the only picture entered for the premium when it won in 1762.[32] More crucially, the subjects themselves cannot always be pinned down as definitely antimonarchical.[33] Thomas Hollis, who was closely involved in the Society's fine art premiums in the period, certainly thought of himself as a True Whig; but he did not declare himself opposed to the Hanoverian monarchy until after the American controversies of the mid-1760s.[34] In fact Samuel Johnson made at least as significant a contribution to the Society in this respect, and even if his politics remain subject to debate among historians there could be no basis for claiming him as a True Whig.[35] Finally, artists chose their own subject matter in the Society of Arts' painting competitions; where the committee attempted to dictate their subjects, with the original list of suggestions from 1759, their choice cannot be read as openly antimonarchical and, indeed, it includes not one of the subjects depicted by the winning artists in the following years.

The thematic content of the competitions registers not so much an antimonarchical stance, but a revaluation of the idea of the hero to encompass a new and enlarged notion of citizenship that could be articulated without reference to the king—although not necessarily through active criticism of the institution of monarchy. The preeminent theme among the works submitted for competition was not heroic action, or activity, but personal suffering. Three of the six subjects originally suggested for history paintings by the Society referred to the sufferings of a male figure: the deaths of Epaminondas and Socrates and the poisoning of Edward III. Among the other premiums we find subjects of masculine suffering selected with surprising frequency: Mutius Scaevola burning himself before Porsenna;[36] the deaths of Julius Caesar,[37] Tatius[38] and, again, Socrates[39] and Epaminondas;[40] the suicide of Curtius;[41] and a number of emotionally

violent Homeric subjects.[42] Narratives centered on the suffering of a female character occur also, with the deaths of the ancient heroines Cleopatra,[43] Virginia,[44] and Lucretia.[45] Reviewing the competitions of the 1760s as a whole, one gets the sense of a roll call of violent death, rape, self-mutilation, and suicide. To an extent, this tendency is intrinsic to the academic definition of high art: these are emotionally engaging themes based around the great lives, and great sufferings, of worthy historical figures. But in the context of 1760s Britain, human pain and distress were privileged as subjects in art for more particular, if not wholly coherent, reasons. Physical pain became significant as a way of making visible—and thus socially legible—the emotional ties that were, according to new economic and sociological theories, meant to bond modern, commercial society together in the absence of more formal political controls.[46] The senses emerged as a "baseline" of human experience, supposedly shared by almost all members of society regardless of social origins, despite all the other divisions and inequities effected by commercial enterprise. The suffering body emerged as a means of articulating and working through relations between the private individual and the aggregate public realm and revisions within predominant gender formations. Thus the competition subjects may suggest the "feminization" of the hero, that is, an eschewal of the martial ideal of heroic masculinity in favor of purportedly feminine qualities exemplified by the capacity to feel strongly, and the resulting creation of a heroic type whose private sufferings could serve public purposes if presented in appropriate cultural forms.[47]

Without a substantial body of examples of premium-winning works these observations must remain of a generalized nature. The works that do survive come from the competitions for national history painting, and all would not necessarily support a reading as sentimental. However, the very first painting awarded the top premium is suggestive in this respect. Robert Edge Pine's *Surrender of Calais to Edward III* is now known only through an engraving published by the artist.[48] This is a capable reiteration of the conventions of continental history painting. It bears close comparison to the absolute epitome of academic painting, Charles Le Brun's *Alexander before the Tent of Darius*, a work known in Britain through a reproductive engraving and the translation of Félibien's essay on the picture.[49] Like the *Alexander*, Pine's picture concerns the actions of a national leader (Edward III) toward his defeated enemy (representatives of the besieged city of Calais).[50] Pine has similarly organized his composition around a central event to ensure a dramatic focus on the gesture of the most significant actor, in this case the raised hand of Edward III. In narrative terms, the king's is a decisive gesture, giving physical (and thus visually legible) expression to his decision to spare or execute his prisoners; formally, the hand occupies the apex of a triangle encompassing the king, the burghers, and the kneeling figure of the queen. Probably on politically motivated grounds, Pine's picture implies a critique of the king and his authority. The painter certainly had True Whig inclinations, and the picture convincingly can be read as providing an illustration of the propriety of limitations on royal authority. The king is characterized as a tyrannical, militarized, almost bestial figure, with deeply set eyes. The curious, Hogarthian narrative detail of a dog sniffing his ermine-trimmed cloak must serve to suggest his repulsive personal nature. But this is a critique of monarchy that operates by invoking the terms of sentimental discourse, quite literally embodying a shift in the economy of power toward the feminine. As the text appended to the print explains, Edward III was intent upon a cruel punishment for his prisoners, which even the entreaties of the Prince of Wales could not prevent. Only when the queen intervened were the prisoners spared. It is her presence that bridles the king's brutal passions; she represents the feminine qualities that refine and regulate the otherwise base actions of men.[51] Is it not the nobly suffering burghers who present the more distinguished masculine aspect of the image? Hence in addition to being a direct political critique of authoritarian monarchy, the image functions also

8. Robert Edge Pine, *Surrender of Calais to Edward III*, engraving. Photographic Survey, Courtauld Institute, London.

to question the identification of masculine virtue with political authority, and represents the greater virtue (or at least the effective enforcement of virtue) as the province of women. Pine's picture is a public statement valorizing "private" virtues and personal suffering over formal political power.

Pine's picture complexly incorporates the narrative structures of conventionally academic high art, which should focus on a central hero who embodies in his person the unity of political authority, masculinity, and virtue, and the idea of sentimental or feminized virtue current in social-economic and literary discourse, and more closely or at least self-consciously oriented to the demands of contemporary society. The picture mimics the hierarchical format of high narrative art, while subversively articulating a different and conflicting set of values; it is both high-minded and demotic. The evidence is that Pine succeeded in this effort, if market success is a proper measure. The artist exploited the public interest generated by the competition and the coincidental art exhibition by organizing the publication of the engraving after the picture, executed by the leading French engraver Ravenet.[52] This print had an extended commercial life; the impression illustrated here was published by the commercial publisher John Boydell in 1771 from the original plate acquired from Pine.

If the success of the print reproducing Pine's picture, and the generally high level of critical interest in the competitions during the 1760s among newspapers and

magazines, can be taken as evidence of an emerging "public" interest in the visual arts, and thus the fulfillment of the Society's aims of "encouraging" the arts, we can nonetheless detect a fatal flaw. The "public" constituted here is an aggregate of individual consumers and readers; managing their interest, which may not go beyond the purchase of a print (profiting the print publisher rather more greatly than the original artist, on the whole) or reading an article, for the benefit of the painter or sculptor, was a greater challenge. Very few of this new "public" had the desire or the means to support artists in any meaningful way: "encouragement" was quite definitely not the same as "patronage." While the Society's pecuniary awards were doubtless of very considerable assistance to the winning artists, the works themselves enjoyed little success. A number failed to find a buyer, and those that did tended to sell for very low prices. Pine's *Canute* (premium winner 1762) entered the collection of John Taylor, from whence it sold for only £23.2.0.[53] Mortimer's *St Paul Preaching to the Ancient Britons* was famously neglected, and remained in his studio for years until it caught the attention of a generous patron.[54] George Romney sold one premium work for twenty-five guineas (less than the prize itself) and destroyed another when it failed to find a buyer.[55] John Vandermeulen's winning bas-reliefs of 1765 and 1767 were in the collection of Lord Montfort by 1776, and Andrea Casali succeeded in selling his premium paintings to William Constable of Burton Constable by 1766.[56] There is evidence that some works entered the collection of the Society, whether they were presented by the artists themselves or by individual members. A list of the Society's possessions drawn up in 1779 included five bas-reliefs in plaster, and also an unidentified marble bas-relief in a glass case.[57] The plaster bas-reliefs include a version of "Jepthah's Rash Vow," the subject of a premium in 1760 won by Joseph Nollekens and John Bacon. The Society at this time certainly had prints after Pine's winning pictures.[58] Additionally, the Society now holds three plaster roundels that may formerly have been the property of the Society's secretary, Samuel More. One of these shows "Priam Pleading with Achilles for Hector's Body"—the subject of a premium-winning relief in marble by Thomas Banks in 1765.[59] It is tempting to suggest this plaster is a cast after Banks's relief. But the vast majority of the premium-winning works remain unidentified and, if the information given here in any way reflects the general pattern, could not have had a distinguished provenance. As William Blake noted, bitterly and cynically, in his well-known comments on Barry's great scheme for the Adelphi, "A Society Composed of the Flower of the English Nobility & Gentry" had been able to make great efforts in the way of "encouragement" without concerning itself with the fate of any individual artist.[60]

By 1770 almost all the major competitions initiated around 1760 had ended. Proposals for travel grants for art students and for a premium for designing an art academy were rejected,[61] and as early as 1765 it was reported that the Society was giving up prizes for history painting.[62] After a long period of abeyance, this competition was eventually canceled with permanent effect in 1779. The premium for chiaroscuro paintings lasted only a few years, and all the premiums for historical bas-reliefs were discontinued by 1770. Only the prize for historical drawings continued into the next century; this, together with the continuation of only the junior prizes for specifically "fine art" works, signaled the abandonment of the Society's efforts to promote the manufacturing economy through the promotion of high art.[63]

There are a number of possible explanations for these changes. The authority of the Society as an institution useful to professional fine artists came increasingly into question from the mid-1760s. The Committee of Polite Arts was sullied by accusations of nepotism and corruption, while the emergence of more authoritative artists' groups, first the Society of Artists (especially after it was granted a Royal Charter in 1765) and then the Royal Academy, meant that by the 1770s artists had abandoned the Society's membership almost entirely.[64] More profoundly, the Society's faith that

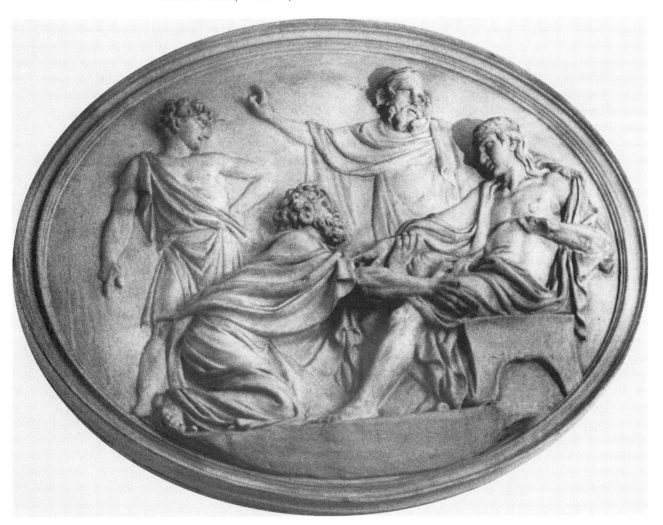

9. Thomas Banks, *"Priam Pleading with Achilles for Hector's Body,"* plaster cast from prize-winning submission in marble, 1765. Royal Society of Arts, London.

historical art could, indeed should, be economically useful, that it should be able to fabricate heroic identities of common cultural value, and that arts, manufactures, and commerce could be not only reconciled but mutually supportive, came into question as the more rarefied varieties of high art practice promoted by the Academy came to prominence. The loose ideological consensus and optimism that prevailed in the first years of George III's reign, a consensus that lent some impetus and direction to institutional attempts to redefine British high culture, began rapidly to break down.[65]

During the 1760s the language of sentiment had formed a bridge between the specialist interests of artists as a group intent on raising their status within society, and the self-consciously generalizing aims of the gentlemen and professionals of the Society, giving impetus to a concerted effort to formulate a public language of high art. The ancient and national past had provided a resource of subjects of apparently common applicability and value. In the succeeding decades, the sentimental themes encouraged by the Society became standard in the more popular, and often simply decorative, modes of history painting and sculpture, and a major class of commodity on the mass print market. It was in the sphere of commercial enterprise that the effort to compose a new language of high art that could address the peculiar desires

of a socially diverse art public and embody a national culture was taken up with the greatest vigor. Accordingly, the image of the hero became diversified and divided, with images of contemporary military heroes—a phenomenon pioneered by George Romney whose depiction of General James Wolfe had been, tellingly, rejected by the Society from the premium competition in 1762[66]—domesticated and sentimental heroes, spectacular, amoral, and extravagant heroes. Contemporary heroes appealed very directly to present-day viewers, yet neither were they universally accepted as the proper subject matter of the most-high-minded kinds of art (the rejection of Romney's picture suggests the Society's view on this matter); meanwhile, the virile and severe heroes of the ancient and Gothic past could look simply ludicrous or outright criminal when assessed by modern-day standards of morality and manners.[67] Susceptible to the vagaries of the market, such images could only further aggravate the concerns about the failure of public institutions, including after 1768 the new Royal Academy, to encourage more strenuously virtuous high art. Among the most vocal of those to express such concerns was, of course, Barry.

The years between the first competition for history painting and the completion of his "Great Room" decorations witnessed the birth of the modern British art world, with its centralized institutions and vital commercialism, and also the divisiveness and lack of direction that remain all too familiar, and a dramatic reversal of the national fortunes. The global empire of English-speaking people promised by the success of the Seven Years' War gave way to a reality of bitter political discord, economic uncertainty, and profound anxiety about the fate of British culture. We need to appreciate Barry's grand narrative of the consistent role of high culture in public life as, against that background, a most defiant kind of fantasy, one which could be received, with bitter irony, only as evidence of the artist's self-delusion.

NOTES

1. RSA, Minutes of the Committee of Polite Arts [hereafter cited as Com. Mins. PA], December 1780.

2. Com. Mins. PA, 5 December 1783. See also the letter from Green to the Council of the Royal Academy, dated December 12, 1783, in the Library of the Royal Academy, Council Minutes, December 31, 1783, vol. 1, 350.

3. Valentine Green, *A Review of the Polite Arts in France at the Time of Their Establishment under Louis the XIVth Compared with Their Present State in England* (London: n.p., 1782), 34.

4. For a richly suggestive analysis of the crises in identity through the 1770s and 1780s see Dror Wahrman, *The Making of the Modern Self: Identity and Culture in Eighteenth-Century England* (New Haven: Yale University Press, 2004).

5. For selective and far from wholly accurate overviews of all the art premiums see Robert Dossie, *Memoirs of Agriculture and Other Oeconomical Arts*, 3 vols. (London: n.p., 1768–82), vol. III, 391–443, and Henry Trueman Wood, *A History of the Royal Society of Arts* (London: John Murray, 1913), 162–212. The lists of premiums offered and awarded by the Society of Arts were published separately to 1782, and thereafter in the *Transactions* of the Society; these lists are referred to in the present notes as the *"Premium Lists."*

6. RSA, Minutes of the Society [hereafter cited as Soc. Mins.], 22 March 1754, printed in Derek Hudson and Kenneth W. Luckhurst, *The Royal Society of Arts 1754–1954* (London: John Murray, 1954), 8.

7. Com. Mins. PA, February 2, 1759.

8. Soc. Mins, February 28, 1759.

9. For "the best *Models in Clay*, of Basso Relievo's, by Youths under the Age of Twenty Five, being their own Composition; the Height of the principal Figure not less than Twelve Inches" (*Premium Lists*). The premium was offered from 1760–1770, when it was discontinued (Com. Mins. PA, February 9, 1770).

10. For "the best *Basso Relievo* in white Marble, being an Original Composition of five or more Human Figures" (Com. Mins. PA, April 15, 1762). This premium was offered in 1762, and from 1764 to 1767, when it was discontinued (Com. Mins. PA, February 28, 1766).

11. For "the best *Basso relievo* in Portland or Purbeck Stone, by Artists under 30 Years of Age; the Composition to be their own" (Com. Mins. PA, March 27, 1760). This premium was offered from 1761 to 1766, when it was discontinued (Com. Mins. PA, February 26, 1766).

12. For "the best Historical Drawing the Subject to be taken from the Greek or Roman History, being the Original Composition of two or more human figures, the height of the Principal Figure not less than 8 inches, by Persons under the age of 25; to be made with Chalk, Black Lead, Pen, Indian Ink, or Bister" (Com. Mins. PA, December 17, 1763). This premium was first awarded in 1764, and continued into the nineteenth century.

13. For "the best Original Picture in *Chiaro Oscuro* the subject to be taken from the Greek or Roman History, containing five or more human Figures, the height of the Principal Figure not less than 15 Inches, by Persons under the age of Thirty" (Com. Mins. PA, January 22, 1762). This premium was offered from 1763 to 1766.

14. This essay elaborates points made previously in my *Bodybuilding: Reforming Masculinities in British Art 1750–1810* (New Haven: Yale University Press, 2005), 34–46.

15. Mons. L'Abbé Bernard Le Blanc, *Letters on the English and French Nations*, 2 vols. (London, J. Brundley, 1747), vol. 1, 155–56.

16. *Painting Illustrated in Three Dialogues, Containing Some Choice Observations upon the Art. Together with the Lives of the Most Eminent Painters, from Cimabue, to the Time of Raphael and Michael Angelo. With an Explanation of the Difficult Terms* (London: printed by John Gain for the author, 1685), unpaginated preface.

17. See Patricia Crown, "British Rococo as Social and Political Style," *Eighteenth Century Studies* 23 (1989–90): 269–82.

18. See the comments in Hudson and Luckhurst, *Royal Society of Arts*, 42.

19. For the following see D. G. C. Allan, "Artists and the Society in the Eighteenth Century," in D. G. C. Allan and J. L. Abbott, eds., *The Virtuoso Tribe of Arts and Sciences Studies in the Work and Membership of the London Society of Arts* (Athens: University of Georgia Press, 1992), 91–119, esp. 95–107, and Ilaria Bignamini, "The Accompaniment to Patronage: A Study in the Origins, Rise and Development of an Institutional System for the Arts in Britain, 1692-1768," 2 vols. (PhD thesis, University of London, 1988), vol. II: 423–43.

20. See David Irwin, "Art Versus Design: The Debate 1760–1860," *Journal of Design History* 4 (1991): 219–32, and Anne Puetz, "Design Instruction for Artisans in Eighteenth-Century Britain," *Journal of Design History* 12 (1999): 217–39.

21. J. G. A. Pocock, *The Machiavellian Moment: Florentine Political Thought and the Atlantic Republican Tradition* (Princeton: Princeton University Press, 1975), 465–505 and J. G. A., Pocock, *Virtue, Commerce and History: Essays on Political Thought and History, Chiefly in the Eighteenth Century* (Cambridge: Cambridge University Press, 1985), 234–53. See also Shelley Burtt, "Private Interest, Public Passion, and Patriot Virtue: Comments on a Classical Republican Ideal in English Political Thought," in Gordon J. Schochet, ed., *Politics, Politeness and Patriotism, Proceedings of the Folger Institute Center for the History of British Political Thought*, vol. 5 (Washington, DC, 1993), 257–78.

22. Pocock, *Virtue*, 239–40.

23. See Robert D. Spector, *English Literary Periodicals and the Climate of Opinion during the Seven Years' War* (The Hague: Mouton and Company, 1966), 65–68 and Gerald Newman, *The Rise of English Nationalism: A Cultural History 1740–1830* (London: Weidenfeld and Nicolson, 1987), 68.

24. *An Estimate of the Manners and Principles of the Times*, 2 vols. (London: n.p., 1757–58). See Spector, *English Literary Periodicals*: 62–65, John Sekora, *Luxury: The Concept in Western Thought, Eden to Smollett* (Baltimore: John Hopkins University Press, 1977), 93–100, and Harriet Guest, "'These Neuter Somethings': Gender Difference and Commercial Culture in Mid-Eighteenth Century England," in Kevin Sharpe and Steven N. Zwicker, eds., *Refiguring Revolutions: Aesthetics and Politics from the English Revolution to the Romantic Revolution* (Berkeley: University of California Press, 1998), 173–94.

25. *Estimate*, vol. II, 159–65, 251–59. See also Edward Wortley Montagu, *Reflections on the Rise and Fall of Antient Republics Adapted to the Present State of Great Britain* (London: n.p., 1759), 378–84.

26. As Eliga H. Gould has explained, the previously intractable resistance to the militia had been removed by the events of the Forty-Five. See "To Strengthen the King's Hand: Dynastic Legitimacy, Militia Reform and Ideas of National Unity in England 1745–1760," *Historical Journal* 34 (1991): 329–48.

27. On the crisis of the Seven Years' War and the production of a discourse of national culture see Peter de Bolla, *The Discourse of the Sublime: Readings in History, Aesthetics and the Subject* (London: Basil Blackwell, 1989), 122–31.

28. See for example Thomas Mortimer, *The Universal Director* (London: n.p., 1763), iii; anon., *Propositions for Improving the Manufactures, Agriculture and Commerce, of Great Britain* (London: W. Sandby, 1763), 3–4.

29. See David H. Solkin, *Painting for Money: The Visual Arts and the Pubic Sphere in Eighteenth-Century England* (New Haven: Yale University Press, 1993), 163–68, 190–99.

30. See Robert Campbell, *The London Tradesman* (London: T. Gardner, 1747), 137, and Isaac Ware, *A Complete Body of Architecture* (London: T. Osborne and J. Shipton, 1756), 43–44.

31. "Mortimer, Pine and Some Political Aspects of English History Painting," *Burlington Magazine* 116 (1974): 217–26; "Samuel Johnson and History Painting," in Allan and Abbot, *Virtuoso Tribe*, 183–94;

"Les Bourgeois de Calais dans l'art britannique au XVIIIe siècle," *Les Bourgeois de Calais: Fortunes d'un Mythe*, exhibition catalogue Musée des Beaux Arts et de la Dentelle, Calais, 1995, 47–51.

32. Com. Mins. PA, April 6, 1762, May 21, 1762.

33. Edward Morris, letter to the editor, *Burlington Magazine* 116 (1974): 672. With regard to Casali's premium-winning *Assassination of Edward Martyr* we could note, for instance, that newspaper reports used the Smollett's Tory historical account to illustrate the narrative. See: *London Chronicle*, April 16–18, 1761; *Whitehall Evening Post*, April 16–18, 1761; *Public Ledger*, April 18, 1761.

34. Caroline Robbins, "The Strenuous Whig: Thomas Hollis of Lincoln's Inn," in Barbara Tuft, ed., *Absolute Liberty: A Selection from the Articles and Papers of Caroline Robbins* (Hamden: Anchor Books, 1982), 168–92, 186.

35. Sunderland, "Samuel Johnson and History Painting," in Allan and Abbot, *Virtuoso Tube*, 183–94.

36. Set subject for a bas-relief in clay, 1764 (Com. Mins. PA, February 17, 1763, April 5, 1763).

37. Set subject for a bas-relief in clay, 1768 (Com. Mins. PA, February 13, 1767).

38. The subject of a winning chiaroscuro painting by Edward Edwards, 1764 (Com. Mins. PA, March 30, 1764, April 21, 1764).

39. Set subject for a bas-relief in stone, 1766 (*Premium Lists*; cf. Com. Mins. PA, March 8, 1765).

40. Set subject for a bas-relief in stone, 1762 and 1763 (Com. Mins. PA, March 13, 1761, February 17, 1763). Also, John Donaldson entered a drawing on the subject in 1764 (Com. Mins. PA, February 17, 1764, May 25, 1764).

41. Set subject for a bas-relief in stone, 1764 (Com. Mins. PA, February 17, 1763).

42. See the winning bas-reliefs in marble by Lloyd Anderson Holme, 1764 (*The Parting of Hector and Andromache*, Com. Mins. PA, April 27, 1764), and Thomas Banks, 1765 (*The Redemption of Hector's Body*; Com. Mins. PA, April 6, 1765, May 24, 1765), and a chiaroscuro painting by Hugh Douglas Hamilton, 1764 (*Priam and Hecuba Lamenting over the Corpse of Hector*, Com. Mins. PA, March 30, 1764, April 21, 1764).

43. Set subject for a bas-relief in clay, 1769 (Com. Mins. PA, February 19, 1768). Also the subject of a premium-winning historical drawing by William Parry in 1766 (Com. Mins. PA, February 14, 1766, April 11, 1766).

44. Set subject for a bas-relief in clay, 1763 (*Premium Lists*).

45. Set subject for bas-reliefs in clay, 1766 and 1767 (Com. Mins. PA, March 8, 1765; *Premium Lists*).

46. On the corporeal aspects of sentimental discourse see G. S. Rousseau, "Nerves, Spirits, and Fibres: Towards an Anthropology of Sensibility," in his *Enlightenment Crossings: Pre- and Post-Modern Discourse: Anthropological* (Manchester: Manchester University Press, 1991), 122–41, also John Mullan, *Sentiment and Sociability: The Languague of Feeling in the Eighteenth Century* (Oxford: Clarendon, 1988), 201–40.

47. See Terry Eagleton, *The Rape of Clarissa: Writing, sexuality and class struggle in Samuel Richardson* (Oxford: Basil Blackwell, 1982), 15. See also Mullan, *Sentiment and Sociability*, 238–40; G. J. Barker-Benfield, *The Culture of Sensibility: Sex and Society in Eighteenth-Century Britain* (Chicago: University of Chicago Press, 1992), 104; Markman Ellis, *The Politics of Sensibility: Race, Gender and Commerce in the Sentimental Novel* (Cambridge: Cambridge University Press, 1996), 23–25.

48. Com. Mins. PA, March 31, 1760, April 9, 1760. Exhibited with the Society of Artists, 1760, no. 42. The painting came into the possession of the Corporation of Newbury, who gave it as a lottery prize in 1773 (*Bath Chronicle*, 13 May 1773). See Sunderland, "Mortimer, Pine and Some Political Aspects," 325.

49. André Félibien, trans. William Parsons, *The Tent of Darius Explain'd: Or the Queens of Persia at the Feet of Alexander* (London: n.p., 1703).

50. For the narrative see: Rapin de Thoyras, trans. John Kelly and Joseph Morgan, *The History of England*, 3 vols. (vol. 3 by Thomas Lediard) (London: J. J. and P. Knapton, 1732–37), vol. I, 480 and David Hume, *The History of England*, 6 vols. (Indianapolis: Liberty Fund, 1983), vol. II (first published 1761), 237–38.

51. This theme is especially clear in an account of the painting published in *The Universal Museum*, March 1765, 116–18.

52. Pine announced the publication of the *Burghers of Calais* on April 16, 1760, just weeks after the competition. See Timothy Clayton, *The English Print 1680–1802* (New Haven: Yale University Press, 1997), 198 and 302 n. 57.

53. Christie's, April 26, 1787, first day's sale, lot no. 66; price taken from annotated copy of the catalogue in Christie's Archive.

54. John Sunderland, *John Hamilton Mortimer: His Life and Works*, Walpole Society 52 (1986), cat. no. 13.

55. See William Hayley, *Life of George Romney, Esq.* (London: T. Payne, 1809), 39–40.

56. For Vandermeulen see Christie's, February 16–17, 1776, first day's sale, lots 20–22. The information on Casali comes from the Photographic Survey, Courtauld Institute of Art.

57. Library of the Royal Society of Arts, *A Catalogue of the Books, Manuscripts, Medals, Basso-*

Relievo's . . . belonging to the Society for the Encouragement of the Arts, Manufactures and Commerce Adelphi Building Strand taken May 1779, 4, 18.

58. Ibid., 5.

59. See D. G. C. Allan, "Bas-relief Plaques in the Society's House: An Inquiry," *Journal of RSA*, 119 (1970–71): 44–46, who misidentifies the subject of the "Priam."

60. David V. Erdman, ed, *The Complete Poetry and Prose of William Blake* (New York: Anchor Books/ Doubleday, 1988), 636.

61. Soc. Mins, April 8, 1765.

62. *The Gazetteer*, March 27, 1765.

63. Allan, "Artists and the Society," Allan and Abbott, *Virtuous Tribe*, 112.

64. See Allan, *Virtuoso Tribe*, also James Taylor, "Sea Pieces and Scandal: The Society of Arts' Encouragement of Marine Art, 1764–70," in *Journal of RSA*, 144 (1996): 32–34.

65. See George Rudé, *Wilkes and Liberty* (Oxford: Clarendon Press, 1962); John Brewer, *Party Ideology and Popular Politics at the Accession of George III* (Cambridge: Cambridge University Press, 1976); John Sainsbury, *London Supporters of the Revolutionary America 1769–1782* (Kingston: McGill-Queen's Press, 1987), 3–21.

66. See Alex Kidson, *George Romney 1734–1802*, exhibition catalogue, National Portrait Gallery. London, 2002, 13–15; Alan McNairn, *Behold the Hero General Wolfe & the Arts in the Eighteenth Century* (Montréal: McGill-Queen's Press, 1997); Myrone, *Bodybuilding*, 36–38.

67. See Myrone, *Bodybuilding* and Martin Myrone, *Gothic Nightmares: Fuseli, Blake and the Romantic Imagination*, exhibition catalogue, London: Tate, 2006.

Arts and Commerce Promoted:
"female excellence" and the Society of Arts' "patriotic and truly noble purposes"

Charlotte Grant

THE TERM "FEMALE EXCELLENCE" COMES FROM JAMES BARRY'S DESCRIPTION OF HIS murals, *The Progress of Human Knowledge and Culture*, painted for the "Great Room" of the [Royal] Society of Arts.[1] The Society for the encouragement of Arts, Manufactures and Commerce, to give it its full original title, is a voluntary association, a product of the sentimental reform movement of the mid-eighteenth century. From its foundation in 1754 the Society awarded prizes, or "premiums," for innovation in different fields of "arts, manufactures and commerce." Barry's fifth picture in his cycle casts *The Distribution of Premiums in the Society of Arts* as the apogee of contemporary cultural activity. I want to focus on this prize giving and ask: why does Barry place a woman at the center of his representation of this event?

The woman is Elizabeth Montagu, described by Samuel Johnson as "Queen of the Blue-Stockings."[2] Until fairly recently, the extent of the Bluestockings' contribution to the eighteenth-century cultural sphere has been underestimated.[3] For Barry, as for at least for some of his contemporaries however, Montagu embodied "female excellence," In his 1783 *Account of a Series of Pictures in the "Great Room" of the Society of Arts, Manufactures and Commerce at the Adelphi*, he describes her as a patron of female industry: "Towards the centre of the picture is a distinguished example of female excellence, Mrs. Montagu, who is earnestly recommending the ingenuity and industry of a young female, whose work she is producing."[4] Barry frequently portrayed both real and mythical women in his paintings. Elizabeth Eger draws attention to his *Letter to the Diletantti Society* of 1798, in which he links the Classical practice of representing the Muses to a lengthy and positive reference to the "celebrated and long-to-be-lamented" Mary Wollstonecraft.[5]

Elizabeth Montagu was a much less controversial figure than Wollstonecraft. She joined the Society of Arts in 1758, the year her husband inherited extensive and lucrative estates in Northumberland. The estates included coal mines, and Montagu became closely involved both in their management, and in the welfare of the miners and their families. She assumed overall control of the mines from 1766 and was so successful in raising the income they generated that she was, by the time Barry painted her, extremely wealthy. She was concerned to make good use of that wealth; in 1772 she wrote to her sister, the novelist Sarah Scott, whom she also supported: "My principal attention has been to providing food for my poor Neighbours, who are in the most litteral sense starving . . . If the rich people do not check their wanton extravagance to enable them to assist the poor I know not what must become of the labouring people."[6] She was a visible and recognized patron of the arts as well as being

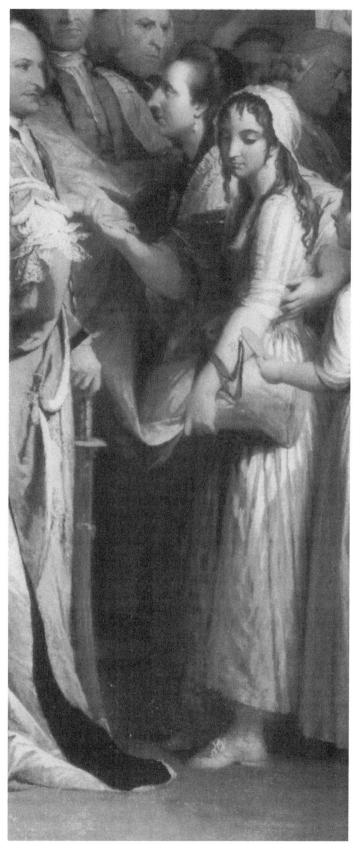

10. James Barry, detail from 5th picture, *The Distribution of Premiums at the Society of Arts* showing Mrs Montagu, 1777–84. Royal Society of Arts, London.

known for her benevolence.[7] Barry shows her as an ideal patron, and as a suitable model for emulation:

> Near Mrs. Montagu stand the two beautiful Duchesses of Rutland and Devonshire; and if I have been able to preserve one half of those winning graces in my picture, that I have so often admired in the amiable originals, the world will have no reason to be dissatisfied with what has been done. Between them I have placed that venerable sage, Dr Samuel Johnson, who is pointing out this example of Mrs Montagu, as a matter well worthy their grace's most serious attention and imitation.[8]

Barry thus describes three categories of women: Mrs Montagu; the "unnamed female" with her "medal of the Society of Arts"; and the "beautiful Duchesses" to whom Montagu is offered as a role model. The distinction made between these classes of women is important. As we shall see, the Society became increasingly aware of social distinctions; by the late 1820s it was explicitly promoting different roles for women according to their status.

Barry links this scene of prize giving to his general theme of "the progress of human knowledge and culture" by drawing attention to the patriotism of the Society: it is, he says, "picturesque":

> The distribution of premiums in a society, founded for the patriotic and truly noble purposes of raising up and perfecting those useful and ingenious arts in their own country, for which in many they were formerly obliged to have recourse to foreign nations, forms an idea picturesque and ethical in itself, and makes a limb of my general subject, not ill suited to the other parts.[9]

"Patriotic . . . purposes" motivate the Society's activities, and nowhere more clearly than in its desire to further Britain's manufacture of fabric. France was Britain's major competitor, the "foreign nation" Britain was "obliged to have recourse to." The first two premiums offered by the Society in 1754 were for cobalt and madder, pigments for blue and red dyes; as Linda Colley puts it: "the Society wanted to enable Britain's most important industry, its textile manufacturers, to be able to dye their cloth at home rather than having to send it abroad."[10] The prizewinning girl in Barry's painting holds what appears to be a bale of cloth under her arm.

This patriotism was typical of the many voluntary associations which emerged in the aftermath of 1745 Jacobite uprising. Colley describes them as "breaking out like measles over the face of Britain."[11] One such association was "The Laudable Association of Antigallicans" founded in 1745. D. G. C. Allan draws attention to the considerable common membership between the Society and the Association, but states that while "patriotism and paternalism proved to be abiding common interests of the Society and the Association," the Society fostered an international community of science, including French members from 1761 onward, and managed to combine economic nationalism with a desire to spread knowledge.[12] The Antigallicans offered premiums, and they, too, rewarded female labor. Members were all male, but the Countess of Middlesex was elected an "honorary associate" on account of her "refusal to wear French fabrics."[13] The Association first offered premiums in 1751, in the first instance "Ten Guineas for the best piece of English bone lace proper for Men's ruffles and five guineas for the second best; also a premium of ten guineas to the drawer of the best pattern for brocade weaving, and five guineas for the second best." One of the two satisfactory recipients for the lace premiums was a woman: a Mrs Elizabeth Waterman of Salisbury. In 1753 the majority of premiums for English fine lace went to women. The practice of offering premiums for lace was however condemned as "giving encouragement to a frivolous article," since, as Isaac Hunt, their first historian, had stated it was "their intention to discourage domestic as well as foreign luxury."[14]

It is obvious how the manufacture of lace, a costly and ornamental product, can be seen as encouraging luxury, but anxiety over luxury is a common feature of the discourses surrounding the establishment and practices of the early art institutions in Britain. Women occupy a prominent role in the rhetoric and representation of that debate since anti-luxury rhetoric suggests that luxury, frequently linked to the rise of commerce, encourages "effeminacy."[15] On the other hand, the full name of the Society encodes the happy union of the commercial and the artistic that Barry advocates, as does the motto "Arts and Commerce Promoted" inscribed on the façade of the main RSA building in the Strand. This virtuous alliance of commerce and the arts was achieved with some difficulty, as recent historians and art historians have demonstrated.[16]

Barry, however, is clear and unabashed as to the engine of the patronage offered by the Society of Arts—it is funded and driven by commercial success. The fourth painting in the cycle shows *Commerce, or the Triumph of the Thames*. The Thames is personified, a "practice" described by Barry as "ancient as the arts of poetry, painting and sculpture." The painting celebrates "the mariner's compass":

> from the use of which modern navigation has arrived at a certainty, importance, and magnitude, superior to anything known in the ancient world; it connects places the most remote from each other; and Europe, Asia, Africa, and America, are thus brought together, pouring their several productions into the lap of the Thames.[17]

The importance of the Thames as the vehicle of British trade was consistently stressed through the eighteenth century, as was its function as a conduit of knowledge and discovery. In *Windsor-Forest* (1704–13) Pope looks forward to when:

> The Time shall come, when free as Seas or Wind
> Unbounded Thames shall flow for all Mankind,
> Whole Nations enter with each swelling Tyde,
> And Seas but join the Regions they divide;
> Earth's distant Ends our Glory shall behold,
> and the new World launch forth to seek the Old.[18]

As early as 1667 in his prescriptive *History of the Royal Society*, written just ten years after its foundation, Thomas Sprat argues that the geographical position of London makes it suitable to be the new Athens:

> In a short time, there will scarce a Ship come up the *Thames*, that does not make some return of *Experiments*, as well as of *Merchandize* . . . those that border upon the *Seas*, are most properly seated, to bring home matter for *new sciences*, and to make the same proportion of Discoveries above others, in the *Intellectual* Globe, as they have done in the *Material*.[19]

Sprat's idealizing vision of England is as both a trading and an intellectual nation. Like Barry a century later, he is anxious to see "the intellectual" and the "material" as complementary.

Barry is keen to place commerce within a specifically patriotic frame by emphasizing the importance of British naval strength. Commerce and the navy were mutually dependent, the navy relying on sailors trained in merchant ships, and merchants relying in turn on the protection offered by the navy.[20] This association is strengthened by the addition Barry made to his painting in 1801: a tower inspired by a competition run in 1799 to design a column to commemorate Britain's naval victories over the French. Thus, as William Pressly points out, "what began as a work celebrating the promotion of peace and plenty under the stimulus of benign commerce became increasingly more martial and jingoistic in spirit under the influence of the continuing struggles with France."[21]

The patriotic program of the murals fit the intentions of the Society (even if its covert Catholic symbolism does not).[22] Thames, like an ancient River God, is supported by Tritons: "our great navigators, Sir Frances Drake, Sir Walter Raleigh, Sebastian Cabot, and the late Captain Cook of admirable memory." Cook was added after his death in combat in 1779. Barry's account continues: "over-head is Mercury, or Commerce, summoning the nations together, and in the rear are Nereids carrying several articles of our manufactures and commerce of Manchester, Birmingham, &c." The "Nereids" provoke an interesting digression in Barry's account, and one highly pertinent to my focus on women and the Society of Arts:

> If some of those Nereids appear more sportive than industrious, and others still more wanton than sportive, the Picture has the more variety and, I am sorry to add, the greater resemblance to the truth; for it must be allowed, that if through the means of an extensive commerce, we are furnished with incentives to ingenuity and industry, this ingenuity and industry is but too frequently found to be employed in the procuring and fabricating such commercial matters as are subversive of the very foundations of virtue and happiness. Our females (of whom there are at least as many born as males) are totally shamefully, and cruelly neglected, in the appropriation of trades and employments; this is a source of infinite and most extensive mischief.[23]

It seems natural to Barry to move from his description of the role of commerce to a diatribe about the importance of female employment. Discussion of women's employment is fairly widespread in the Society's papers, and can be linked to another of its concerns, prostitution.[24] This is a typical preoccupation of the voluntary associations: prostitutes represented not only a moral weakness, but also wasted the country's resources, spreading disease rather than helping to increase the healthy population necessary to safeguard national security.

In 1765 the Society received a radical suggestion in a letter from someone signing himself "Publicus." Complaining about the number of prostitutes to be found on the streets of London, he claims that while more men than women are born,"The infinite Variety of Professions, Trades & Manufactures, join'd to the Army Navy & Services, leave few Men idle, unless from choice; whilst Women have, but few Trades and fewer Manufactures to employ them."[25] The mismatch between "places" and women looking for work is such, Publicus argues, that "they from pinching Necessity, become a Prey to their own Passions, the Pimp & the Debauchee." The prostitute is seen as an enemy to progress, to the "young Apprentice," as well as being the symbol of her own destruction. "Publicus" offers a solution to this depressing state of affairs: "It is certain that many Women might be employed & get a comfortable, nay, a genteel, Subsistence, by many Trades that are now engross'd by Men, where Ingenuity is more requisite than Strength; and the Strength of Men therein is consequently misapplied." He further suggests that in order to facilitate this improvement, the Society should consider offering premiums specifically for women in suitable trades:

> Were you then to offer a Premium for the best Watch, the best Piece of Engraving, Chasing &c or any other thing that shall occur to you from these Hints that shall be executed by a Woman; This would multiply their employments, encourage Parents to bring one or more of their Daughters up to their own Trades (when they are such as Women may execute & excel in) and in time take off that Superfluity of Servants of the better kind that now wait in vain for such Stations 'till they fall a Prey as above.[26]

These suggestions are clearly aimed at the Society's involvement in the movement for the reformation of prostitutes, in which several Members, notably Jonas Hanway, were key figures. In 1758 Hanway put forward a proposal for "the Relief and Employment of Friendless Girls and repenting Prostitutes."[27] Women are, however, not only seen as a problem for society, they are, like Mrs Montagu, possible agents of benevo-

lence. As early as 1753 William Shipley had envisaged women as full members of his patriotic Society: "Ladies as well as gentlemen are invited into this subscription, as there is no reason to imagine they will be behindhand in a generous and sincere regard for the good of their country."[28]

The third premium offered by the Society was specifically aimed at girls as well as boys, and links artistic skills directly to industry:

> It was likewise proposed, to consider of giving Rewards for the Encouragement of Boys and Girls in the Art of Drawing, and it being the opinion of all present, that the Art of Drawing is absolutely necessary in many Employments Trades, and Manufactures, and that the Encouragement thereof may prove of great Utility to the public, it was resolved to bestow Premiums on a certain number of Boys or Girls under the Age of Sixteen, who shall produce the best pieces of Drawing, & shew themselves most capable, when properly examined.[29]

In 1754 the Society's first premiums list consisted of four awards, by 1764 there were three hundred and sixty-four. Initially premiums were listed in order of introduction;[30] after 1758 the list was divided up into categories: Agriculture; Chemistry; Colonies and Trade; Manufactures; Mechanics; and the Polite Arts. The category of Polite Arts was the major area in which girls were awarded premiums.[31] One of our main sources for the lists of premium winners up to 1782 is Robert Dossie's *Memoirs of Agriculture and other Oeconomical Arts.* Dossie notes that in 1756 a class was devised that "very suitably became a field of contention for young ladies": "The Candidates, allowed to be near the Age of 20 were to produce fancy Designs and Compositions of Ornaments, with Flowers, Fruit, and Foliage, after Nature; Such drawings were meant to be of use to Fabrics and Manufactures."[32] Under the growing category of "Premiums relating to Manufactures" there were also a high proportion of premiums awarded to women, especially in relation to designs for fabrics.[33]

From 1758 onward the following category appeared: "Compositions of Ornament after Nature arranged according to Fancy, by either sex, under 15 years. The subject generally taken from Prints after Baptiste." We can look at these designs today, since winning entries for many premiums were kept by the Society, and now form an important part of the RSA archive. The apparently contradictory statement that the images were to be after nature, arranged according to fancy, with the subjects taken from prints by Baptiste (a seventeenth-century French flower painter who worked for the Gobelins tapestry factory in Paris), is borne out in the odd qualities of some of the surviving designs. Some of the images show the kind of detailed observation motivated by the eighteenth-century interest in botany. In a recent study of drawing practices, Ann Bermingham demonstrates how the observation of flowers was seen as a suitable pastime for women, who are consistently figured in relation to what becomes, in the course of the century, a highly stylized language of flowers.[34] An edition of *The Spectator* in 1714 which condemned women's propensity to "Scandal, the usual Attendant of Tea-Tables, and all other unactive Scenes of Life," instead recommended women to pass "their hours in imitating fruits and flowers, and transplanting all the beauties of nature into their own dress," suggesting that: "This is, methinks, the most proper way wherein a Lady can shew a fine Genius, and I cannot forbear wishing, that several Writers of that Sex had chosen to apply themselves rather to Tapestry than Rhime."[35] Books on botany aimed at a female readership appeared, several written by women, such as Charlotte Smith's *Rural walks: in dialogues, Intended for the use of young persons* (1795) and Priscilla Wakefield's *An Introduction to Botany, in a Series of Familiar Letters, with Illustrative Engravings* (1796). By the end of the eighteenth century the study of botany, and the associated practices of botanical illustration, were well established as a popular and apparently appropriate study for polite women.[36]

Models for floral designs come not only from nature, but also from Indian printed muslin, from prints, pattern books, and from "the growing body of scientific and

horticultural literature such as herbals, botanical treatises, and seed catalogues."[37] This variety of sources is apparent in the designs in the RSA archives, which frequently include elements of relative botanical accuracy with some more obviously fanciful components. An example by a young male prizewinner contains recognizable flowers: a more or less stylized tulip, wild roses, and, at the base, something like a cornflower, with, on the left-hand side, a highly colored and artificial-looking creation which might very well have been adapted from an Indian Chintz.

For the most part, the RSA images are not the product of polite accomplishment, but envisaged as contributing to what Helen Clifford has called a "national design initiative."[38] Winners of premium prizes were not displaying the skills of an expensive education designed to demonstrate elite social status and desirability in the marriage market, but rather more practical skills linked to the needs of the manufacturing industry. In this respect, it is not surprising that there is little variation between the prizewinning entries for boys and girls, although, as I have already pointed out, Dossie describes the designs involving flowers and fruit intended for textiles, as becoming "very properly" a category in which young women "excelled," presumably for the reasons linking women and botanical illustration which I have just outlined.

One of the other terms in the description of the premiums is "fancy," signifying "an aptitude for the invention of illustrative or decorative imagery" (Oxford English Dictionary). The designs fit into a genre of flower painting already geared toward the manufacturing industry, and the students are to demonstrate their powers of imitation. It is interesting the model for that imitation should be French, given as I have already suggested, that one of the driving forces behind the premiums offered for design was a desire to promote British over rival French manufacture.

Categories continued to be expanded, and the lists of prizewinners include many otherwise unknown young women artists. Surviving successful premium drawings by these women range from amateur images to numerous "Compositions of flowers," illustrated by an accomplished flower painting by Hannah Chambers (1759), as well as designs for commodities; see for example the Design for a Candelabra, also by Hannah Chambers (1757), and the purely decorative, such as Hannah Rush's Compartment with cattle (1758/59). According to Dossie, Rush won a fifth share in 1759 under the category "Original Compositions of Ornaments, with Beasts, Birds, Fruit, and Flowers, after Nature, for Embroiderers, Manufacturers, &C. the general Subjects from Prints after Baptiste." He notes that she was "not 11 years." The drawing is disjointed—the central image is of peasant figures and cattle and a goat wading through water. A small child carried by one of the women turns to look out at us. The sepia border, shaded in pencil, culminates in grotesque heads top and bottom. It seems to have been copied from a seventeenth-century French source—an etching by Jaques Callot entitled "L'Eventail" from 1619.[39] Rush has simplified the border, removing the figures at the side and substituting them with ribbon ties. These ribbons are drawn in pencil and they support a lower border of flowers, some recognizable, like the large passionflower on the lower left. Overall the composition is a strange combination of elements, which exhibit different techniques, but fail to coalesce.

Reading Dossie's account, which consists of the numbered premiums together with the names of the successful candidates in each category, one gets a sense of the numbers of individuals involved. He is keen to point out those premium winners who went on to have successful careers as artists; one such was Mary Moser. Her father, George Michael Moser, was a founding member of the Royal Academy and first Keeper of the Academy Schools.[40] Like her, many of the young women artists who received prizes were the daughters or sisters of male artists. Children from particular families, for example the Vivares family, and the Pingos, a family of medal makers, gained prizes at different times.[41]

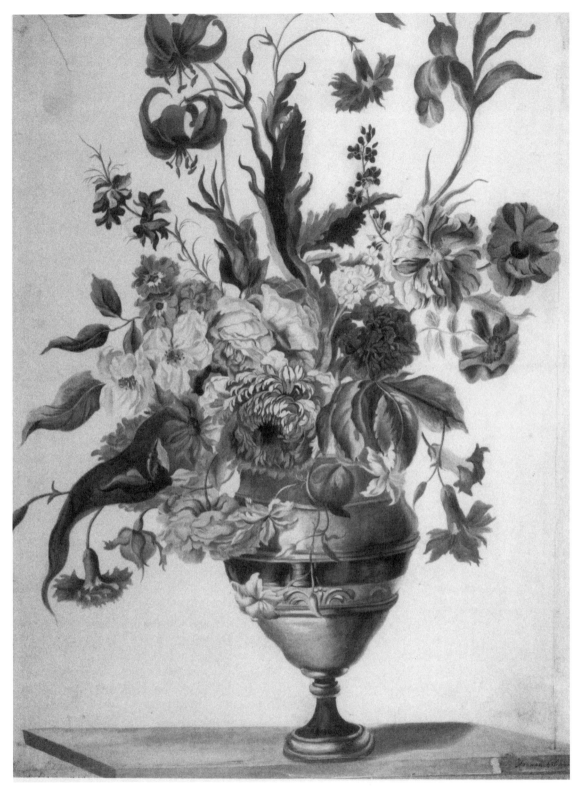

11. Hannah Chambers, prize-winning painting of flowers in a vase, 1759. Royal Society of Arts, London.

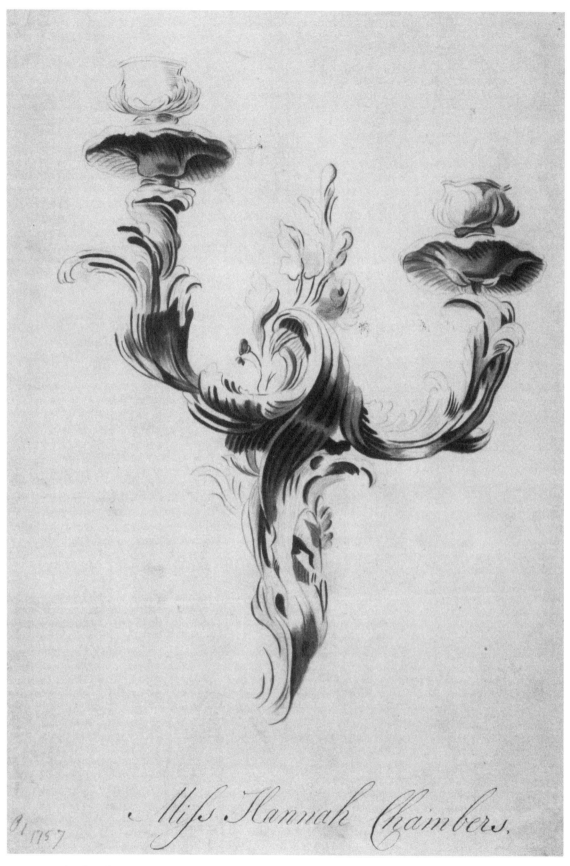

Miss Hannah Chambers.

12. **Hannah Chambers, prize-winning design for a candelabra, 1757. Royal Society of Arts, London.**

Between 1757 and 1828 changes occur in the Premium lists which signal the Society's growing awareness of social status. The year 1757 saw the introduction of premiums for the genteel in the form of gold and silver medals. Dr Templeman's *Transactions* note that these should act: "As an Honourable Encouragement to young Gentlemen or Ladies of Fortune, or Distinction, . . . who Entertain or Amuse themselves with Drawings."[42] The first honorary Gold Medal was won in 1758 by the Hon. Lady Louisa Augusta Greville, daughter of the eighth Earl of Warwick, for a drawing of *A View of the Priory of Warwick*. Overall the Honorary Premiums were won consistently more often by women.

After the introduction of honorary premiums, further adjustments were made to the categories of prizes on offer. In 1760, for example, premium class 55 presumes that some girls will be apprenticed or employed: "For the Best Drawings or Compositions of Ornaments, consisting of Birds, Beasts, Flowers or Foliage, fit for weavers, Embroiderers, or any Art or Manufacture; by Girls under the Age of 18, who are Apprentices, or employed in any Art or Manufacture; to be produced as determined as above, fifteen Guineas."

Women's participation continues into the early nineteenth century, but the premium categories become increasingly specific. These divisions illustrate both the increasing professionalization of the discipline, and a growing concern with the hierarchy of society, resulting in the definition of the amateur.

Between 1775 and 1776 there seems to have been an adjustment in the description of those eligible for honorary premiums. Until 1775 there is a single category for Honorary Premiums for Drawings, for the best Drawings of any kind, made with chalk, black lead, pen, India ink, or bister, by young gentlemen under the age of twenty-one, sons or grandsons of Peers, or Peeresses in their own right, of Great Britain or Ireland with an equivalent category for "young ladies." In 1776 there is a split between the nobility: "the sons or grandsons of Peers, or Peeresses in their own right" etc., and the gentry, "young gentlemen" (with equivalent divisions for young ladies). Professionals are explicitly excluded: "NB. Persons professing any branch of the Polite Arts, or any Business dependant on the Arts of Design, or the Sons or Daughters of such Persons will not be admitted Candidates in these Classes."

Until 1827 these distinctions remain, and are given separate headings in the Society's Premium lists: "Honorary Premiums for Paintings or Drawings by Nobility" and "by Gentlemen or Ladies" respectively. In 1828 there is a change in practice, with a new heading at the beginning of the section of "Class of Polite Arts"

The following Premiums in Polite Arts are offered in five distinct classes:—

Class I. Includes Sons and Grandsons of Peers, or of Peeresses in their own right, of the United Kingdom.
Class II. Includes Daughters and Grand-daughters of Peers, or of Peeresses in their own right, of the United Kingdom.
Class III. Includes Gentlemen who claim as Amateurs.
Class IV. Includes Ladies who claim as Amateurs.
Class V. Includes Artists, who profess and practise the Arts of Painting, Sculpture, Architecture, or Engraving, or who are pursuing their Studies in contemplation of becoming Artists.[43]

From its foundation in 1754 onward, the Society of Arts' "patriotic and truly noble purposes" included promoting the activities of women (as well as men) as artists and patrons. By 1828 three distinct categories based on social status: artistic patron, genteel amateur, and professional artist, seem to have been firmly established. James Barry's representation of *The Distribution of Premiums at the Society of Arts* (1777–84) celebrates this female activity, and already registers the social distinctions between the women portrayed. His iconography embodies the allegiance between "Art and

Commerce" sought by the Society, and he places women at the center of his representation of *The Progress of Human Knowledge and Culture.* His paintings chart "one great maxim, or moral truth, viz. that the obtaining of happiness, as well individual as public, depends upon cultivating the human faculties."[44] Women's "faculties" are not merely included in this project; "female excellence," for Barry, seems to have been a central image of the process of cultivation. In Barry's patriotic image Mrs Montagu and her young female protégé are both, variously, "ornament(s) of the nation."

NOTES

1. James Barry, *An account of a Series of Pictures, in the "Great Room" of the Society of Arts, Manufactures and Commerce at the Adelphi* (London: printed for author, 1783), 73.

2. Quoted in Edith Sedgwick Larson, "A Measure of Power: The Personal Charity of Elizabeth Montagu." *Studies in Eighteenth-Century Culture* 16, (1986): 197–210. See also *Mrs. Montagu, "Queen of the Blues:" Her Letters and Friendships from 1762 to 1800*, edited by Reginald Blunt, 2 vols. (London: Coustade and Caupauy, 1923), and Elizabeth Eger, ed., "Introduction," *Elizabeth Montagu. Bluestocking Feminism: Writings of the Bluestocking Circle.* Vol. 1, 6 vols. (London: Pickering and Chatt., 1999), lxv–lxxvii.

3. The Montagu Collection at the Huntington Library contains three thousand items from Montagu's extensive correspondence. Selections have been published: *Elizabeth Montagu, the Queen of the Bluestockings: Her Correspondence from 1720 to 1761*, edited by Emily J. Climenson, 2 vols. (n.p.: John Murray, 1906). For reassessment of the importance of the Bluestockings see: Sylvia Harcstark Myers, *The Bluestocking Circle: women, friendship, and the life of the mind in eighteenth-century England* (Oxford: Clarendon Press, 1990) and Kelly *Bluestocking Feminism.*

4. Barry, *Account*, 73.

5. James Barry, "A Letter to the Dilettanti Society," in *The Works of James Barry*, ed. Edward Fryer, 2 vols. (London: T. Cadell and W. Davies, 1809), vol. II, 594; Elizabeth Eger, "Representing Culture: 'The Nine Living Muses of Great Britain'" (1779), in Eger, Grant, O'Gallchoir, and Warburton, eds., *Women, Writing and the Public Sphere, 1700–1830* (Cambridge: Cambridge University Press, 2001), 104–32, 104ff, 116.

6. Elizabeth Montagu to Sarah Scott, July 28, 1772, MO5930 (Montagu Collection, Huntington Library), quoted in Larson, "A Measure of Power," 207.

7. Eger, "Introduction," *Elizabeth Montagu*, lxii–lxv, Larson, "A Measure of Power."

8. Barry, *Letter*, 73.

9. Ibid., 338. His footnote points to the fact that the Society has "become an object of imitation in other countries."

10. Linda Colley, *Britons: Forging the Nation 1707–1837* (London: Pimlico, 1994), 90.

11. Ibid., 88.

12. D. G. C. Allan, "The Laudable Association of Antigallicans," *RSA Journal* 137 (1989): 623–28, 626; Colley, *Britons*, 88–90.

13. Allan, "Laudable Association," 623.

14. Isaac Hunt, "Some Account of the Laudable Institution of the Society of Antigallicans," in *A Sermon preached before the Laudable Association of Antigallicans*, 1778, viii, quoted in Allan, "Laudable Association," 625.

15. On luxury see John Sekora, *Luxury: The Concept in Western Thought Eden to Smollett* (Baltimore: John Hopkins University Press, 1977); Christopher Berry, *The Idea of Luxury, A conceptual and historical investigation* (Cambridge: Cambridge University Press, 1994); Charlotte Grant, "The Choice of Hercules: 'The Polite Arts' and 'Female Excellence' in Eighteenth-Century London," in Eger, *Women*, 75–104 discusses this topic in more detail.

16. John Barrell, *The Political Theory of Painting from Reynolds to Hazlitt: "The Body of the Public"* (New Haven: Yale University Press, 1986), David H. Solkin, *Painting for Money: The Visual Arts and the Public Sphere in Eighteenth-Century England* (New Haven: Yale University Press, 1992).

17. James Barry, *Account of a series of Pictures, in the "Great Room" of the Society of Arts, Manufactures, and Commerce, at the Adelphi*, 1783, 59–60. London: n.p., 1783.

18. *The Poems of Alexander Pope*, ed. John Butt (London: Metheun and Company, 1963), 209–10, lines 397–406.

19. Thomas Sprat, *The history of the Royal-Society of London for the improving of natural knowledge* (London: n.p., 1667), 86.

20. See Colley, *Britons*, 65–66.

21. William L. Pressly, *James Barry: The Artist as Hero* (London: Tate Gallery, 1983), 83.

22. Ibid., 26–28.

23. Barry, *Works*, 333.

24. See John L. Abbott and D. G. C. Allan, "'Compassion and Horror in Every Humane Mind': Samuel Johnson, The Society of Arts, and Eighteenth Century Prostitution" (i) *RSA Journal* 136 (1988): 749–53; 827–32.

25. Letter from Publicus about reducing the number of prostitutes in London, 1765, RSA Guard Books, vol. 18, PR.GE/110/18/83.

26. Ibid.

27. Abbot, "Compassion," 828. For Hanway's involvement in the Magdalen Hospital see Markman Ellis, "'Recovering the path of virtue': The Politics of Prostitution and the Sentimental Novel," in *The Politics of Sensibility: Race, Gender and Commerce in the Sentimental Novel* (Cambridge: Cambridge University Press, 1996), 160–90.

28. William Shipley, "A Scheme for putting the Proposals in Execution" (1753), quoted in D. G. C. Allan, *William Shipley, Founder of the Royal Society of Arts* (London: Scolar Press, 1979), 44. On women's early involvement in the Society see: Alicia C. Percival, "Women and the Society of Arts in its Early Days," *Journal of Royal Society of Arts* 125 (1977): 266–69; 330–33; 416–18.

29. RSA, Minutes of the Society of Arts quoted in Derek Hudson and Kenneth Luckhurst, *The Royal Society of Arts 1754–1954* (London: John Murray, 1954), 8.

30. Allan, "Artists and the Society in the 18th Century: (ii) Members and Premiums in the First Decade, 1755–64," *Journal of Royal Society of Arts* 32 (1984): 275.

31. See Robert Dossie, *Memoirs of Agriculture and other Oeconomical Arts* (London: n.p., 1782).

32. Ibid., 398.

33. See Helen Clifford, "Key Document from the Archives: The Awards of Premiums and Bounties by the Society of Arts," *RSA Journal* 145 (1997): 78.

34. Ann Bermingham, *Learning to Draw; Studies in the Cultural History of a Polite and Useful Art* (New Haven: Yale University Press, 2000), 204.

35. Charlotte Grant, ed., "Introduction," *Flora*, vol. 4 of Literature and Science, 1660–1834, general ed., Judith Hawley, 8 vols. (London: Pickering & Chatto, 2003).

36. *The Spectator*, no 606, October 13, 1714. *The Spectator*, ed. by Donald F Bond, 5 vols. (Oxford: Clarendon Press, 1965), vol. 5, 72. Bond notes that this edition was by Thomas Tickell.

37. Bermingham cites: Vibeke Woldbye, ed., *Flowers into Art: Floral Motifs in European Painting and Decorative Arts.* (The Hague: SDU, 1991), 14.

38. Clifford, "Key Document," 79.

39. F. L. Leipnick, *History of French Etching* (London: John Lane, 1924), 13.

40. Marcia Pointon, *Strategies for Showing: Women, Possession, and Representation in English Visual Culture 1665–1800* (Oxford: Oxford University Press, 1997), 145–46.

41. On the Pingos see *Christopher Eimer, The Pingo Family and Medal-Making in Eighteenth-Century Britain* (London: British Art Medal Trust, 1998).

42. RSA, Dr Templeman's Transactions, vol. 1 (1754–58), 115–16.

43. RSA, Society of Arts, *Premium Lists* (1828), xi.

44. Barry, *Account*, 40.

Making a Place for Ornament:
The Social Spaces of the Society of Arts

Andrea MacKean

IN 1749, JOHN GWYNN OBSERVED: "A LOVE OF THE POLITE ARTS IS NOT IRRECONCILABLE with the Pursuit of Commerce and Riches: As it is usually grafted upon the Success of the latter so it may live and grow with it in perfect Harmony . . . there may be great pecuniary Advantages, such as ought to engage the Attention of the mere Merchant obtained from our Improvements in the Art of Design." For Gwynn, the polite arts were an ornament of a successful nation, a mark of its maturity. At the heart of his analysis was an understanding of the polite arts as differing from the commercial arts as degrees of the same enterprise, not as distinct pursuits, either in their production or their consumption.[1]

Fifty-five years later, Martin Archer Shee approached similar territory, the relationship between commerce and art, in *Rhymes on Art*. For Shee, there was no common ground between the arts and commerce, nor should there be. "The principle of trade," he stated, "and the principle of the arts, are not only dissimilar, but incompatible. Profit is the impelling power of the one—praise of the other."[2] Shee's identification of fine art as a virtuous public endeavor, and rejection of the machinations of commerce—presumably coupled with the commercially driven applied arts—goes against the economic analysis of Adam Smith, who stressed the interdependence of all levels of production and consumption. However, while the market had, by 1805, integrated Smith's economic thinking, Shee was asserting the unequivocal independence of fine art from commercial interests—identifying one as a transient and essentially private concern of the masses, and the other as a recognition of sustaining public worth.

It is this historical separation of the fine arts from the ornamental arts, of the aesthetic from the market, that I explore here, by examining three spaces where this distinction was being drawn: the Society for the encouragement of Arts, Manufactures and Commerce and its promotions of all spheres of the polite arts, that Society's house in the Adelphi built by the Adams brothers, and James Barry's paintings of the *Progress of Human Knowledge and Culture* painted for the Society's "Great Room." It was as a point of mediation between the general ideals of art and the particulars of commerce, between grand narratives of History and particular activities of individuals, where the Society of Arts, the Adam brothers, and James Barry self-consciously sought to position themselves and their works. These three projects were engaged in the historical process of distinction and distanciation between the commercial and aesthetic aspects of artistic practice occurring in eighteenth-century Britain, the results of which we are familiar with today. These three projects also shared common ground, coming together physically as they do in the social space of the Society of Arts building.

I use the phrase "social space" rather than "architecture" or "building" to indicate

that my concern is not only with a particular building, but with that building as a lived environment, as a conceptual, organized, and experienced space as well as a physical one.[3] Underlying my understanding of space are certain assumptions.

Firstly, a building and its surroundings form a structured, continuous space, which allows people to circulate around the building's exterior but which permits only "inhabitants" or "visitors" to enter. A number of elements regulate the space, and order the individual's actions and engagements within it: the visual and architectural relationships between inside and outside, the arrangement and articulation of entrances, the spoken or unspoken regulations defining who can enter into a space, what one can or cannot see such as ornamentation, decorations, furnishings, the sequences of rooms, and patterns of movement. Such orderings make a place comprehensible; they identify the space and the places occupied by individuals within it by instituting patterns and hierarchies, visible on and experienced by visitors, patterns which are often similar to other socially identifying orders.

Secondly, both society and space are understood through social relations. While society and space tend to be described as abstracts, social relations involve actual people and occur within concrete places. The physical arrangements of buildings and streets direct and shape peoples' interactions with themselves and others. Thought of as a complex of ordering structures—not necessarily homologous—presented materially in buildings, space can be seen as more than a stage on which social experience unfolds. By providing certain routes of passage or closure, particular juxtapositions of open and closed areas, views onto transparent or opaque surfaces, space makes actions possible while it imparts meaning—in its many forms—to those activities. I argue that the spatial design, organization, and decoration of the Society of Arts building, and the arrangement of activities occurring within, can tell us something about where the Society of Arts wished to locate itself within contemporary debates of artistic identity, and more broadly, within British society in the late eighteenth century.

The Society of Arts was formed in 1754 to promote the development of British agricultural, manufacturing, artistic, and commercial activity principally through a scheme of monetary awards and medals.[4] In the polite arts, this support was spread across the spectrum of the arts, encompassing the fine and the applied arts, and including several projects to encourage the patronage of British rather than foreign artists. This agenda was twofold. It encouraged particular individuals to develop the skills to produce designs and ornaments for a wide range of products. It was also directed toward the more general goal of educating the "public" to a more refined taste. This second form of education was itself a two-part process. One aspect involved the popularization and hence greater commercialization of British design. The second was the regularization and management of that design. This agenda was partly aesthetic, partly commercial, involving as it did the relating of taste and sensibility to those more traditional civic humanist values of virtue and liberty. While consistent in its encouragement of British invention and design, the particular areas where the Society's support was expressed were diverse, a diversity indicated in William Bailey's engraving representing the range of projects the Society involved itself in. The circular coherence of Bailey's composition establishes an order for this multitude of otherwise discontinuous objects, an order analogous to the Society's coherence of support.

The Society sought to encourage patrons of the arts through exhibitions and the awarding of medals, while maintaining pecuniary support for designers of more commercially directed goods whose works might benefit from a patron's refinement of taste, sensibility, and national spirit. Thus the Society reworked the differentiating of the higher and lower arts into a distinction between consumers and producers. This distinction was also recognized in the assumed motivations of those two groups of recipients, as made clear in *An Account of the Present State of the Society*, that "profit and honour are two sharp spurs, which quicken invention and animate application."[5]

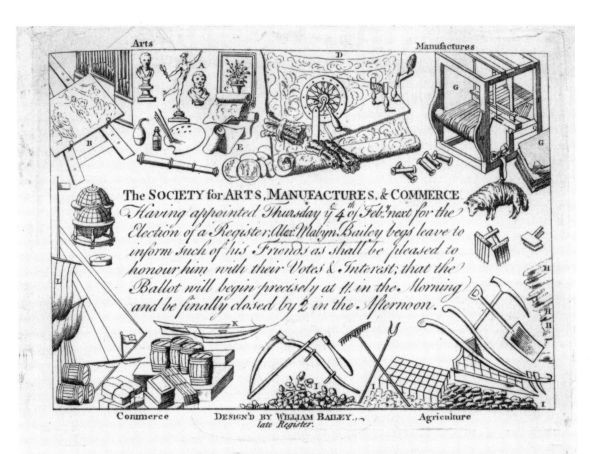

A . *Drawings & Models by Youths, from the Statues and Busts in the Duke of Richmonds Gallery.*

B . *A Capital History Piece by M.ʳ Pine.*

C . *A Beautiful Flower Piece by Miss Moser.*

D . *A Curious Carpet by M.ʳ Moor.*

E . *Medals and Medaglions by Youths.*

F . *Yarn, spun in Work-houses, Died Black, Green, & Scarlet in Grain.*

GG. *A Loom with Druggets of a particular Fabrick, & other Woollen Goods for Foreign Markets.*

HHH. *Saltpetre, Cobalt, Fossils, and Minerals of divers Sorts.*

III . *Plantations of Chesnuts Madder, Acorns &c.*

K . *Ships Blocks of a New Construction.*

L . *The Ship Folkestone, from the British Plantations, deeply loaded with Furrs, Flax, Hemp, Bales of Silk, Log-wood, Pot-ash Indigo, Saflower, Cochineal, Silk-grass, Mirtle-wax, Spices, Wines, Oile, Olives and Mangoes.*

13. William Bailey, flyer for election of a Register for the Society of Arts, engraving. In Anderdon, *Society of Artists*, vol.1: 195. © Copyright the Trustees of The British Museum.

Thus on the surface the Society of Arts might justly be seen as not engaged in promoting the separation of the fine arts from more commercial interests. However, while its activities seem to present an image of equitable promotion of all forms of artistic practice, made equal by their import to commercial enterprise, on closer examination, the two, both in terms of audience and product, were divided as profit and honor, money and medals.

Even prior to the installation of Barry's paintings in 1783, the Society's meetings were described as a sight providing a spectacle worthy of public attention. What were potential visitors being encouraged to look at? In 1810, the *Microcosm of London* observed that "[the] mode in which the whole ceremony [of the Society of Arts' annual distribution of premiums] is conducted, displays one of the most interesting scenes which the metropolis affords." This spectacle, according to Ackermann, offered a variety of visual pleasures. These ranged from views of the nobility, men of ability, and displays of ingenuity, to the more sentimental sight of "the satisfaction of a father . . . [witnessing] the bounties conferred on a promising son," or in a slightly more eroticized tone "the lovely diffidence of blooming beauty, trembling alive to the distinction, approaching to receive the honours which await her." Such sights Ackermann assured his readers could not allow "the mind of any spectator [to] remain inanimate."[6] His language utilised the rhetoric of connoisseurs—variety, sentiment, edification, grace, and grandeur—terms which resonated with attendant aesthetic connotations, with each part supportively subordinate to the experience of the entire scene. It was also the language of the exhibition, drawing attention to the variety of visual experiences but also to the commonality of viewers' emotional responses. Such language set a distance between members and visitors by positioning the Society of Arts meeting as an exhibition presented for visitors' contemplation and consumption.

The "Great Room" was a nexus of the Society's activities, the place where that Society's public presence was constructed, performed, and displayed, the place where audiences came to participate within its publicity. The "Great Room" was a large room containing several rows of benches, designed by Adam. These were laid out in semicircles around the president's place located across from the entrance, rather like the seating in a classical amphitheater.[7] In the few engravings of the "Great Room" these benches do not appear to obstruct the view. However, if we take the ruling that they were "not to exceed five feet" as an estimation of their height, these benches would have hampered the entering visitors' view of either the events or the seated members within, thus underscoring a separation between the Society's visitors and its members.[8]

Ackermann's description echoed many of the sentiments of Sophie von la Roche, who in 1786 described the same scene in similar language, pointing to the effects that the Society had upon the nation, and that the sight of the Society had upon her as a viewer. She began by situating the Society in relation to the nation, commenting at length on the assistances distributed by this society to the public. She then moved closer to describe the view the Society in its "Great Room" afforded to the spectator:

> A large picture runs the whole round of this honourable and esteemed Society's conference hall . . . depicting all the labours and activities of mankind, and ending with the reward of the philanthropist's good deeds at the door of eternity . . . My heart was big with blessings, and tears of joy filled my eyes at the list of the many names to which rewards had been given for improved methods of cultivation or invention of tools.[9]

What is interesting about La Roche's commentary is that she clearly differentiated the Society from those commercial projects it supported. It is not the improvements which inspired her sentimental tears, but the witnessing of the list of names of those who received its support. Pierre-Jean Grosley was more emphatic in his separation of

the Society from the recipients of its awards. While, in his view, the premium-winning works in the polite arts "do not often raise the reputation of their authors, they reflect the highest honour upon the generosity and magnificence of the society."[10]

These various scenes were witnessed in the Society's house in the Adelphi, where that Society resided from 1774 onward. Its internal spaces were hierarchically arranged, ascending from the entry hall up to the "deepest" space of the "Great Room." Upon entering through a common entrance, a visitor first passed the inspection of the Registrar, whose office was to the right of the entrance. From there, the clearest path was directly forward into the Repository, where useful models of manufacturing and agricultural projects supported by the Society were displayed for public view. An enclosed staircase, to the left of the entrance, led to the second floor, and the Society's "Great Room." That the stair was enclosed, signaled that it led to a more private area of the Society's house. At the top of the stair was an anteroom, and beyond, the "Great Room." Glass-paneled doors with curtains, installed in 1784, blocked physical and visual entrance into the "Great Room."[11] Visitors who wished to attend the meetings in the "Great Room" were to be introduced by a member and their visit voted on before they could enter.[12] Thus, ironically, the "Great Room," although the focus of the Society's public activities, was in actuality a very private space, when thought of in terms of its spatial location and accessibility. Yet, the "privacy" conveyed by the seclusion of the "Great Room" was not a privacy that identified visitors to those deep spaces as participants in the Society—they were its viewers. Compared with the "Great Room," the Repository on the entry level was more accessible. Visitors had only to pass through the entry area, and past the Registrar's scrutinizing glance. Such variations in accessibility, circulation, and address between the "Great Room" and the Repository—the two spaces where the Society displayed itself and its works to the public—suggests that different audiences were desired in each. They also indicate that different agendas organized what was seen inside these spaces, for while the useful exhibitions in the Repository were relevant to individuals involved in particular commercial activities, those in the "Great Room" were displays of the recognition of worthy projects presented to a more exclusive audience, perhaps those whose consumption would support these commercial activities.[13]

That such distinctions within the Society's audiences were desired rather than circumstantial, is suggested by an early set of plans for the Society's rooms, now in the Sir John Soane's Museum collection of Adam drawings.[14] The differences between these unexecuted plans and the rooms as built indicate the Society's members decided to enlarge the "Great Room," and add a Tea Room between the anteroom and the Committee Room, an addition that functioned as a kind of buffer between the spaces open to visitors, and those reserved for members. Further changes included the relocation of the staircase from the center of the building, where it would have served both the private offices and public areas, to the outer, west wall, and the Registrar's office from the first floor to the ground floor. These changes served both to make the display provided by the meetings in the "Great Room" more imposing, while simultaneously segregating the public's passage to those upper areas away from the acknowledged private areas of the house, including the Committee Room and the Secretary and Registrar's apartments.[15] They also served to emphasize the distance between the two display rooms and their respective audiences, the one exhibiting the Society as a corporate body engaged in encouraging the nation's development, and the other exhibiting the useful products of those benevolent attentions.

The distinction between commercial and aesthetic perspectives, between the changes of progress and the ideals of civilized order, between private and public, was also measured by temporality and duration. Ornament, understood as a detail or, in its older sense, as an emblem, functioned as a link connecting a particular situation, person, or place, embedded in its time, with a more general, abstract meaning. Thus,

ornament was seen as dynamic and changing. Thomas Sheraton, in *A Cabinet-Maker's Drawing Book*, admitted ornament was "of a changeable kind," an identification he qualified by adding, the "materials for proper ornaments are now brought to such a perfection as will not, in future, admit of much, if any, degree of improvement, though they may, . . . be varied *ad infinitum*, to suit any taste at any time."[16] Change and variation were essential characteristics of his understanding of ornament. Such changeability was for Barry an anathema, as we may understand from his objection to the Presidents' portraits hanging amidst his Progress. "Individuals are short lived & transitory, yet Society's may be eternal . . . these two Portraits, unconnected with everything else, stand like ominous obstructions to the further progress of the Society."[17] Counter to this distracting and potentially disastrous focus on private persons or concerns, "History" painting carried the connotation of expressing timeless, universal ideals.

An image of permanence was one benefit James Adam claimed a new building could provide for the Society. He described, in 1771, the Adam brothers' desire to see the Society "fixt somewhere, as we are strongly of opinion, that an Elegant and established Residence, would give to the Society a greater appearance of permanency and Eclat."[18] He continued, proposing that a house for that Society could be incorporated in their Adelphi project. The Adelphi, the Adam brothers' unprecedented, high-density urban development, is likely one of the more famous of the Adam brothers' projects, if only because of the anecdotes surrounding its financing. This speculative venture, begun in 1768, involved embanking a stretch of muddy land along the Thames. On this reclaimed land, they built a complex of wharves, warehouses, and vaulted arcades, with streets connecting the river to the Strand. This substructure was supported by an iron framework and covered with masonry.[19] On this foundation, and raised by it to the level of the Strand, were built four terraced streets of grand houses, residential and commercial.

The exteriors of the Adelphi houses were relatively plain, a few ornamented with low-relief pilasters. Those houses terminating the two outmost blocks carried pediments, producing the effect of wings to a central block.[20] This selective articulation of ornamentation subdued the distinction between individual buildings and emphasized the Adelphi's unified, palatial appearance. While conscious identification was made between the contemporary buildings and Classical palaces, it was not on military enterprise, but on an unseen foundation of commercial activity, independently functioning beneath the upper streets, invisible yet integral to the whole complex, that the stately buildings of the Adelphi rested.[21]

Referencing the *antique* as the precedent and model of their architecture served to imbue the Adams' designs, including their ornaments, with associations of the timeless rationality of the Classical past, a rationality which subordinated individual elements to the conception of the whole. Such apparent traditionalism masks the innovative nature and commercial sagacity of the Adam brothers' planning and building methods. Lady Elizabeth Montagu characterized the Adam brothers' organization as a "manufactory of virtu." This phrase, for all its pithy simplicity, sets up a telling contrast. While "virtu" could refer to objects of fine arts or to those interested in the arts, and allude to that classic civic ideal of disinterested virtue, "manufactory" speaks clearly of commercial interests.[22] The Adams were consummate in balancing these potentially contradictory elements. On the small plots of urban London, their designs accommodated the requirements of their clients' decorous lifestyles for the visibility of grand and commanding exteriors, and gracious and "agreeably varied" interiors, and the equally necessary invisibility of passages and routes providing "uncommon Convenience" to servants and employers alike.[23] Modern materials were not eschewed in their pursuit of this "antique," and notable manufacturers and nascent industrialists such as Josiah Wedgwood and Matthew Boulton—with whom

the brothers had discussed the possibility of constructing a showroom within the Adelphi—were involved in producing ornamental objects to the Adams' designs.[24] Such innovative elements were held under the tight control of the architects' design, treated, as at the Adelphi, as a unified, comprehensible whole. This control of design, production and materials encompassed the entire edifice and interior, from the major architectural structures, to the delicate internal ornamentation, including works of fine arts. As Robert Adam wrote, in a letter to Lord Kames in 1763, "Painting and sculpture depend more upon good architecture than one would imagine. They are the necessary accompaniments of the great style of architecture."[25] Rather than edifices, the Adams created environments.[26]

The Society of Arts' building was on the northern edge of the Adelphi complex. With its engaged columns, pediment, and large central window, it anchored the center of its block, its dissimilar exterior setting its building apart from the others surrounding it. The restrained style and the sturdy materials of the white stone entablature and columns, set deeply into, and emphasized by the yellow brick of the walls, presents an image of solidity and permanence. Equally, unlike the other houses in this complex, and somewhat incongruously given the architects' reputation for innovative decorative style, the rooms of the Society of Arts—one of their few "public" projects and one where a totalizing treatment of space could well be expected—carried little of that ornamentation which so defined other interiors of the Adam brothers.[27] Although so many of the Society of Arts awards were directed at the development of the ornamental arts, it was precisely ornamental detail that was stripped from the fabric of its building. Its hall and staircase were dressed only in Portland stone, "rubbed smooth."[28] There were, no doubt, practical (perhaps financial) explanations for this austerity. But austerity is not meanness. Although often described as the Society's house, the "Great Room" together with the rooms leading to it were not, strictly speaking, private or domestic spaces. They were extensions of the publicly visible exteriors, occurring in spaces whose purpose was to direct audiences' attention toward ideals of public service. In keeping, the ornaments of the Society's interiors were of a more ephemeral but purposeful nature. Walls which otherwise would have been filled with delicate plasterwork were hung instead with examples of award-winning works.[29] The other ornamentation, perhaps less recognizable but more important in the end, was provided by the Society's collected membership in action. As noted by the *Monthly Review* in 1760, the Society of Arts meetings "are exceedingly well attended, and it is pleasing to behold how laudable a zeal of every one endeavours to promote the public good."[30] The Society's building and its inhabitants projected an image of action and permanence—an institution whose energies were directed at permanently supporting a changing commerce.

How might we make sense of such apparent contradictions of appearances and activities, of permanence and progress? For Samuel Johnson, "the natural progress of the works of men is from rudeness to convenience, from convenience to elegance, and from elegance to nicety" or, from "elegance to luxury" as he worded it later in that same essay.[31] History takes on a material guise, measured by gradual refinement of goods, techniques, and manners. In this manner, Johnson summarized the condition of progress later detailed by Adam Smith in *Wealth of Nations*. There, Smith advocated an understanding of social progress as a conjunction of opulence and freedom, luxury and civilization, where civilization was to be measured by the interdependence of social individuals. From these perspectives, the changing requirements of luxury and ornament were necessary for maintaining civilized freedom, and were not the marks of its corruption.[32]

James Barry pictured a similar theme of historical progress in the six pictures painted for the Society of Arts between 1777 and 1784. He portrayed the "great maxim or moral truth, viz. That the obtaining of happiness as well individual as public, depends

upon cultivating the human faculties." Positioning the inception of human society within "man in a savage state," he pictured the development of civilized life "through several gradations of culture" from Greek civic society to contemporary Britain, composed in the faces of the Society, and culminating in a scene of "the State of the final Retribution" in *Elysium and Tartarus*.[33]

But Barry also claimed he had decorated "the Great Room of the Society with Paintings Analogous to the views of its institution"; he had, in other words, represented its ideal portrait.[34] Where most portrayals of groups represented a gathering of individuals each identified by particular characteristics, it was the Society of Arts' corporate identity and philosophy that was featured, i.e., the ideals of civilized progress that could be achieved by way of commerce. The image of the collective unit dominates, so that individuals are subsumed by their incorporation under the ideals of that assembly, and subordinated to the conceptual, almost mythical body of the whole. In this format, additions, subtractions, or substitutions of particular individuals did not much affect the total identity of the group portrayed. Similarly, the Society of Arts' overall concern with the nation's commercial strength can be seen as demonstrated by the collection of projects and supports displayed in its Repository, or more graphically represented in the engraving by Bailey, and not by the success or failure or quality of the individual projects. This collective conception of commercial interest works in a way akin to Barry's massing of figures. It deflects the changing associations with individual commercial ventures away from identifying the Society, which instead is defined by its general, constant actions of support.

This quality of predictability and stability was commented favorably upon by the reviewer for the *Public Advertiser* in 1784 when he described, in what sounds like a round of casual social calls, his visits to the exhibitions that season: "surfeited with Caps and Petticoats at the Royal Academy" he decided instead to take a "Peep . . . upon our old Friend Barry's Pictures." His choice of language emphasized the comfort to be found in the familiarity and permanence of Barry's paintings, a male bastion to which the reviewer returned to escape the caps and petticoats of feminine fashionable novelty.

Barry's scenes look like staged performances, the main figures compressed into shallow foregrounds. While an occasional figure is recognizable, most are known only through Barry's descriptions published in his *Account*. These pictorial spaces are not continuations of the "Great Room," and the position of the paintings just clear of the doors keeps them removed from the audience. Like a stage set, they locate the public performances of the Society's meetings within the grand narrative frame of "History," divested of particular events and individual actions. Barry's preference for the room to be painted in "grave modest colours in preference to white or other strong Colours," would have emphasized this stage-like quality, while simultaneously differentiating this space from other Adam interiors where strong colors and white predominated the color palette.[35]

Barry's seemingly "objective" representation of history presented a specific ordering, not of the past, but of the present in association with the Society's public activities. His history identified Commerce as a process of progressive refinement of civilized society, as well as an aspect within that same process. Mercury, as Commerce, is a pivotal figure in Barry's *Progress*, marking the move between ancient and contemporary society. Mercury—in the guise of Invention—is also more subtly introduced by the lyre Orpheus plays in the first picture to accompany his speech introducing barbarians to the ideals of civilization. But Mercury was also the trickster, who, in mythology, moves between heaven and hell. Barry's ambivalent view of the particulars of commerce is evident in his writing. Aside from Mercury, one of his few explicit references to commerce is in relation to the Nereids surrounding the figure of Thames. He described these female figures, who carry several articles of the manufactures of

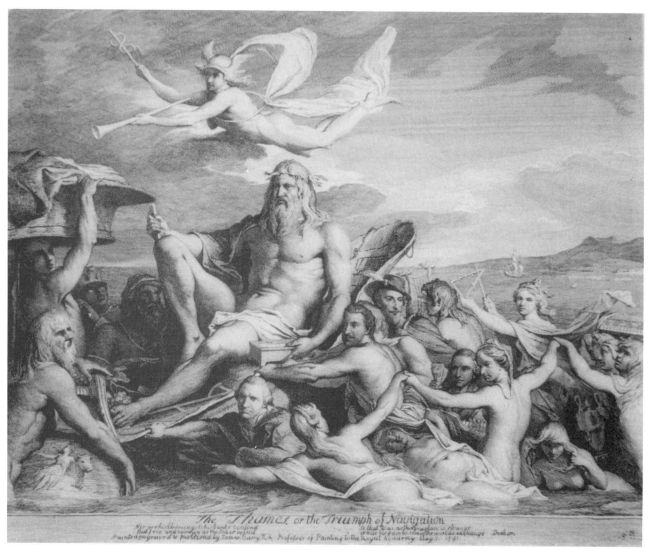

14. James Barry, *The Triumph of the Thames or Commerce*, engraving, 1792. Royal Society of Arts, London.

Manchester and Birmingham, as ranging from "more sportive than industrious, and others still more wanton than sportive."[36] As Barry's Nereids could as easily be industrious, sportive, or wanton, Mercury's presence signals the need for the vigilance and control of rational men who could refine Mercury's actions while maintaining a sufficient distance from his lures. Barry provided an abundance of exemplars, including among them the Society of Arts who, as a corporate institution, was positioned as a model refining force.

Two constructs of history are fused in Barry's picture of civilization. On one level, civilization is opposed to barbarity, as generality is opposed to particularity. In this sense, the sequence represents a continuity of past and present civilization, wherein the values which had originated its existence, pictured in Orpheus's song, are revitalized by each successive generation. On another level, civilization is shown to develop out of barbarity. In this second sense, history is represented as a linear development, which made the sequential relationship between the canvases meaningful as a progressive temporality. However, these two readings of a history of progress can result in two different readings of his paintings as they hang encircling the Society's "Great Room." For the continuation of progress achieved through the integration of history,

commerce, and civic virtue was not inevitable in Barry's images. If one follows his narrative through to its end, a cyclical progress is portrayed, the rise and decline and renewal of civilization. For within that room, Barry's progress can only circle back on itself, moving inevitably to civilization's decline into the barbarism of Tartarus. However, if we think of this room as a physical, social space, where members gathered to engage with the public ideals of the Society, but who in other places were concerned with pursuing their private commercial ventures, then we can begin to appreciate Barry's situating of his massive angels above the door. Here, in *Elysium and Tartarus*, as viewers turned to leave to reenter their commercial lives, they were presented with a choice, or perhaps a challenge, between acting for the benefit of society or of themselves.

To return to my central concern—the differentiation between the aesthetic and commercial arts. As I have pointed to, in the Society of Arts building and the events which occurred within its "Great Room," there was an enactment of polite society in a space that suggested commerce needed to be displayed differently. The tension between the polite and commercial is subsumed into an image of the polite enactment of philanthropic and disinterested support of commercial activities as separate from the actual inventions and improvements relegated downstairs to the Repository, or hung unused as ornaments on its walls. Yet, this segregated polite space was set in a narrative space—of the building, its hierarchy of rooms, and Barry's paintings—which located the polite arts in a spectrum with commerce. While particular commercial activities were segregated in the Society's public self-presentation, these were in actuality its bedrock, for most members were industrialists, manufacturers, and men of business, and their membership contributions financed the Society's philanthropy. It is perhaps fortuitous that the Society's building in the Adelphi was so matched to this dual situation, incorporated into a building which projected an image of timeless classical nobility, and yet rested on foundations of modern business practice and unseen commercial movement. The tension between these elements reentered in Barry's final painting, *Elysium and Tartarus*. There, critically situated above the door, Barry presented viewers with a choice between salvation and damnation, articulated as a choice between the pursuit of commercial goals guided by the progressive ideals of collective integration as portrayed in *Elysium* to the left of the door, or to remain within the spaces of detached observation emphasized by the enclosed space of the "Great Room."

NOTES

1. [John Gwynn], *An Essay on Design: Including Proposals for Erecting a Public Academy To be Supported by Voluntary Subscription (Till a Royal Foundation can be obtain'd) For Educating the British Youth in Drawing, And the Several Arts depending thereon* (London: n.p., 1749), 26–27.

2. Martin Archer Shee, *Rhymes on Art; or, The Remonstrance or The Painter in Two Parts. With Notes and a Preface, including Strictures on the State of the Arts, Criticism, Patronage and Public Taste* (London: Murray, 1805), xix. Shee's argument is contained principally in his footnotes and preface.

3. I draw on the thinking of Henri Lefebvre, Michel deCerteau, and Thomas Markus in my investigation of social spaces. See particularly Henri Lefebvre, *The Production of space*, trans. Donald Nicholson-Smith (Oxford: Blackwell, 1998); Michel deCerteau, *The Practice of Everyday Life*, trans. Steven Rendall (Berkeley: University of California Press, 1984); and Thomas A. Markus, *Buildings and Power: Freedom and Control of the Origin of Modern Building Types* (London: Routledge, 1993).

4. Financing was provided through the subscriptions paid by the elected membership.

5. [Mortimer], *An Account of the Rise, Progress and Present State of the Society* (London: n.p., 1763), 11.

6. R. Ackermann, A. C. Pugin, and T. Rowlandson, *Microcosm of London*, 3 vols. (London: R. Ackerman, 1808–10), vol.3, 49.

7. RSA, Minutes relating to the Adam Building, 7, 11 December 1771. This arrangement of seating, and

the color of green selected, is similar to the description given by Louis Simond of the House of Commons, described in his *Journal of a Tour and Residences in Great Britain during the Years 1810 and 1811*, 2 vols. (Edinburgh: Constable, 1817), vol. 1, 68.

8. In 1784, when the Society of Arts moved back into its "Great Room," after the completion of Barry's paintings, Mr. Adam was again called upon to make a plan for the benches, and a Mr. Wilson was asked to execute their building, in beech with leather cushions; RSA, Minutes of Committee of Miscellaneous Matters, May 5, May 18, May 24, May 26, 1784.

9. Clare Williams, *Sophie in London* (London: Jonathan Cape, 1933), 141–42 and 103–10.

10. Pierre-Jean Grosley, *A Tour to London, or, New Observations on England, and its Inhabitants*, trans. Thomas Nugent, 2 vols. (London: n.p., 1772), vol. 2, 18. Similarly when *The Critical Review* in its commentary of Robert Dossie's *Memoirs of Agriculture* reported that "it has been alleged that [the Society of Arts] repository is the gulf which receives all improvements, and from which they seldom return . . . and [the Society's] enormous expenses often squandered without a proportional object"—a criticism aimed solely at the authors of the improvements and not at the Society that supported them. Review of "Memoirs of Agriculture, and other oeconomical Arts" by Robert Dossie, *The Critical Review; or Annals of Literature* (London: n.p., 1783), 104.

11. RSA, Minutes of Committee of Miscellaneous Matters, November 6, 1784 and November 22, 1784. Robert Adam designed the doors.

12. Alongside these public rooms of the Society's house was the area where the Secretary's house was built as a separate residence.

13. The criteria of "utility" was evidently central in deciding on the displays in the Repository, and the "lower Vault by the side of the great Arch from which it has an Entrance, may be appropriated to the Reception of such Machines as seem to be of the least Utility;" RSA, Minutes of House Committee and Committee of Polite Arts, March 23, 1774.

14. Robert Adam, Architectural Drawings, Society of Arts, vol. 32, nos. 14 and 15, Sir John Soane's Museum, London.

15. These alterations were made at the behest of the Society: "Resolved that it be considered . . . whether it will not be expedient to enlarge the "Great Room" and Area and such part of the Registers office and Anteroom as are equal in Breadth to them." RSA, Minutes relating to the Adam building, Ms copy of Minutes and Manuscript Correspondence, January 26, 1772.

16. Thomas Sheraton, *The Cabinet-Maker and Upholsterer's Drawing Book* (London: n.p., 1793), 12.

17. RSA, Letters from Barry since 1798, Letter no. 4, March 31, 1801.

18. Letter from James Adam to the Secretary of the Society, November 5, 1771.

19. Percy Fitzgerald, *Robert Adam, Artist and Architect: His Work and His System* (London: T. Fisher Unwin, 1904), 56.

20. Horace Walpole commented that the pilasters of the Adelphi reminded him of "warehouses laced down the seams, like a trull in a soldier's old coat," Fitzgerald, *Robert Adams*, 53.

21. In Robert Adam, *Works in Architecture* (1779, reprinted 1901), vol. 3, notes to plates, Robert Adam notes that the design of the Adelphi was "so contrived as to keep the Access to the Houses, level with the Strand, and distinct from the Traffic of the Wharfs and Warehouses." Initially, the Adelphi project had been financed on an expectation of leasing these subterranean spaces to the Government Ordnance, an expectation that was not, in the end, realized.

22. The *Oxford English Dictionary* defines "Virtu" or "Vertu" as either: "a love or taste for or interest in works of art or curios"; or as "an object or article such as virtuosos are interested in, a curio, antique or other product of the fine arts," a meaning that slides from a definition of the consumer of the polite arts, to one of its produced objects.

23. "It may be satisfactory to say, that they [the houses in the Adelphi] are remarkably strong and substantial, and finished in the most elegant and complete Manner, much beyond the common Stile of London houses; they have all a double Tier of Offices, which gives an uncommon Convenience to the Servants of the Family." *Particulars Composing the Prizes in the Adelphi Lottery* (London, 18 January 1774), 5. See also: Adam, *Works*, vol. 1, 3rd preface.

24. Joseph and Anne Rykwert, *The Brothers Adam: The Men and the Style* (London: Collins, 1985), 101.

25. Letter from Robert Adam to Lord Kames, March 31, 1763, as quoted in Albert Boime, *Art in the Age of Revolution 1750–1800* (Chicago: University of Chicago Press, 1987), 98.

26. Interestingly, this dual identification is in part due to the corporate nature of the Adam brothers enterprise, for while Robert Adam is generally credited with most of the major architectural designs and is identified as the "architect," James and William Adam are most regularly identified with their business affairs.

27. Other public buildings designed by the Adams were ornamented, see for example, "Lloyd's Coffee House, London. Design for the Interior, 1772" (Sir John Soane Museum), in Damie Stillman, *The Decorative Work of Robert Adam* (London: Tiranti, 1973), pl. 40.

28. D. G. C. Allan, *The Houses of the Royal Society of Arts: A History and a Guide* (London: The Royal Society of Arts, 1966), 14.

29. RSA, Minutes of House Committee and Committee of Polite Arts, April 18, 1774. The Minutes record it resolved that "a sufficient number of Hooks and Screws be provided for the hanging such Machines and Instruments to be disposed against the Walls of the several Rooms."

30. "London and its Environs Described," *The Monthly Review, or, Literary Journal* 23 (1760): 431, 433.

31. Samuel Johnson, *The Idler*, no. 63, 30 June 1759, in *The Yale Edition of the Works of Samuel Johnson* (New Haven: Yale University Press, 1965), vol. 2, 196.

32. For Smith, interdependence was not to be taken as nonhierarchical, for Smith did not equate interdependence with social equality.

33. James Barry, *An Account of a Series of Pictures in the "Great Room" of the Society of Arts, Manufactures and Commerce, at the Adelphi* (London: printed for author, 1783), 40–41.

34. RSA, "Extracts relating to the Pictures painting by James Barry, Esq. in the "Great Room" March 14/March 5, 1777, n.p."

35. RSA, Minutes of Committee of Miscellaneous Matters, July 13, 1787.

36. Barry, *Account*, 60–61.

The Olympic Victors: The Third Painting in James Barry's Series, *The Progress of Human Culture and Knowledge*

David G. C. Allan

BY ITS ESTABLISHMENT IN 1774, IN A BUILDING DESIGNED BY THE MOST FASHIONABLE architect of the day, and by sponsoring the adornment of its meeting room in 1777 with the epic works of a much talked of practitioner of "High Art," the Society for the encouragement of Arts, Manufactures and Commerce was able to ensure a further period of active public and official interest in the work which it began at a Covent Garden coffee house some quarter of a century before. Both Adam and Barry were to go out of fashion in the nineteenth century and there were to be a number of occasions when the Society of Arts would give serious consideration to moving away from the Adelphi. Had such a move taken place the house would almost certainly have been demolished and the paintings, if preserved at all, would most likely have been consigned to the cellars of a reluctant museum.

The taste for Adam was in full revival by the beginning of the last century and in 1922 the *Royal* Society of Arts,[1] as it had by then become, was so attached to its Adelphi premises that it rejected the idea of moving as "unthinkable" and made a considerable financial exertion to buy the freehold of the building. When the central terrace of the Adelphi was demolished in 1936 the Society's determination to preserve its house was intensified and in 1957 it obtained possession of another surviving fragment of the Adelphi. The reappraisal of Barry's work took longer to develop and as late as 1915 the Society gave away the *Temptation of Adam* to the National Gallery of Ireland. However by the 1940s Thomas Bodkin had secured recognition of its significance in art history and this was confirmed in later scholarly studies by R. R. Wark, David Irwin, David Solkin, and of course, William L. Pressly.[2]

The writer of this paper has been fortunate to have had repeated access to Barry's paintings for the Society for a period of over fifty years, to have seen them in winter and in summertime, by daylight and various forms of artificial light, and to have had readily available a historic library and archive collection, in which the artist's own printed works and manuscript are carefully preserved. The paintings themselves, and Barry's not always consistent writings upon them, reveal his vision of the human predicament and the struggle he had with his persecution mania. Barry has bequeathed us an extraordinary work into which a great visual relic and some literary fragments invite us to linger and once there we find ourselves held within its spell. As Johnson put it: "Whatever the hand may have done, the mind has done its part. There is a grasp of mind you will find nowhere else."[3] My favorite has always been the third picture, *The Crowning of the Victors at Olympia*, which is the culmination of the first part of Barry's cycle.

It should be remembered that until 1863 this painting remained the focus of the

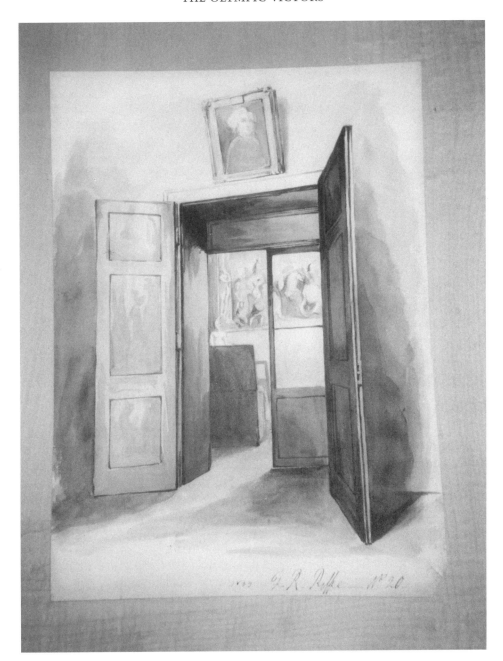

15. F.R. Roffe, *Entrance to the Society's "Great Room,"* watercolor, 1839. Royal Society of Arts, London.

room. Beneath it was no west/east raking of the floor as there is today. Even now the painting still dominates the view of those entering the "Great Room" from the main landing. The effect it would have had in earlier times can be gauged from Roffe's watercolor sketch of 1839 and from the often reproduced views by Taylor (1804) and Rowlandson (1809). Below the middle panel was a dais for the President's Chair, and facing this and on either side were benches for members attending the Society's meetings. The paintings had not been raised to the frieze and of course the floor was on the level of the landing.[4]

The story of the Olympic Games was much in Barry's mind when he began his paintings for the Society. While working on the first picture, *Orpheus reclaiming mankind from a savage state*, in April 1777 he was thinking of following it directly

16. Isaac Taylor, *"Great Room" of the Society of Arts*, detail from engraving, 1804

with what was to be the main theme of the third painting, the moment at the Olympic games when the Hellanodices are distributing the rewards. After this he thought he would paint two more pictures with Olympic subjects: *The contest and matching of the competitors* and *Prodicus reading to the assembly his performance of the choice of Hercules, Aetion the painter and a number of other ingenious men, producing their several performances*.[5] The pictures were not painted though their subjects were hinted at by Barry in his second and third painting.

In his second picture Barry illustrated what he called "a state of happiness simplicity and fecundity," through the details of farm work which appear in the middle distance of the painting. He calls it a state "in which the duty we owe to God, to our neighbour and ourselves, is much better attended to in this, than in any other stage of our progress; [yet] . . . it is but a stage of our progress, at which we cannot stop." The marriage procession coming from the temple, and the temple itself foreshadows the view in the next picture of the temple of Jupiter and a sacrificial procession. They are a reminder that this Italianate scene is a *Grecian Harvest Home*. The "group of contending figures in the middle distance" was deliberately introduced by Barry in order to lead us on to thinking about the Classical stage of civilization. The man with the discus under his arm has features which clearly recall the Apollo Belvedere and there are points of resemblance to be found throughout the paintings with other great specimens of antique sculpture. Barry mentions "the Laocoon, the Gladiator, the Apollo, the Venus" as examples he thought especially memorable.

Barry believed that art had reached an unsurpassed peak in the sculpture of ancient Greece and that a painter should give his work the quality of living sculpture. The third picture, *The Crowning of the Victors at Olympia*, illustrates the development of this idea. The group of the Diagorides, he thought, could be realized in a sculpture copied from his painting. In the procession of victorious athletes a resemblance to the Parthenon frieze can be discerned, and Barry had come to know the frieze when he had worked for "Athenian" Stuart. The influence of the frieze is well illustrated in

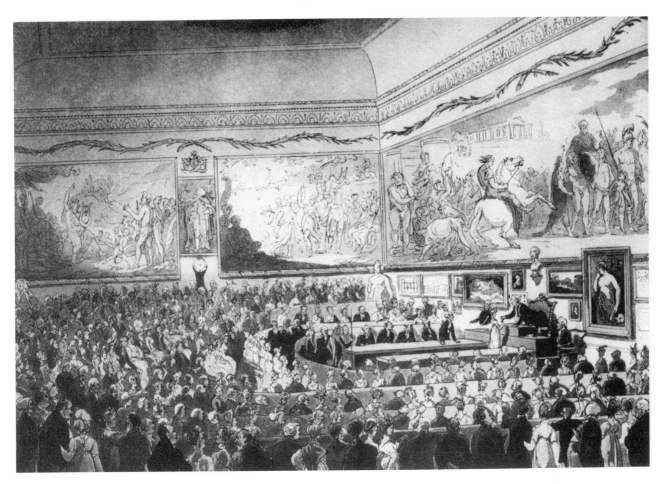

17. **A. C. Pugin and T. Rowlandson,** *The "Great Room" of the Society of Arts,* aquatint, 1809. Royal Society of Arts, London.

a small preliminary sketch which has fortunately been preserved in the Victoria and Albert Museum. The horse racer and his steed, which appear in both, made a strong impression on Susan Burney when she was shown the near completed picture, "the Greek youth who appears just receiving a very fine horse," she recorded in her *Journal.*[6] Here the effect of the frieze is strongly marked and the appearance of the armed footracer is actually more Classical in the sketch than in the painting. The picture illustrates, wrote Barry, "the point of time when the Victors in the several games pass in procession before Hellanodicks or Judges, where they are crowned with olive in the presence of all the Grecians."[7] Barry took great care in his reconstruction of the ceremony, following Gilbert West's "Dissertation on the Olympic Games," to which he refers the reader in his 1783 *Account.* According to West, it was probable "that the Hellanodices, in the public execution of their office were clothed in Purple Robes and carried in their hands that usual Ensign of Magistracy a Wand or Sceptre." Similarly West wrote of the ceremony of crowning:

> It was performed (as far as I have been able to collect from several passages scattered up and down in ancient authors) in the following manner; the conquerors, being summoned by proclamation, marched in order to the tribunal of the Hellanodicks, where a herald taking the crowns of olive from the table, placed one upon the head of each of the conquerors; and giving into their hands branches of palm, led them . . . along the stadium, preceded by trumpets, proclaiming at the same time with a loud voice of their names, the names of their fathers, and their countries; and specifying the particular exercise in which each of them had gained the victory.

Barry presents the ceremony in much the same manner. The victors are proceeding toward the tribunal shown in the right-hand panel and the trumpeters are in the left-hand panel behind the chorus led by Pindar. The footracer, like the other competitors, wears a light scarf, noted by West as having been worn in the earlier Olympiads, and has "short buskins" upon his feet, and the victor at the cestus wears the special straps West described as "brought over the fingers and fastened upon the wrists." Barry duly includes a "foot racer who ran armed" among his victorious athletes, West having recorded that "in the 65th Olympiad the race of armed men was added." West described the palm branches, which were to be presented to the victors, as being "laid upon a tripod or table," but in the painting the palm branches are on the ground though the 1791 etching shows them on the table Barry shows the procession coming through the hippodrome or area reserved for horse and chariot races, hence the large column behind Hiero's chariot inscribed with the word ARISTEVE ("Strive") which West noted as present in the Constantinople Hippodrome, and for which Barry gives no explanation in his own *Account*.

Recent cleaning of the painting makes it easier to see the trumpeter and charioteer coming up behind Hiero (whose Neronic robes now glitter) as well as the figure sitting on the edge of the stadium in the manner of Michelangelo's *Lorenzo de Medici*. The Temple of Jupiter Olympus and the Altis, which appears in the background of the painting, were reconstructed by Barry with great care as may be seen from West's quotation from Pausanias's *Description of Greece*. Pausanias wrote that "the Temple of Jupiter was built in the Doric order," and was surrounded on the outside with colonnade. "The whole Edifice" was made of "a beautiful sort of marble found in that country. On each corner of the roof is placed a gilded vase, and on the top of the pediment a statue of victory, gilded likewise."[8] All these details can now be seen in the painting. The religious procession approaching the Temple in the background of the middle panel has also become clearer, as has the interesting group of three figures just below the Temple on the edge of the stadium. In this group an artist or writer, perhaps Aetion or Prodicus, appears to be sharing his work with a companion, next to whom there is a standing figure, possibly the artist's model, looking over the edge of the altis toward the procession.

In his 1793 *Letter to the Society of Arts* Barry wrote of the

> two statues of Minerva and Hercules, the temple of Jupiter in the altis, and the procession approaching the altar, [as bringing] . . . the mind naturally to the contemplation of those numberless blessings which society derives and can only derive from the exercise of religious worship. The Greeks, the most belligerent of all people, who were divided into so many distinct polities, with such rivalships, strife, and animosities, to embitter and to increase their estrangement from each other, were, notwithstanding, from the influence of religion, obliged every four years to lay aside all manner of hostility, and declare a general armistice or truce for the peaceful, fraternal celebration of those sacred games.

In another comment on the picture written in 1798, when Europe had suffered six years of war, Barry hoped that the Papal States in Italy might become an area of equivalent neutrality for the nations of his time.[9] The neutral city of Elis and river Alpheus in the middle distance of the right-hand panel of the picture is more or less discernible and we can speculate on the identity of the mysterious figures standing to the right of Hippocrates as well as of those shaded faces adjoining the judges' tribunal. Barry had said he wanted to include portraits of Sir George Savile and Lord Camden among the Hellanodicae, but they do not seem to be present there though Sir George is to be seen in the fifth picture in his capacity as vice-president of the Society of Arts.[10] Unable to find a bust of Pericles he gave his version of the great Athenian the features of Pitt the Elder. Between Socrates and his disciple in the middle panel there appears the head of

an unnamed philosopher, and Barry does not identify the stooping figure next to Pindar and his accompanying choir. It has been suggested that this is Callipateira, daughter of Diagoras, who went to the games disguised as her son's trainer, and that Barry illustrates the dramatic moment when, overcome with joy at her family's triumph, she stoops to gather flowers and reveals that she is a woman and therefore liable to be punished by death.[11]

Barry tells us that he painted the statues of Hercules and Minerva at either end of the painting as "comprehensive examples of that strength of body and strength of mind which were the two great objects of Grecian education." The Hercules "treading down envy" and his self-portrait as Timanthes sitting at its base are the first hints we are given of the artist's persecution mania which caused him so much unhappiness and yet stimulated him to so much richness of invention. "As to the Hercules treading down Envy," he wrote,

> Horace observes, that this was Hercules' last labour, and cost his life before it could be effected; by-the-bye, it is no doubt a good and wise distribution, that envy should continually haunt and persecute the greatest characters; though for the time, it may give them uneasiness yet it tends on the one hand to make them more perfect, by obliging them to weed out whatever may be faulty, and occasions them on the other, to keep their good qualities in that state of continued unrelaxed exertion, from which the world derives greater benefit, and themselves in the end, still greater glory. On the basement of this statue of Hercules, sits Timanthes the painter with his picture which is mentioned by Pliny, etc. of the Cyclops and Satyr; as there is no portrait of Timanthes remaining, (from a vanity not uncommon amongst artists) I shall take the liberty of supplying him with my own.

Barry was influenced by a passage in Horace's *Epistles:* "He who crushed the fell Hydra and laid low with fated toil the monsters of story, found that envy is quelled only by death that comes at last." To balance the Hercules he placed a statue of Minerva at the other end of the painting, thus copying Raphael's example in the *School of Athens.*[12]

Beyond the general indebtedness to Raphael there is little to connect the third picture with the fourth. Modern commerce represented another stage of progress and contained elements, such as the weeping Negro and the wanton nereids, which were uncongenial to the artist and had presumably been absent from the previous peak of civilization attained at Olympia. Nonetheless Father Thames is dragged through the waters by heroic navigators and the musical attributes of the sea nymphs echo the trumpeters following Pindar. The fifth picture, *The Distribution of Premiums in the Society of Arts*, is also concerned with Barry's "modern times," but its links with the *Victors at Olympia* are self-evident. Merit is being rewarded in the presence of the modern worthies. Both old and young can qualify for rewards and we notice the young girl's medal is attached to a blue ribbon reflecting that worn by the youngest of the Diagorides. Finally at the end of time as seen in the sixth painting, *Elysium or the state of final retribution*, the great and good of all ages crowd a canvas which faces, and is of the same size as, the *Crowning of the Victors*. Here it is Divine Providence which awards the palm and we notice winged cherubim showering the mortals with flowers, an image which was foreshadowed by the applauding spectators at *Olympia*. Lycurgus, prominently painted here among the "Legislators" had been anticipated in his medallion on the Olympian throne. Plato stares across at his disciples, only one of whom (Socrates) appears next to him in this picture, though we have little doubt that the other Olympians have also, in Barry's mind, received their invitations to paradise. Thus Barry's cycle, at first sight seemingly disjointed and disparate, is united both visually and iconographically by these two great canvases. The darkened right edge of no. 6 (*Elysium*) prepares us for the savage world of no. 1. (*Orpheus*), to be redeemed by Orpheus and thus the story is renewed.[13]

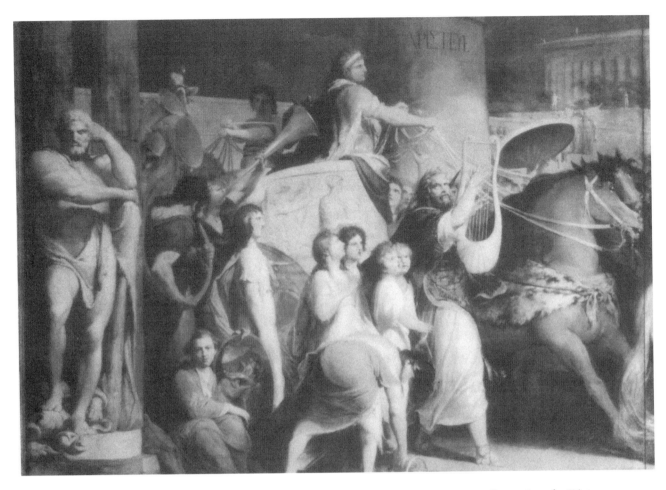

18. James Barry, *Crowning the Victors at Olympia*, left-hand panel, 1777–84. Royal Society of Arts, London.

KEY TO THE LEFT PANEL

Figures named by Barry
1. Pindar
2. Hiero of Syracruse
3. Timanthes the Painter

Other figures
A1 Tambourine player
A2-4 Spectators behind Pindar
B1-5 Choristers
C1 Figure bending to pick up flower possibly Callipteira
C2-3 Trumpeters
D1 Charioteer following Hiero
D2-3 Figures on edge of stadium

Adjuncts to the painting named by Barry
I The Stadium
II The Altis with statues of the Victors
III The Temple of Jupiter Olympus
IV Chariot ornamented with bas-relief of the contest between Neptune and Minerva for the naming and patronage of Athens
V Picture of the Cyclops and Satyrs
VI Statue of Hercules 'treading down envy'

Other adjuncts
Pillar around which the races were run inscribed with the word 'Aristeve', Strive
(ii) Basket of flowers

19. **Key to left-hand panel**

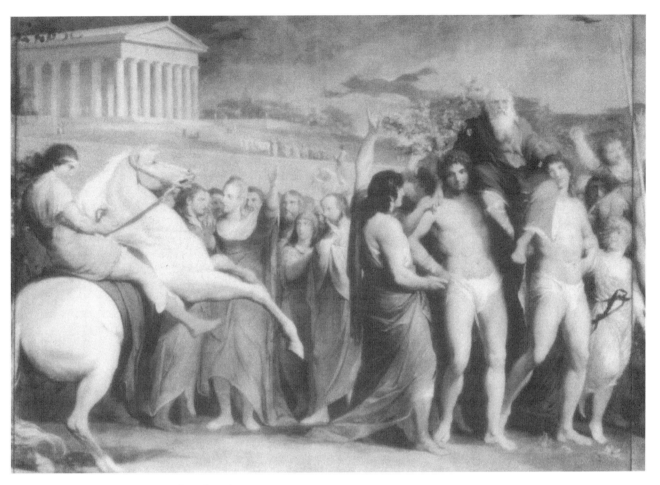

20. James Barry, *Crowning the Victors at Olympia*, middle panel, 1777–84. Royal Society of Arts, London.

21. Key to middle panel.

KEY TO MIDDLE PANEL

Figures named by Barry

1. The Pancratiast
2. Diagoras of Rhodes
3. The Boxer
4. A Spartan
5. Socrates
6. Anaxagoras
7. Aristophanes
8. Pericles
9. Euripedes
10. Cimon

Other figures

A1 Young Victor
A2 Applauding child
A3 Onlooker
B1 Disciple of Socrates
B2 Unnamed philosopher
B3 Horse racer
C1 Artist at work on edge of the stadium
C2 Procession with sacrifical bull advancing towards an altar

Adjuncts to the painting named by Barry

I The Stadium
II The Altis with statues of the Victors
III The Temple of Juipter Olympus
IV The Horse

Other adjuncts

r (i) Flowers

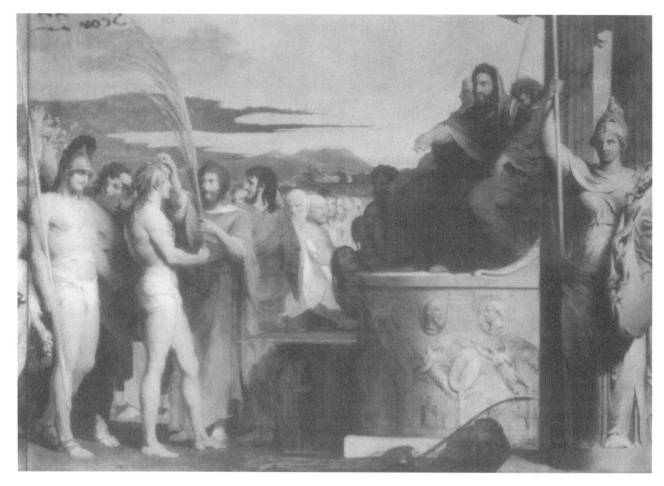

22. James Barry, *Crowning the Victors at Olympia*, right-hand panel, 1777–84. Royal Society of Arts, London.

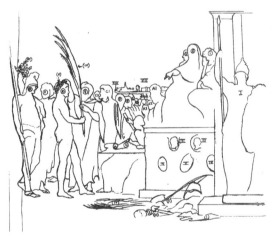

KEY TO THE RIGHT PANEL

Figures named by Barry
1, 2, 3 Hellanodicae (Judges) No.2 'Declaring the Olympiad
4. Scribe
5. Hippocrates
6. Herodotus, with his history of Greece in his hand
7. Democritus
8. 'One in white' [Philolaus]
9. Inferior Hellanodick
10. Footracer
11. Bandaged Competitor
12. Armed Footracer

Other figures
A1-3 Figures adjoining the judges throne
B1-3 Figures to the right of Hippocrates
C1 2nd inferior Hellanodick
C2 Figures looking over the shoulder of the first Hellanodick

Adjuncts to the painting named by Barry
I Statue of Minerva with rim of Serpents round the Aegis
II Medallion of Lycurgus

III Medallion of Solon
IV Trophy of Salamis
V Trophy of Thermoplyae
VI Trophy of Marathon
VII Town of Elis
VIII River Alpehus

Other adjuncts
(i) Hat and robes
(ii) Bow and helmet
(iii) Staff with clay jar
(iv) Palms
(v) Crown of laurels
(vi) Flowers

23. Key to right-hand panel.

Notes

1. The Society was granted the right to use the prefix "Royal" in 1908.

2. See my article, "The Progress of Human Culture and Knowledge," *The Connoisseur* 186 (1974): 100 and "Barry's Adelphi Cycle Revisited," in *Proceedings of the International Conference in Cork and London*, February 2006.

3. G. Birkbeck Hill and L. F. Powell, eds., *Boswell's Life of Johnson* (London: Printed by H. Baldwin and son for Charles Dilly, 1934), IV, 224. See also D G C Allan, "Barry and Johnson," *Journal of RSA*, 133 (1985): 628–32.

4. D. G. C. Allan, *The Houses of the Royal Society of Arts* (London: RSA, 1974): 17–21.

5. James Barry to Sir George Savile, 19 April 1777, printed in E. Fryer ed, *The Works of James Barry* (London: T. Cadell and W. Davies, 1809), II, 255.

6. British Library, Egerton Manuscript, 3691, f19.

7. James Barry, *An Account of a series of Pictures in the "Great Room" of the Society of Arts, Manufactures and Commerce in the Adelphi* (London: Printed for author, 1783), 31, 47–49.

8. Ibid., 50; Gilbert West, *Odes of Pindar*, 2nd ed (London: R. Dodsley, 1753), 15–16, 66, 90–91, 115, 174.

9. James Barry, *A Letter to the Society for the encouragement of Arts, Manufactures and Commerce* (London: The author, 1793), 31; *A Letter to the Dilettanti Society* (London: J. Walker, 1798), 28.

10. James Barry to the Earl of Chatham, 27 December 1777 quoted in W. L. Pressly, *The Life and Art of James Barry.* (New Haven: Paul Mellon Centre for British Art by Yale University Press, 1981), 98.

11. See H. T. Peck, *Harpers Dictionary of Classical Antiquities* (New York: Harper and Brothers, 1898), "Calipateira." I am indebted to Peter Murray, Director of the Crawford Gallery for this suggestion.

12. James Barry, *Account*, 56–57; R R Wark, "The Iconography and Date of James Barry's Self Portrait in Dublin," *Burlington Magazine* 94 (1954): 153; H. R. Fairclough, trans., *Horace Epistles* (New York: Heinemann, Putnam, 1926), Book II, Epistle 1, ll.10–14.

13. See the keys in my edition of Barry's *Description* (2005).

Elysium's Elite: Barry's Continuing Meditations on the Society of Arts Murals

William L. Pressly

JAMES BARRY'S SERIES ON THE PROGRESS OF HUMAN CULTURE FORM ONE OF THE MOST important historical cycles in Great Britain. The artist embarked on these works in 1777; he first exhibited them in 1783 and again in 1784; but throughout the remainder of his career, he was repeatedly to return to these works, sometimes retouching the canvases themselves, but more often issuing prints after them. Indeed, over a third of his considerable production as a printmaker was devoted to reproducing this series in whole or in part. Initially he published a set of seven prints, reproducing with variations each of the six murals along with a seventh plate showing the pictures of King George and Queen Charlotte with which he had hoped to replace the existing portraits of the former and current presidents of the Society by Reynolds and Gainsborough. Soon after issuing this set, Barry published a large detail of a portion of *Elysium*, replacing William Penn with Lord Baltimore as "the first Colonizer who established equal laws of Religious & Civil Liberty [in America]."[1] This large detail was eventually followed by six more. These fourteen works, the original set of seven and the seven large details, compose Barry's public record in prints of his monumental cycle at the Society of Arts. The large details allowed him to emphasize or refine his ideas on what was appropriate for inclusion in his series.

Even the creation of fourteen prints proved insufficient to satisfy the artist's need continually to tinker with this his greatest achievement. At one point late in his career, he executed another print of those scientists and philosophers in the lower left-hand corner of *Elysium*,[2] an area he had already treated in one of his large details. There are three principal figures. To the left sits the Greek philosopher and scientist Thales, a heroic nude with Barry's own features, who points to his scroll showing diagrams displaying the derivation of eclipses, the tropical and polar divisions of the earth, and how to tell the height of the pyramids by means of their shadows. Seated next to him, with compass in hand, is Descartes, the only figure to look out at the viewer. In the lower right corner sprawls the Franciscan Roger Bacon, opening his book *Opus Majus*. I interpret the dark void beneath Thales as the mouth of a cave, a reference to Plato's allegory of mankind's arduous and dangerous ascent from enchained darkness into the light of truth.

Barry, however, does not seem to have considered this image as forming a part of the more public series of fourteen prints. With its square format, it differs in size and shape; it contains no space for a caption as do the other works reproducing the Society's pictures; and the nick in the left-hand edge of the plate (the right side of the print itself) suggests he chose from the beginning a scrap of copper more suitable for a personal performance than an official one. This print was also not included in the

24. James Barry, *Lord Baltimore and the Group of Legislators*, 1793. Etching and engraving.
© Copyright the Trustees of The British Museum.

25. James Barry, *Scientists and Philosophers*, etching and engraving, c. 1800–1805. Royal Society of Arts, London.

posthumous publication of the 1808 book *A Series of Etchings by James Barry, Esq. from his Original and Justly Celebrated Paintings, in the Great Room of the Society of Arts, Manufactures, and Commerce, Adelphi*, which contains the other fourteen works. In addition, today only two impressions are known, both of which are posthumous, made by the Society when it had possession of the plate. Presumably there never were many impressions. Indeed, the print came close to vanishing without a trace.

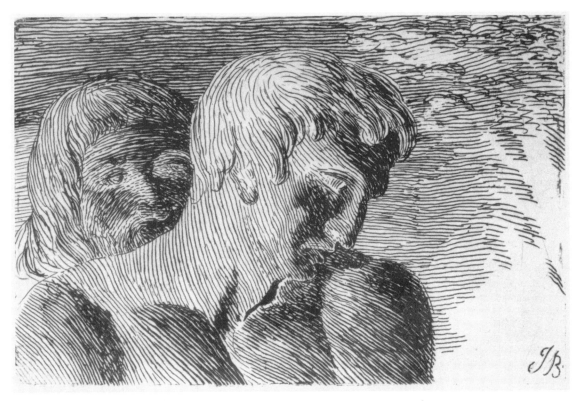

26. **James Barry, Two of Elysium's** *Pensive Sages*, **etching and engraving, c. 1800. Collection of W. L. Pressly.**

TWO NEW PRINTS

Two previously unrecorded prints, the discovery of the print dealer Christopher Mendez, have recently reemerged. There were probably few impressions of these works as well: only two impressions are now known of the first and only one of the latter. They also are Barry's smallest prints: one measures 3 $^3/_{16}$ × 4 $^7/_8$ inches, while the other is only 2 ½ × 3 ½ inches. Both images depict the type of brooding philosophers encountered in Barry's *Elysium*. Yet unlike *Scientists and Philosophers*, neither reproduces a particular section of the composition of *Elysium*. Rather each is a variation on the theme of its meditating geniuses. I have given the larger work, to which the artist fixed his initials, the title *Two of Elysium's Pensive Sages* and the smaller the title *Blessed Exegesis*.

In *Pensive Sages*, the bare shoulders of the foremost figure suggest a heroic nude, but while none of the inhabitants in the painting of *Elysium* are similarly disrobed, his nudity is not unlike that of the figure of Thales in *Scientists and Philosophers*. The figure at the left peering over his companion's shoulder is reminiscent of one of Barry's late self-portraits. In addition, the placement is similar to that of an earlier self-portrait, where in his print *The Phœnix, or The Resurrection of Freedom* the artist stands at the far right in a group of the illustrious dead looking over the shoulder of Andrew Marvell. In both works, he is a modest presence, but a presence nonetheless, and in *Pensive Sages* the foremost philosopher with inclined head contemplates for eternity the artist's own initials.

On the left side of *Blessed Exegesis*, a bearded philosopher, wearing what is surely a monk's cowl, ponders an open book, the upper right-hand corner of which is held

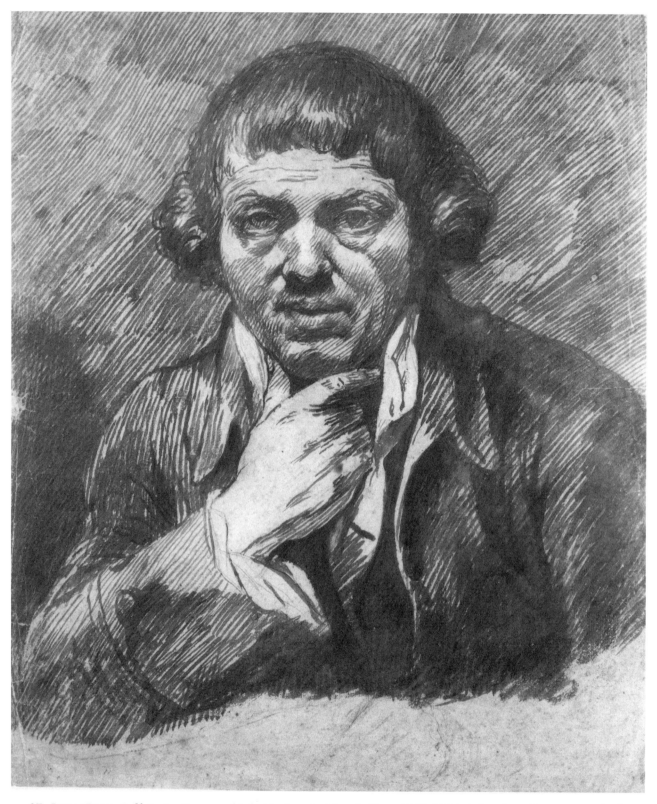

27. James Barry, *Self-Portrait*, pen and ink, black and white chalk, c. 1800–1805. Ashmolean Museum, Oxford.

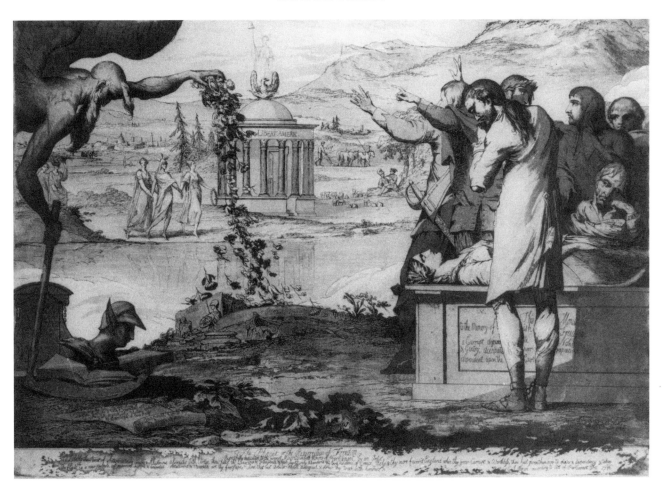

28. James Barry, *The Phoenix or the Resurrection of Freedom*, etching and aquatint, 1776. Yale Center for British Art, Paul Mellon Fund, New Haven.

firmly by his right hand. He closely resembles Barry's other portrayals of Roger Bacon, particularly as visualized in the lower right corner of *Reserved Knowledge*, one of the large engraved details of *Elysium*, but perhaps in this instance a specific identification is not the artist's intent.

On the right side are young, beardless soldiers. The principal helmeted figures in Barry's *Elysium* are the Angelic Guards, and, like other angels in the larger composition, these figures instruct: the mouth of the one in profile at the far right is opened as if in the act of speaking, while one of the two raises an expository finger. It is a tightly compressed image, made all the denser by the print's small size.

While the prints are similar in their size and subjects and are printed on the same paper, they differ substantially in technique. *Pensive Sages* is an essay in pure etching. The parallel lines describing the foreground figure are spaced at regular intervals with the contrasting patterns of light and dark achieved through successive stages of biting as the lines thicken considerably in the dark passages. It is an etched version of the contrasting dark fat lines and lighter thin ones that animate the expressive diagonal hatching of the self-portrait, the nib of the pen achieving in the latter case what successive bitings had accomplished in the former.

The principal figure occupies the etching's center. His hair organically flows over his head, with his ear becoming one more curly lock rather than a separate entity. Parallel hatching continues through his head and upper torso with some areas so

29. James Barry, *Blessed Exegesis*, etching and engraving, c. 1800. Collection of W. L. Pressly.

heavily etched that the lines run together. Defining the Adam's apple is a dark patch that recalls the aggressive scoring and bitings of a printmaker such as James Gillray. The face itself also contains areas of heavy shading, increasing the sense of melancholy brooding, while four vertical lines define the eye with its heavy lid. Parallel hatching again defines the figure behind and to the left, but the curving forms of the face are more horizontal than vertical. The figure also appears to be bearded without, though, detracting from its resemblance to the artist's own features.

The background is darker at the top than at the bottom, forming an oppressive weight bearing down on the two figures. At the right, the parallel hatching fractures into dynamic, energizing, zigzagging scribbles reminiscent of Piranesi's dazzling skies. The rough, pitted edges of the plate along the top and left-hand borders provide a dark frame that contrasts with the open, white space of the lower right, which furnishes the ground for the artist's initials.

Blessed Exegesis is more daring and experimental in its use of technique. Smaller than *Pensive Sages*, it also employs more radical compression and cropping of its figures. Barry again used parallel hatching but in the area of the two soldiers introduced more lines of dashes and stippling. Along the center of the bottom edge, which defines the book's cover, he employed a lightly impressed rocker with no burr, creating a different textured pattern from the stippling and dashes above. Short, choppy, curved lines, animated by touches of stopping-out varnish, play across the cheek of the cowled figure in a distinctly painterly fashion. The treatment of the hand grasping the book is remarkable for its lack of contours. Wavy parallel lines without a bounding outline or internal definition form the thumb and fingers.

The uneven aquatint wash provides the greatest contrast with *Pensive Sages*. It was applied in a single biting, as the contrast in light and dark tones across the surface of

the plate is achieved through the varying density of the etched lines. Luminous white highlights occur in the eyes, where the artist has applied with a brush a stopping-out varnish, while introducing other small highlights in the helmets through burnishing. The effect is like that of a photographic negative. The image possesses a haunting, hallucinatory power as the faces of the soldiers swim in and out of view.

THE REPRODUCTIVE ENGRAVER AND THE PAINTER-ETCHER

Where do these two new images fit within the framework of Barry's entire oeuvre as a printmaker? Earlier in 1771 when he had returned to London to establish himself as a painter after five and a half years of study on the Continent, Barry had lost little time in joining the ranks of those whose paintings were considered worthy of reproduction, quickly aligning himself with an important publisher and a distinguished engraver. On November 16, 1772, John Boydell published a mezzotint by Valentine Green after the artist's painting *The Birth of Venus*, which he had exhibited at the Royal Academy in the spring of that same year. Boydell was also the publisher of his next painting to be reproduced, *Mercury Inventing the Lyre*, which appeared in John Raphael Smith's mezzotint of February 1, 1775. Whether because of disappointing sales or difficulties with the artist these were the only two reproductive prints of importance to be engraved after Barry's work in his early years.

In 1776 Barry himself turned to printmaking, producing in that year a sizable volume of work for which he was printmaker, publisher, and apparently sole distributor. Artists such as Angelica Kauffmann, John Hamilton Mortimer, and Barry's close friend, the Scotsman Alexander Runciman, offered examples of other painters of historical subjects who had turned to printmaking, but in the scale of his activity Barry soon outstripped his predecessors. Obviously a number of motives prompted this departure. Among them were the continuing need for the promotion of his paintings and the need to find new sources of income not long before he was to embark on the series of murals at the Society. One also suspects that questions concerning the quality of the prints reproducing his paintings were another issue. In reproducing his own work, Barry could fully control how his paintings were presented through the print market.

Printmaking also allowed Barry to expand his range of subject matter, creating works that were more topical in their content than had been his oils. It is important to remember as well that his prints after his paintings often depart from the pictures' compositions. These prints do not reproduce the paintings in any strict sense of the term, becoming instead creative variations on the original theme. Even the terms "category" and "originals" tells us more about modern preoccupations than his own and can lead to a dichotomy that obscures as much as it reveals. Barry was not born into a world where "reproductive" was as yet a pejorative term. In the eighteenth century, reproductive prints were held in high regard as works of art in their own right, not yet having been dismissed as derivative, mechanical, and dull in line with the Romantic movement's preoccupation with originality. Barry as well continued until the end of his career to execute prints reproducing the work of other artists, as in the case of his print *Jonah* after Michelangelo, dated 1801.

Still, the concept of what Adam Bartsch at the beginning of the nineteenth century was to term the painter-etcher was already emerging, as a new appreciation for prints created by artists from their own designs was beginning to make itself felt. One should not minimize as a prime motivation for Barry's turning printmaker the intense satisfaction he must have found in working with copperplates, acid, etching needles, and burins. He was remarkable for the experimentation with which he pursued a variety of media. In this regard, he belongs to an elite few: among painters in late eighteenth-century England only Thomas Gainsborough and Barry's friend George Stubbs showed

a comparable creativity in the exploration of printmaking, with William Blake, who had apprenticed as an engraver, occupying a niche of his own.

For Barry, printmaking was about more than promotion and the expansion of markets in that it also involved at a visceral level the exploration of new aesthetic possibilities. The professional printmakers issued proofs of their works as a money-making venture, the proofs' rarity and the guarantee of early, rich impressions, making them highly desirable for collectors. Barry was constantly tinkering with his plates, his prints often existing in multiple states, but his changes have more to do with an obsessive engagement with the act of printing itself than with any concern about increasing market value.

In *Pensive Sages* and *Blessed Exegesis*, working on a small scale and on a familiar subject, Barry was freer to experiment. These two images are among his most expressive, fully representing the aspirations of what was to be termed the painter-etcher. It is not just a modern prejudice in favor of original designs that makes their rediscovery of particular interest. In the case of the unsigned *Blessed Exegesis*, clearly an experimental effort, the artist may have intended this work only for an audience of one—himself.

The rediscovery of *Pensive Sages* and *Blessed Exegesis* shows Barry's involvement in printmaking to have been more varied and more daring than has previously been assumed. Unlike his professional counterparts, he was as interested in process as he was in product.

RECEPTION

The artist's contemporaries apparently did not value these two works. The copperplates for these two prints appear to have been included in the posthumous sale of Barry's effects. The second entry in this section lists a grouping of six works, the subject matter of five of which are indicated. The first item is listed as "Descartes," which I believe to be the plate for the print we have already seen of the lower left corner of *Elysium* in which the philosopher Descartes is seated in the center of the composition. The next work is simply entitled "a Portrait," which may be Barry's self-portrait. Then comes "two Studies of Heads," which are the two new prints, and they are followed by "a small Mezzotinto Portrait of a Youth," Barry's *Bust of a Young Boy* after Reynolds. Thus, the plates for the new prints were lumped in with four others, and this entire lot of six sold for only two pounds, five shillings, one of the lowest sums for any of the lots in this section.[3] In addition, no impressions are recorded as having accompanied any of these plates. Either impressions were considered too inconsequential to be worth mentioning or Barry never accumulated any stock, another indication that their primary purpose was not commercial in nature.

INTENTIONS

Despite their indifferent reception, these two prints, *Pensive Sages* and *Blessed Exegesis*, go to the heart of Barry's intentions in his Society of Arts series. They instruct us how we are to approach this or any meaningful endeavor. In his publication of 1783 explaining his series, he paraphrases a verse from the book of Habakkuk. The Old Testament prophet quotes God as telling him, "Write the vision, and make *it* plain upon tables, that he may run that readeth it" (2:2). It is of interest that in America at the turn of the last century, God's mandate to Habakkuk was frequently quoted as being particularly applicable to mural painting. In 1896, the critic William A. Coffin praised in the following terms Robert Reid's nine panels recently unveiled in the Library of

Congress in Washington, D.C.: "It is gratifying to record the fact that his meaning is so plain that he who runs may read."[4] Writing a few years later in 1913, the muralist Edwin Howland Blashfield approvingly echoed such sentiments: "[T]he decoration in a building which belongs to the public must speak to the people, to the man in the street. It *must* embody thought, and that so plainly that he who runs may read."[5]

In Barry's own time, the poet William Cowper also echoed Habakkuk's meaning in his poem "Tirocinium," which, begun in 1782, was completed in 1784. After denouncing truths that are too dearly bought because they are obscure, requiring too much in the way of "philosophic pains" to unravel their "pompous strains," he praises that which shines forth:

> But truths on which depends our main concern,
> That 'tis our shame and mis'ry not to learn,
> Shine by the side of ev'ry path we tread
> With such a lustre, he that runs may read.[6]

In his murals, Barry has written his vision for all to see, but significantly when he paraphrases Habakkuk, it is to reverse the prophet's meaning. As Barry writes in his account of the series: "It is an absurdity to suppose . . . that the Art ought to be so trite, so brought down to the understanding of the vulgar, that they who run may read."[7] He purposefully stands the tradition on its head, arguing for complexity over simplicity.

Barry's earlier painting *The Education of Achilles*, exhibited at the Royal Academy in 1772, contains a similar message. The monolithic herm that towers over the centaur Chiron as well as the youthful Achilles is a majestic reminder of life's mysteries. It is related to a passage in Plutarch's treatise "Of *Isis* and *Osiris*," which describes the religion and philosophy of the ancient Egyptians. Plutarch describes how, after having been elected, the Egyptian king would be "admitted unto the College of priests, and unto him were disclosed and communicated the secrets of their Philosophy, which under the veil of fables and dark speeches couched and covered many mysteries, through which the light of the truth in some sort though dimly appeareth." Here there were no plain truths, for "all their Theology containeth under ænigmatical and covert words, the secrets of wisdome." Plutarch goes on to describe a Minerva that is the inspiration for Barry's herm: "In the city of *Sais*, the image of *Minerva* which they take to be *Isis*, had such an inscription over it, as this: I am all that which hath been, which is, and which shall be, and never any man yet was able to draw open my veil."[8] Barry's Greek inscription, which translates into English as "all things: one and in one," harmonizes with the first part of the inscription described by Plutarch, and the impressive head, cropped by the picture frame, is draped with the veil that no man hath lifted.[9] It is in the afterlife, as seen in *Elysium*, that man will be fully able to discern truth, but even here its acquirement requires laborious study.

Barry's murals conceal as much as they reveal. They require effort on the part of the viewer. If you run through this "Great Room," you will not even begin to read their meaning.

The two new prints are a restatement of the need for this continuous search for enlightened understanding. In these small works, Barry was not addressing whom his audience should emulate. It is unnecessary for us to attach names to these figures. Instead he is showing us how we should respond to existence's deeper mysteries. This small cast of characters show members of an all-male intellectual elite engaged in a never-ending quest for knowledge and meaning. Judging from these images, it is a quest that is filled with angst and melancholy reflection. The search for truth is painful, and for Barry the meaning of existence is sobering rather than uplifting.

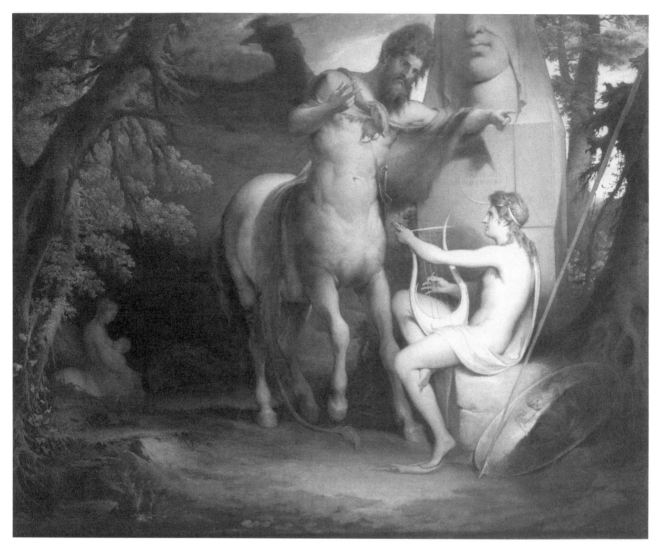

30. James Barry, *The Education of Achilles*, oil on canvas, c. 1772. Yale Center for British Art, Paul Mellon Fund, New Haven.

NOTES

I first discussed Barry's two newly discovered prints in the essay "James Barry and the Print Market: A Painter-Etcher *avant la lettre*," in *Art and Culture in the Eighteenth Century: New Dimensions and Multiple Perspectives*, ed. Elise Goodman (Newark: University of Delaware Press, 2001).

1. This quote is taken from Barry's inscription to the print, the full text of which can be found in William L. Pressly, *The Life and Art of James Barry* (New Haven: Yale University Press, 1981), 275 no.24

2. This work is discussed in William L. Pressly, "*Scientists and Philosophers:* A Rediscovered Print by James Barry," *Journal of RSA* 129 (1981): 510–15.

3. London, Christie's, April 11, 1807, lot 57.

4. William A Coffin, "Robert Reid's Decorations in the Congressional Library, Washington D.C.," *Harper's Weekly*, October 17, 1896, 1029. I am indebted to Dr Marian Wardle, a former graduate student at the University of Maryland, for this and the following two citations.

5. Edwin Howland Blashfield, "Mural Painting in America," *Scribner's Magazine* 54 (1913): 362.

6. "Tirocinium," in *The Poems of William Cowper*, ed. John D. Baird and Charles Ryskamp, 2 vols. (Oxford: Clarendon Press, 1995), 2:273.

7. James Barry, *An Account of a Series of Pictures in the Great Room of the Society of Art, Manufactures, and Commerce at the Adelphi* (London: William Adlard, 1783), 24.

8. Plutarch, *The Philosophy Commonly Called, The Morals*, translated from the Greek into English, and conferred with the Latin and French translations, by Philemon Holland (London: printed by S.G., 1657), 1050.

9. Barry cites Plutarch's account in his book *A Letter to the Dilettanti Society* of 1798 (see *The Works of James Barry*, ed. Dr Edward Fryer, 2 vols. (London: J. M'Creery, 1809), 2:591. Barry quotes the inscription as, "I *am* whatever *was, is* and *will be*, and my vail no mortal hath raised." I have not, however, been able to locate the precise source for this translation.

"This Little Slip of Copper": Barry's Engraved Detail of *Queen Isabella, Las Casas and Magellan*

John J. Manning

As a Testimony of Veneration for the Integrity & transcendant Abilities which for more than 20 years have been, tho unsuccessfully, yet, vigorously, uniformly & gracefully exerted in the Publick Service: this little Slip of Copper which, as the Key Stone of an Arch, binds together these Groupes & the Virtues they commemorate is inscribed with the Honourable & Glorious name of Charles James Fox by his humble servant James Barry. July 25 1800.

—Barry's dedicatory inscription in the engraving's lower margin.

Modern scholarship has revealed an enormous amount of information about James Barry and his work, to the sum of which I cannot claim to have added. And as so much of what we know about both the artist and his work is peculiar to the extraordinarily comprehensive work of Dr. Pressly,[1] I hope I shall be forgiven for reflecting in my remarks today so many substantial borrowings from the wide and perceptive scholarship on Barry that is Dr. Pressly's very own.

"This Little Slip of Copper"—the engraving of Queen Isabella, Las Casas, and Magellan that James Barry dedicated to Charles James Fox in 1800—is surely, as Dr. Pressly pointed out several years ago, "a decidedly eccentric production."[2] Mr. Fox appears to have shared that view. Dr. Pressly observes that one can sympathize with Fox's bafflement over the print's meaning upon receiving an impression from the artist: "The figures in the print appear to be in the grandest style," wrote Fox, "but I confess I do not yet perfectly comprehend the whole of the plan."[3]

And I suspect that upon first confronting this picture in the absence of a wider visual context or supporting information, few modern viewers would venture to assert a full comprehension of what Barry is up to here. When I first encountered the picture among the several remarkable prints hanging in Dr. Allan's collection, I confess that it was only its linkage to Fox, announced by its inscription, that prompted me to suspect that its iconography might echo some private undertones, audible two hundred years ago to the circles in which both artist and statesman moved, yet long since silent. As a freestanding picture, I found it puzzling, if intriguing.

For taken simply as a picture, devoid of extrinsic reference, it is surely an oddity. This derives in great part from the fact that although Barry has drawn three specific historical figures here in a style that invites narrative interpretation, and although he labels clearly the identities of all three, each figure nevertheless appears strangely disconnected from the other two. The beautiful young Isabella, a queen in her own right, tends to dominate the grouping, but she is turned away from the viewer. There is a hint of some connection between her and Magellan, but his gaze seems subtly to avoid hers. Indeed, a closer look reveals that the queen's attention is not addressed to

31. James Barry, *Queen Isabella, Las Casas and Magellan*, 1800. Royal Society of Arts, London.

him, but instead to a point beyond the picture's frame near Magellan's left shoulder. In the foreground, Bishop Las Casas, although perhaps attentive to some nearby discourse, seems to gaze in the same direction as Isabella, and his miter and crozier, set carelessly upon the ground beside him, contribute to an overall suggestion that he is very weary indeed. The trio is posed before a cluster of vertical outcroppings looming in the background. These seem at first vaguely geological, perhaps, but otherwise undecipherable.

On the whole, the picture certainly does evoke a sense of some narrative element in progress. Pictures in the historical style naturally invite us to discern and appreciate such narrative. Yet this picture's slender verticality, so resistant to our usual disposition to "read" an obviously historical piece from left to right, requires us to read it from top to bottom, as we seek to clarify our understanding of the relationships that it must surely, if implicitly, present. Further, the three figures engraved here in this narrow space, each intriguing in its own right, seem to lack the mutual dramatic engagement that a narrative picture ought to reveal.

Yet there is surely a *conceptual* linkage among these three figures, if not a satisfying visual one. If we are puzzled about the plot, we surely experience at least a schoolboy's familiarity with these historical characters themselves. And one need not be a citizen of the former transatlantic colonies to recognize in this historical trio certain unmistakably American connections from the early days of exploration.

On this point Barry is not subtle. Isabella's lovely tresses are decorated with a ribbon that serves as a label, upon which is inscribed the legend *"Ysabel de Castilla empeña las Joyas de su Corona para descubrir America . . . escudos 2500"*—"Isabella of Castille pawned her crown jewels for 2500 escudos for the discovery of America."

Bishop Bartolome de las Casas (1474–1566) made his entire career in America, having traveled there with his father as a child, later becoming bishop of Chiapas, in Mexico. His father and three uncles accompanied Columbus on his second voyage to America in 1493. Although the Spanish criticized him for the part his writings played in fomenting the *leyenda nigra*, the "black history" of Spanish atrocities in the New World, the Dominican priest was a hero to those who deplored the colonial exploitation and enslavement of the native Indians. In Barry's picture, the bishop holds a scroll reading *"Leyes de la Cortede Espana para Mexico, y Peru por influxo de Fray Bme de las Casas. 1539,"* a reference to the prohibition, unfortunately short-lived, that Las Casas persuaded the King of Spain to issue against maltreatment of the native population. He also holds a copy of his book, inscribed *"Las Casas brevisima relacion de la Destrucion de las Yndias 1542,"* his account of the deplorable cruelty accorded the native population by the *conquistadores*.

Ferdinand Magellan (in Portuguese Fernao de Magalhaes; 1480–1521), the third figure in this picture, is identified by a scroll labeled *"circum[navigacion] F[ernao]. Magalhaen."* This maritime explorer, like Columbus thwarted in earlier attempts elsewhere to secure patronage for a proposed seagoing venture westward, eventually embarked in 1519 upon his famous circumnavigation of the globe under the sponsorship of Isabella's grandson, Charles I of Spain, who as Emperor Charles V inherited an empire upon which it could be truly said (many years before it was said of Great Britain's) that the sun never set. Magellan proved the earth round, gave Europeans a new sense of the relative scale of land mass to ocean, and demonstrated that the Americas were a new and separate entity.

Thus this slender picture gives us a glimpse of three contemporaries from the late fifteenth century, each prominently associated with both Catholic Spain and the Americas, portions of which were in Barry's day newly independent. The simple fact of their being grouped within a single frame in 1800 suggests that Barry's iconography is evidently geopolitical in character. America, toward the end of the eighteenth century, had become a theater in which questions of political justice and independence

were being played out contentiously, and it remained a reference point for the discussion of both Britain's participation in the slave trade, and the enlargement of religious toleration at home and abroad. Barry was inclined to link his Irish Catholic origins and personal experience to a sense of persecution and professional disadvantage always close to the surface of his personality. It is not difficult to imagine why such an artist might see such a trio of enlightened historical personages as inherently evocative of interesting questions closely associated with the New World that they helped reveal to European understanding, a world in which Barry was inclined to discern ready *exempla* of important issues related to tolerance and human rights.

But even if we grant that Isabella, Las Casas and Magellan might plausibly be brought within a single frame on the strength of a broadly conceived Whiggish political iconography, the picture remains somehow puzzling. The transatlantic connections that we assign to each of them separately do nothing to bind them together visually as a picture. And visually, as I noted above, the effort fails in and of itself to convey a convincing sense of narrative that we intuitively seek from a picture styled in such a historical fashion. As Mr. Fox pointed out, they "appear to be in the grandest style, but I confess I do not yet perfectly comprehend the whole of the plan."

This is so because "this little slip of copper" is eccentric not only because it reflects Barry's sometimes peculiar, and often political, imagination. *Queen Isabella, Magellan and Las Casas* is eccentric in quite another way. Viewed by itself, it is literally uncentered from the specific physical location where it belongs. It is an image conceived and executed remotely in time and space from its proper place, dislocated from the visual context in which, had it appeared there, it would be instantly comprehensible. It is one of Barry's ectopic afterthoughts.

And it is the sort of afterthought that I find particularly charming, because it brings the matter of Barry's interest in America directly into the Society's "Great Room," where matters of Anglo-American interest were so often discussed. It becomes another of the substantial connections with my own country so often evident in the proceedings of this Society even from before the days of Mr Barry.

This afterthought—this engraving—is an image drawn by the artist about seventeen years after his monumental *Elysium and Tartarus or the Final State of Retribution*, the forty-two-foot long canvas representing the final segment of *The Progress of Human Knowledge*. Barry executed the engraving of *Isabella, Las Casas and Magellan* as if he had originally included it as an integral element of that enormous canvas. In his mind's eye, he saw it inserted in the left-hand panel of *Elysium*, at a point exactly between the keepers of *Reserved Knowledge* and the *Glorious Sextumvirate*. Restored to that spot, this little image becomes suddenly and decidedly less eccentric.

The picture of *Isabella, Las Casas and Magellan* originated in the ever-evolving, some might say obsessive concern of James Barry to amend and to perfect, long after their original execution, the pictures that grace this "Great Room." For several years after their exhibition in 1783 Barry made additions and improvements to the canvases, generally prompted by a concern to clarify, to specify, and in a sense to annotate the overall political moral of their meaning. Dr. Pressly has given a full account of these additions and corrections in his book-length studies of Barry,[4] and Dr. Allan summarized the additions concisely in an article in the *RSA Journal* in 1983.[5] But the canvases could not possibly accommodate some of the amendments Mr. Barry would in retrospect have executed. Thus, it was in the series of prints executed after the paintings for sale during the 1790s that he seized the opportunity to put further elements of the paintings right.

What led Barry to conceive of this slender, awkwardly proportioned picture? The answer, of course, lies in part in an understanding of the context for which Barry intended it. To comprehend entirely what Barry had in mind, one must imagine the left panel of *Elysium* sliced vertically, just grazing the left shoulder of the Superior Angel

who supervises the exposition of the cosmological secrets of *Reserved Knowledge* (see ill. 35). The resulting gap would serve to separate more emphatically the grand scientists grouped about the image of the solar system—Francis Bacon, Copernicus, Galileo, and Newton in the upper register, and Thales, Descartes, Archimedes, and Roger Bacon in the lower—from Jonathan Swift's Glorious Sextumvirate to the right: Epaminondas, with his shield behind him, Socrates, Lucius Junius Brutus, Cato the Younger, Sir Thomas More, and Marcus Junius Brutus, all of whom, Dr. Pressly reminds us, died for liberty.[6]

Such a vertical division of the canvas would also suddenly accentuate the relative isolation of Christopher Columbus, who sits with his back to the six freedom-fighters in the right-hand segment, yet seems somehow curiously detached from the physicists to our left. Even before our imagined partition of the canvas he had appeared a trifle hapless in that location, uncomfortably disjoined from the likely conversation of either group.

But if we separate the resulting segments by about fourteen inches, and expand the 1800 engraving to the scale of the mural, we find that adequate space has been furnished to accommodate exactly the insertion of *Isabella, Magellan and Las Casas* precisely as Barry executed them. Indeed, Isabella can now be seen in our mind's eye (and Barry's) to address Columbus quite directly, thus visually and very naturally, drawing him into her group that is so evidently associated with American undertakings.

Once the intended placement of this eccentric production is understood, the explanation suggested by Barry in his dedicatory inscription at its base is confirmed. There he called it "this little Slip of Copper, which as the Key Stone of an Arch, binds together these Groupes & the Virtues they commemorate." The strange shapes in the engraving's upper left corner are seen to be portions of angelic wings already painted; the curved mass in the lower left is Roger Bacon's back. And indeed, with Columbus, Barry's trio of American-oriented personages now provides a logical left-to-right transition from *Reserved Knowledge* to the *Glorious Sextumvirate*.

Now we have a grouping of *four* notables with transatlantic connections and—should one feel that assigning retrospective American preoccupations to him is somewhat conjectural—they invite comparison with another American afterthought of Barry's. This was the engraving *Lord Baltimore and the Group of Legislators*, done seven years before *Isabella* in 1793, but also an afterthought to *Elysium*. Like the image of *Isabella, Las Casas and Magellan*, this engraving, an addition to the set of prints issued to make the "Great Room" pictures available for sale to the general public, was intended by Barry to correct an element of the political moral he sought originally to expose in his painting of *Elysium*.

In the case of this companion afterthought, we have the benefit of Barry's own public accounting of his motivation behind the *Lord Baltimore* engraving in his *Letter to the Right Honourable the President, Vice-Presidents, and the Rest of the Noblemen and Gentlemen of the Society . . .* , published in 1793.

> The particular at which I am troubled is, the having committed a great mistake, or rather a great piece of injustice, which stands in a very conspicuous part of the picture of Elysium and also of the print. It was not committed wilfully; I was misled by general fame, [I had almost said, by the current opinion of the world,] into a belief that William Penn was, in his Pennsylvania code, the first, the original author of an establishment composed of the different denominations of christians, where the laws respecting property and liberty, civil and religious, were originally extended to all, where no particular denomination was permitted to take any lead or posses any advantages not enjoyed by the others. (39)[7]

> Caecilius Calvert, Baron of Baltimore, was really the man to whom all this praise and admiration truly and fairly belongs, and that whatever valuable was done in the way of legisla-

tion in Pennsylvania was but a copy taken from the original executed in Maryland above thirty years before even the granting and signing of Penn's charter, [which authorised him to collect his people for the intended colony in America . . .][8] (42–43)

I shall to the best of my power make honourable amends to Lord Baltimore for my error. It is not now possible to alter that part of the picture of Elysium, nor of the print, they must remain as they are a monument of the general delusion in which I have participated. But I have now made a new design for that part, where the matter is as it should be, and I shall with God's blessing publish a print of it very shortly, which as the figures are two feet high will make an agreeable addition of another print to the set. (52–53)[9]

In this case, Barry invites us to see the original canvas painted over, and to see Penn relegated to the background. "In this new design," Barry continues,

which consists of King Alfred and other legislators, where Lycurgus is looking over the Pacific Code of Laws, which is considered as the ultimatum of legislation for a mixt people, I have instead of Penn, placed those laws in the hands of Caecilius, Lord Baltimore. . . . As after all William Penn must be allowed the merit of having copied this excellent pacific example, I have honourably placed him with his Pennsylvanian code next to Calvert, which keeps up an agreeable diversity in the forms and is an additional weight to the moral of this part. (53)[10]

Here the Irish Catholic Barry is emphasizing the beneficent effects of an enlightened Catholic sensibility planting the seeds of unprecedented religious toleration in the New World, much the same sensibility widely associated with Las Casas and, by implication, Isabella of Castile. He remarks "what a fine contrast does the christian liberality of the Roman Catholics of Maryland form to the intolerant temper and practice of the independents of Massachusetts" (44).[11]

To punctuate this emphasis upon enlightened Catholicism, Barry has transformed the angel strewing flowers upon the legislators beneath into a very recognizable historical figure. This heavenly apparition is now bedecked in tartan and tam o'shanter cap, and is acknowledged by Barry to be the Catholic Mary, Queen of Scots. And Barry makes explicit a particular concern that he would later imply through the figure of Las Casas, that "Calvert purchased the rights of the Aborigines, and with their free consent in the subsequent March took possession of their town, which he called St. Mary's, [and] laid the foundation of his province upon the broad basis of security to property, and of freedom in religion" (43–44).[12]

Barry's concern to have Lord Baltimore shoulder aside the comparatively narrow-minded William Penn in this revisionist redaction of his own pictorial *Elysium* narrative is entirely consistent with the views that the artist expressed throughout his entire life. And his conviction that the benefits of enlightened Catholicism had indeed found in the New World fertile ground in which to flourish invites us to redirect our attention to the picture of Isabella and her friends, in "this little slip of copper."

Dr Pressly reminds us that Barry saw Isabella, who pawned her jewels to finance Columbus's voyage, as an emblem of "enlightened patronage," and that he saw the queen "as the Christian protector of the brutalised Indians, a cause to which the saintly Las Casas . . . devoted his entire career." Barry was especially impressed by General Miranda, the Venezuelan patriot who after service as a French officer became a personal connection of Barry's in London, and who subsequently was regarded in his homeland as the precursor of Simon Bolivar, who accomplished the liberation of South American peoples from European rule. Barry was actually invited to visit America to paint George Washington in the early 1780's, but his work in the Society's "Great Room" during that period of course prevented him from accepting such a commission. And we should note that although *Elysium* as we know it today still lacks the figures of Isabella and Magellan, Barry eventually managed to add to this canvas the picture of

Las Casas and other of his Dominican brethren "with a flock of native worshippers," as Dr. Allan puts it, in 1801.[13]

But why is this engraving of Isabella and her companions dedicated to Charles James Fox? From the foregoing observations certain explanations naturally arise.

These are perforce topical and allusive, to be sure, but in the way of many circumstantial arguments, quite suggestive. First of all, Barry was clearly fond of Fox, not only a prominent Whig who supported the independence of the American colonies, but who later opposed the slave trade with equal vehemence. Fox was also in his early days a macaroni, a dissolute, and for years thereafter a notorious gamester. As early as 1778 Barry had executed an etching of *The Conversion of Polemon*, illustrating the moment of that young man's conversion from his dissolute ways under the prompting of Zenocrates. It was clearly linked to another etching with contemporary political overtones done the previous year, in which Edmund Burke, Fox's friend, appears in a composition portraying the story of Job. Burke also figures in the picture of Polemon's conversion.[14]

But it was not until October 1800, in a letter to Fox written three months after his engraving of *Queen Isabella*, that Barry explained his motives in composing such pictures over twenty years earlier.

About this time [1778] your political conduct upon the American questions was much distinguished and could not fail of being frequently upon the tapis [on the agenda] at our club. For a long time it gave me no small mortification to observe that, in certain matters relating to those grand questions, some . . . knew not how to make the necessary allowances for the fashionable follies of young men of rank and fortune. . . . I pledged myself to them that I would . . . dedicate to him [i.e., Fox] as to the hopes of the country a story relating to one of the distinguished characters of antiquity.

And in this same letter Barry links his picture of Polemon to his picture of Isabella, as suitable for dedication to Fox.[15]

But why associate with Fox a picture specifically focused upon Isabella? I mentioned at the outset that it is to her that our eye is drawn in this splendid, if eccentric, engraving. Ermine-draped, she is aristocratic, even magisterial in her posture, yet remarkably feminine with her upswept hair and radiantly exposed nape—altogether unique among the otherwise frontal countenances of *Elysium*.

I shall conclude my comments with a bit of shameless conjecture, an assertion that I cannot prove, but one that struck me forcibly the very first time I beheld "this little slip of copper" on David Allan's wall. Whether it has merit I am happy to leave to scholars more competent than I.

Isabella seems to me, even apart from her obvious American resonances, an iconographic image of Georgiana, Duchess of Devonshire, whose presence might well flesh out the *roman à clef* we intuitively seek in our effort to discern a narrative analogy in this eccentric picture. The duchess was an intimate of Mr Fox. It was she who shared Fox's every political inclination and plan. Their circle knew, entertained, and admired General Miranda. As late as 1805, it was to her that Fox penned from the House an urgent note: "Pray speak to everybody you can to come down or we shall be lost on the Slave Trade."[16] It was she who, despite her own substantial losses at the gaming tables, was thought to have helped Fox with his own gambling debts. And if she did not, like Isabella, pawn her jewels in favor of the idealistic undertakings of her friend, she certainly pawned her reputation toward securing his reelection to Parliament in the notorious Westminster election of 1784, the event that caused her to be known as "Fox's Duchess," when she was said to have bartered kisses for votes among the precinct's tradesmen.

She penned a rhyme about the involvement of the Duchess of Rutland in Fox's campaign; the work of both was indispensable to Fox's reelection. These two duchesses are coupled in this very room in Barry's rendering of *The Distribution of the Premiums in the Society of Arts*, in which she is presented visually in a way not much unlike the engraving's presentation of Isabella.

Dr Pressly has exposed in convincing detail Barry's habit of introducing portraits of his contemporaries into pictures of historical events. *The Conversion of Polemon* and *Job Reproved by his Friends*, mentioned above, and his *Portraits of Barry and Burke in the Characters of Ulysses and a Companion Fleeing from the Cave of Polyphemus* are striking examples, but not the only ones.[17]

Nor was pictorial representation of the Duchess of Devonshire as a historical figure in any way unprecedented in Barry's day. One picture reveals her as the goddess Diana;[18] J. K. Sherwin painted her as Pharao's daughter, accompanied by the Duchess of Rutland and other notable ladies, discovering the infant Moses in his basket.[19] (Indeed, a contemporary caricature by Isaac Cruikshank plays upon such well-known conceits, showing Georgiana to be one of Faro's daughters in another sense, as a gamestress brought low by the vagaries of the game of Faro so popular in the circles frequented by her and Fox.)[20]

In brief, the duchess was a high-born woman married to great wealth and her circle included prominent men like Fox and Burke, whose then-controversial political initiatives concerning abolition of the slave trade and American colonial independence she actively supported, sometimes at great social risk. Queen Isabella and her line similarly and at some risk supported unpopular undertakings by men whose aspirations looked westward across the Atlantic. The vision of Columbus and Magellan, and the social conscience of Las Casas, are her fitting companions in "this little slip of copper."

I am not at all persuaded that James Barry, whose eye for historical metaphor was unsurpassed, did not intend that we discern such parallel connections.

Barry's inscription upon "this little slip of copper" salutes Charles James Fox for his "Integrity and transcendent Abilities," while recognizing with regret the apparent fact that they had been "unsuccessfully . . . exerted in the Publick Service."

This prompts notice of yet another inscription, similarly dedicated to Fox, that seems to parallel Barry's sentiments in both tone and content, recalling Fox's passionate advocacy—like that of Bishop Las Casas—in transatlantic controversies touching upon both colonial slavery and colonial independence. It reads:

> Here midst the friends he loves the man behold
> In truth unshaken and in virtue bold.
> Whose Patriot zeal and uncorrupted mind,
> Dared to assert the freedom of mankind:
> And whilst, extending desolation far,
> Ambition spread the baneful flames of war,
> Fearless of blame and eloquent to save,
> 'Twas he—'twas Fox, the warning counsel gave:
> Midst jarring conflicts stemmed the tide of blood,
> And to the menaced world a sea-mark stood.
> Oh! had his voice in mercy's cause prevailed,
> What grateful millions had the statesman hailed![21]

These lines were intended ultimately for inscription upon Fox's bust at Woburn Abbey, a popular resort of the circles that both Fox and their author frequented, but their author preceded Fox in death by five months. That author was, of course, Georgiana, Duchess of Devonshire.

Notes

1. William J. Pressly, *James Barry: The Artist as Hero* (London: Tate, 1983).
2. Ibid., 94.
3. Ibid.
4. See especially Pressly, *The Life and Art of James Barry* (New Haven: Yale University Press, 1981).
5. *Journal of RSA* 131 (March/April 1983): 214–21, 283–89.
6. Pressly, *James Barry*, 92.
7. James Barry, *A Letter to the Society for the encouragement of Arts, Manufactures and Commerce* (London: J. Walker, 1798), 39.
8. Ibid., 42–43.
9. Ibid., 52–53.
10. Ibid., 53.
11. Ibid., 44.
12. Ibid., 43–44.
13. D. G. C. Allan, "The Chronology of James Barry's work for the Society's Great Room," *Journal of RSA* 131 (1983), 287.
14. Barry's original drawing of *Polemon and Xenocrates*, in pen and ink with bistre wash, was sold at Sotheby's in February 1830. A printed note in the catalogue states that Barry had sent this drawing to Charles James Fox with a recommendation to meditate upon it. *Catalogue of the library, prints, drawings, pictures, gems, bronzes, antiquities, coins and medals of the late John Henderson, Esq . . . of Charlotte Street, Fitzroy Square* (London: Sotheby's, 1830).
15. Pressley, *Life and Art* (London: Blackie and Son, 1981), 81.
16. Vere Foster, ed., *The Two Duchesses* (1898), 263.
17. Pressley, *Life and Art*, 67ff.
18. Maria Cosway, *Georgiana, Duchess of Devonshire* (1782), reprinted in Amanda Foreman, *Georgiana, Duchess of Devonshire* (London: HarperCollins, 1998), frontispiece.
19. Foster, *Two Duchesses*, facing 278.
20. Isaac Cruickshank, *Faro's Daughters, Or the Kenyonian blow up to Gamblers* (1796). BL Coll. of Prints and Drawings, no. 8879.
21. Foster, *Two Duchesses*, 292, 479.

A Preparatory Drawing for Barry's *Glorious Sextumvirate* Rediscovered: The Search for the Seventh Man

William L. Pressly

Jᴀᴍᴇs ʙᴀʀʀʏ ꜰɪʀsᴛ ᴇxʜɪʙɪᴛᴇᴅ ʜɪs ᴍᴜʀᴀʟs ɪɴ ᴛʜᴇ "ɢʀᴇᴀᴛ ʀᴏᴏᴍ" ᴏꜰ ᴛʜᴇ [ʀᴏʏᴀʟ] Society of Arts in 1783, and on their second exhibition the following year, he considered them completed. He next issued a set of seven plates, dated May 1, 1791, reproducing the series along with a print of the intended portraits of King George III and Queen Charlotte that he still hoped to add in the center of the west and east walls. Yet the murals continued to preoccupy him, and in a print, dated February 28, 1793, he issued a large detail of the group of legislators in *Elysium* in order to substitute Lord Baltimore for William Penn as the first to establish laws in America ensuring religious and civil liberty. Since he was unable to make so significant a change in the painting itself, the print would suffice to update the painting's content.

Presumably when executing this corrective detail, Barry did not envision any additional works, but two years later he executed three more prints of details in his paintings, two of which illustrated figures in *Elysium*. With these two new images, *Reserved Knowledge* and *The Glorious Sextumvirate*, both dated May 1, 1795, he completed illustrating the lower register of the foreground figures in *Elysium* to the left of the Judging Angel. While *Lord Baltimore* had originally been conceived as standing alone, the three prints could now be read as a group. Visually *Reserved Knowledge* on the left, like *Lord Baltimore*, exists as a self-contained image, but the centerpiece *The Glorious Sextumvirate* acts as a bridge between its neighbors. A preparatory drawing for this print has recently reemerged, allowing an opportunity to see how Barry worked toward achieving unity in the creation of his three large print details, which required in the case of the *Glorious Sextumvirate* the resolving of tensions between the print's design and its meaning.

THE CAST OF CHARACTERS

In every version of the *Glorious Sextumvirate* the primary focus is appropriately on the six foreground figures, seated in a tight semicircle. This grouping is derived from Jonathan Swift's *Gulliver's Travels*, in which Gulliver relates how, when on the Island of Blubbdubdrib, he requested the summoning up of the dead: "I had the Honour to have much Conversation with [Marcus Junius] *Brutus*; and was told that his Ancestors [i.e., Ancestor] *Junius*, *Socrates*, *Epaminondas*, *Cato* the younger, Sir *Thomas More* and himself, were perpetually together: a *Sextumvirate*, to which all the Ages of the World cannot add a Seventh."[1] These six men had all died in the defense of liberty

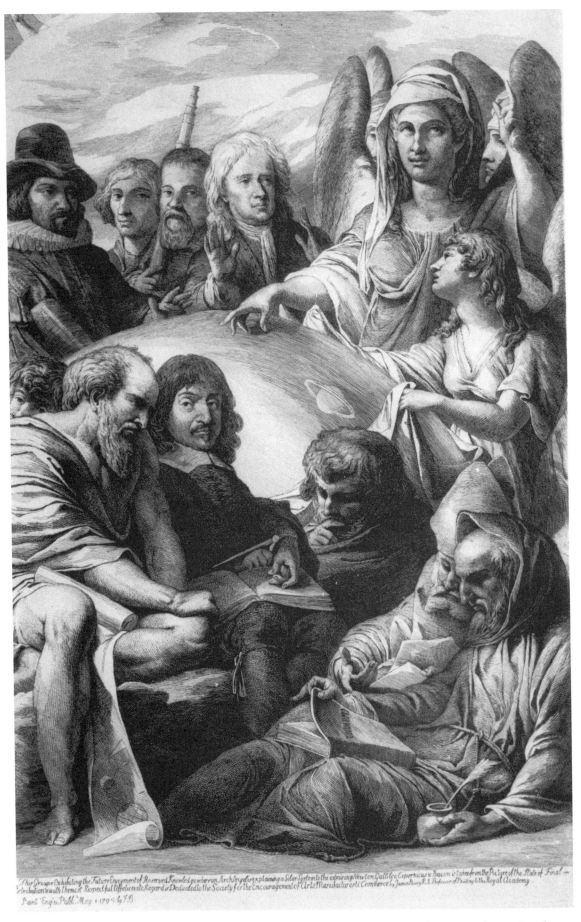

This Groupe Beholding the future Enjoyment of Reserved Knowledge where an Arch Angel is explaining a Solar System to the admiring Newton Galileo Copernicus & Bacon is taken from the Picture of the State of Final Retribution with the most Respectful Affectionate Regard is Dedicated to the Society for the Encouragement of Arts Manufactures & Commerce by James Barry R.A. Professor of Painting to the Royal Academy

Paint. Eng.d Publ. May 1. 1795 by J.B.

32. James Barry, *Reserved Knowledge*, etching and engraving, c. 1800. Royal Society of Arts, London.

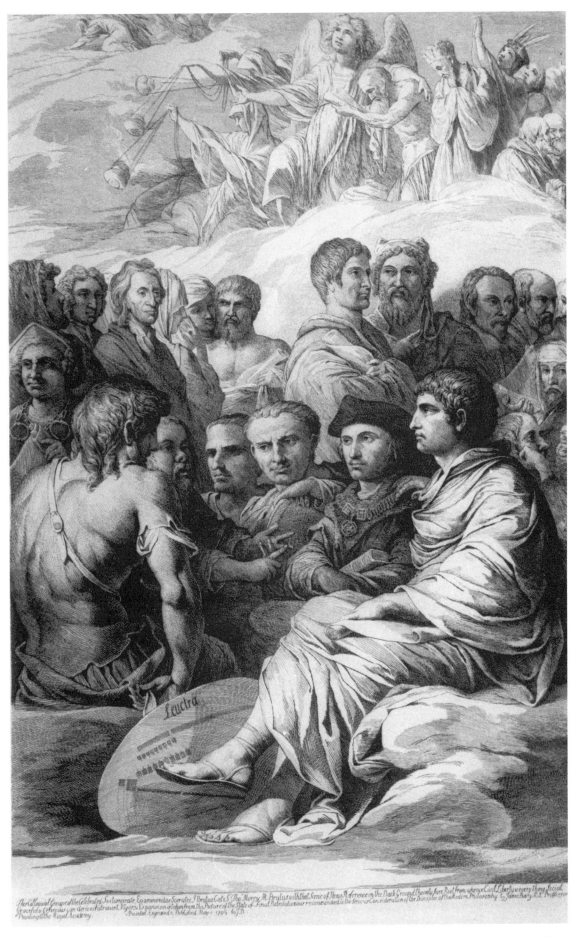

Leuctra

The Historical Groupe of the Celebrated Sextumvirate Examining the Socrates J Brutus Cato S. Tho. Moore M. Brutus with that Sene of Deus Reference in the Back Ground the only fure Rest from whence Civil Liberty & every thing Social Graceful & Glorious, in derives it's reward, Vigour & passion are taken from the Picture of the State of Final Retribution are recommended to the Serious Consideration of the Disciples of Modern Philosophy. By James Barry, R.A. Professor Painting to the Royal Academy. Painted, Engraved, & Published, May 1 1795. by J B.

33. James Barry, *Glorious Sextumvirate*, etching and engraving, third state, c.1800 (bears the date of 1 May 1795). © Copyright the Trustees of The British Museum.

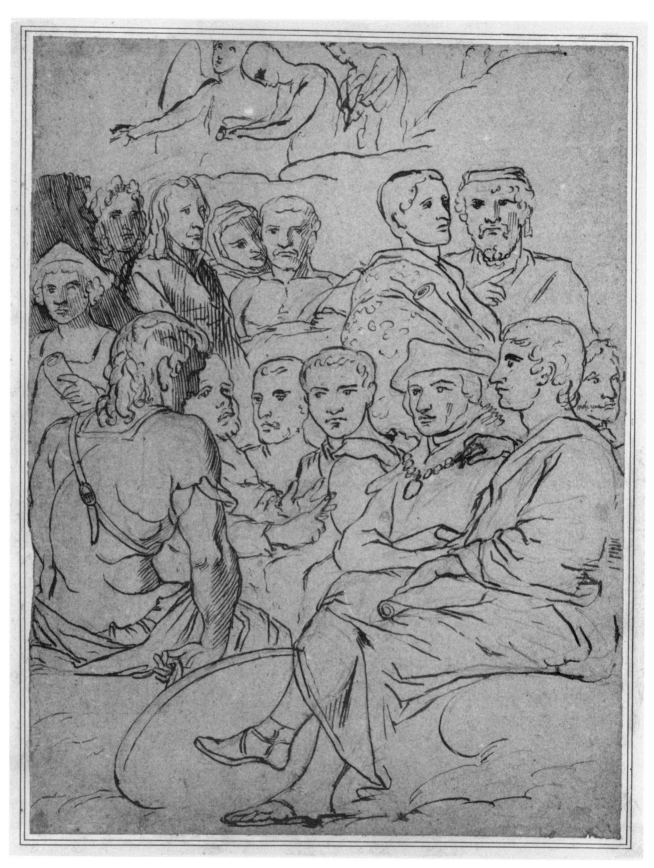

34. James Barry, *Glorious Sextumvirate*, pen and ink over pencil, c.1795 (Private collection). Private collection.

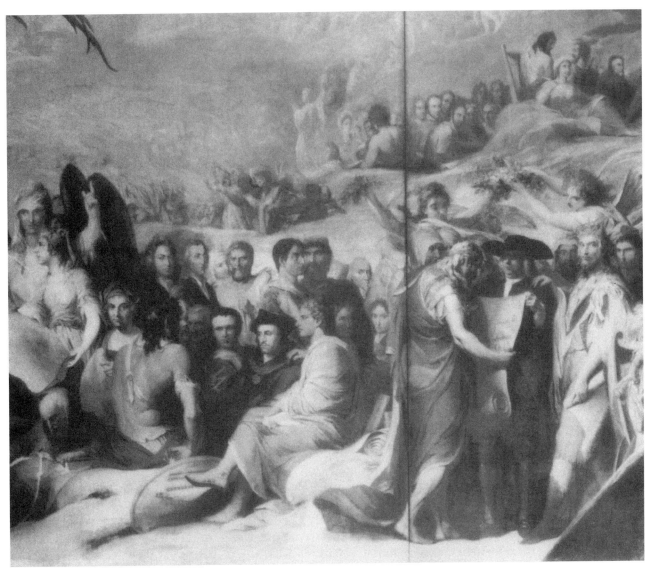

35. James Barry, detail of *Elysium and Tartarus*, 1777–84. Royal Society of Arts, London.

and just principles. Barry gives Brutus, Gulliver's informant, a prominent position at the right. Brutus, one of the conspirators who had slain Julius Caesar when he wished to overturn the Roman Republic, had thrown himself on his own sword rather than surrender to Marc Antony. His right hand rests on the shoulder of the writer and statesman Sir Thomas More, who had been executed after he had refused to accommodate King Henry VIII in his conflict with the papacy.

Next to More is the broad-headed Cato the Younger. Barry had already included Cato's query, "laudandaque velle, sit satis," on the title page of his book *An Account of a Series of Pictures, in the Great Room of the Society of Arts, Manufactures, and Commerce, at the Adelphi* of 1783, thereby giving him a place of honor. This Latin quotation is taken from Lucan's *Pharsalia*, which in Nicholas Rowe's eighteenth-century translation reads, "If truth and Justice with Uprightness dwell, / And Honesty consist in meaning well?"[2] In creating his series, Barry saw himself as a modern Cato, appropriating characteristics that had been ascribed to the Classical hero:

To think he was not for himself design'd,
But born to be of Use to all Mankind.

. .

On universal Good his Thoughts were bent,
Nor knew what Gain, or Self-affection meant;
And while his Benefits the Public share,
Cato was always last in *Cato*'s Care.[3]

Like Marcus Junius Brutus, an opponent of Caesar's, Cato stabbed himself rather than fall into his enemies' hands.

Next to Cato is Lucius Junius Brutus, who had established the Roman Republic on overthrowing the royal Tarquin family, had condemned his own sons to death when they plotted to restore the Tarquins, and had died in battle fighting against their return. Socrates, the Greek philosopher who had been unjustly tried and executed, is beside him, counting off philosophical propositions with his hands, in a manner reminiscent of Raphael's portrayal in his celebrated fresco *The School of Athens*.[4] Finally, anchoring the left-hand side appears Epaminondas, the Theban general and statesman who had died in battle fighting for liberty. Here Barry's conception, with the skin-tight tunic and the languid, twisted right arm, ending in the hand's upturned palm, is indebted to Michelangelo's sculpture of Lorenzo de' Medici in the Medici Chapel in Florence.

Through the rediscovered drawing for this print and through the print's several states, one can trace how Barry evolved the background figures. Unusually for Barry, the drawing is on blue paper. While the print measures 29 1/4 × 18 11/16 inches, the drawing measures only 23 × 17 inches, but it does not appear to be cut down. Presumably Barry was at this point more interested in working out the foreground clusters without paying much attention to the uppermost register, where he cursorily introduced an angel with the roughly sketched figures of Brahma and Confucius. As with many of his drawings, he has in pencil sketched in multiple lines before fixing the outlines in pen and ink. The figures are blocked in, sometimes crudely, showing him working out his idea in a rough, preliminary design. In the composition, he reverts for the most part to the arrangement of the figures in the painting itself, ignoring the variations he had introduced when treating this group in his print dated 1791 that reproduces the entire painting.

From left to right, the figures in the drawing positioned behind the *Glorious Sextumvirate* are as follows: Christopher Columbus beneath an unidentified hooded figure; the moral philosopher Anthony Ashley Cooper, third Earl of Shaftesbury; the philosopher John Locke; a vestal virgin; Zeno, the founder of the Stoic school of philosophy; Aristotle, whose patterned toga is rendered plain in the engraving; and Plato, the student of Socrates and teacher of Aristotle. Just to the viewer's right of Brutus is the head of William Molyneux, across which Barry has inscribed in pen, "molyneux."

The drawing, when compared to the first state of the print that is known to exist, reveals changes in emphasis. In the drawing as in the 1783 painting, Columbus looks out at the viewer, while in the print he looks to the viewer's left. Thus, Barry's first thought was to separate the *Glorious Sextumvirate* from its neighbor, but by altering Columbus's gaze, he linked this print to *Reserved Knowledge*. Later he was to insert a narrow print between the two, the subject of John Manning's essay in this same volume. The bonding, however, with *Reserved Knowledge* was never a major concern: relating this work to *Lord Baltimore* was of greater importance. Heavy, parallel shading anchors the left side of the drawing, particularly in the case of the imposing bearded figure behind Columbus, who is a spectral, unidentified ancestor from the Classical past. The drawing's right-hand side is much lighter, opening up the work

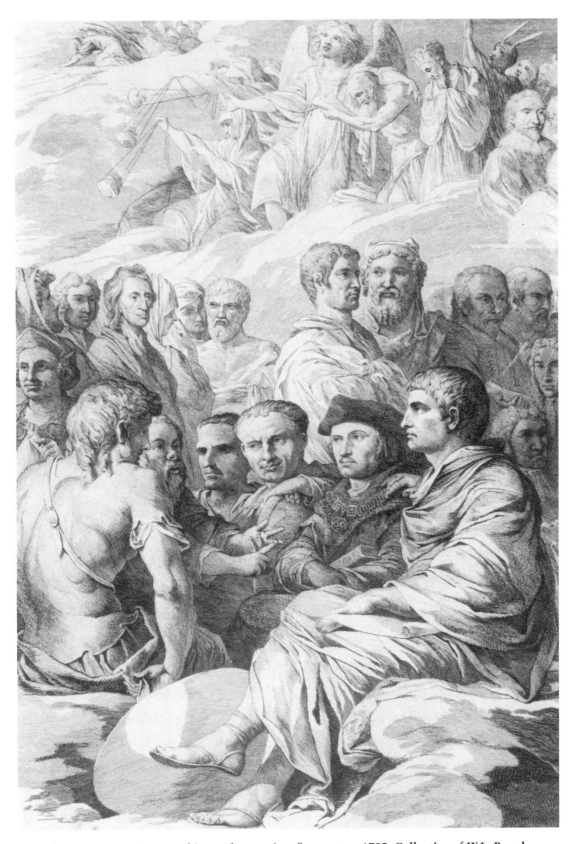

36. *Glorious Sextumvirate*, etching and engraving, first state, c.1795. Collection of W.L. Pressly.

to its neighbor *Lord Baltimore*, toward which so many face and toward which Plato points. From its inception the *Glorious Sextumvirate* relates to and exalts the adjoining legislators.

The print's first state fully articulates the upper register and adds another vestal virgin offering instruction to the attentive Zeno. But the right-hand margin undergoes the greatest change with the addition of figures both above and below looking toward the adjoining print, *Lord Baltimore*. Beside Plato are two physicians, William Harvey and Hippocrates. The former had been present in the painting, but the latter had not, although he had been introduced into the 1791 print reproducing the entire work. Just beneath them is the Irish physicist and chemist Robert Boyle, who looks out at the viewer, and Molyneux, who is positioned where he had appeared in the drawing, the fingers of his right hand curling over his book decorated with an Irish harp, only a portion of which is visible. In the 1783 painting and in the print *Lord Baltimore*, where Molyneux also appears, Barry gives a shortened version of the book's lengthy title *The Case of Ireland's Being Bound by Acts of Parliament in England, Stated.*

In the second state of the *Glorious Sextumvirate* little has changed in the image itself beyond the introduction of additional shading. In the margin, however, Barry inscribed in pencil a lengthy caption, an addition that presumably dates this impression to around 1798.[5] The third and final state, which has an engraved caption, may date to 1800.[6] But the final state also transforms the right-hand edge in order not to repeat characters who are present on the left-hand side of *Lord Baltimore*. In the upper register of the *Glorious Sextumvirate*, Barry had shown Hugo Grotius and the shoulder of Bishop Berkeley, but since they had already appeared in *Lord Baltimore*, they are excised and replaced with scaled-down figures of what appear to be two monks conversing. Boyle and Molyneux, who also appear in *Lord Baltimore*, are dramatically altered. In *Glorious Sextumvirate*, Boyle becomes a bearded, hooded figure, and Molyneux is replaced by a balding man with hand to head in the traditional pose of melancholy reflection. A portion of Molyneux's wig is introduced at the frame's extreme edge to connect with the remainder of his head in *Lord Baltimore*.

THE IMPORTANCE OF MOLYNEUX: IRELAND'S PAST, PRESENT, AND FUTURE

In the interest of visual unity Barry made the decision not to repeat figures in the *Glorious Sextumvirate* that already were present in *Lord Baltimore*. But why had he duplicated these figures in the first place? The preparatory drawing points to Molyneux as the reason. In this instance, he is the only figure to replicate his appearance in *Lord Baltimore*, and he was even important enough to warrant Barry's inscribing his name across his jaw. Once he was replicated, then it was easy to introduce other duplications, but again one needs to ask why he was there in the first place.

Molyneux's double inclusion was important to Barry because he was his choice for the seventh man mentioned by Swift: "a *Sextumvirate* to which all the Ages of the World cannot add a Seventh." As the seventh man, he formed an integral part of the Glorious Sextumvirate and required inclusion, at least in Barry's first sketching out of his composition, even though he had already appeared in the adjacent detail. In his 1783 description of the painting *Elysium*, Barry had first cited Swift as the seventh figure:

> But if a most uniform sincere detestation of all hypocrisy, violence, injustice, and meanness of every kind, with a zeal the most honest, most ardent, and most manly in the cause of every virtue, private and public, could authorize me to add a Seventh, Swift himself should be the man; who had ever employed the united efforts of eloquence, wit, panegyric, and satyr, with more purity, and with a more happy success than he has done, particularly in his Gulliver?[7]

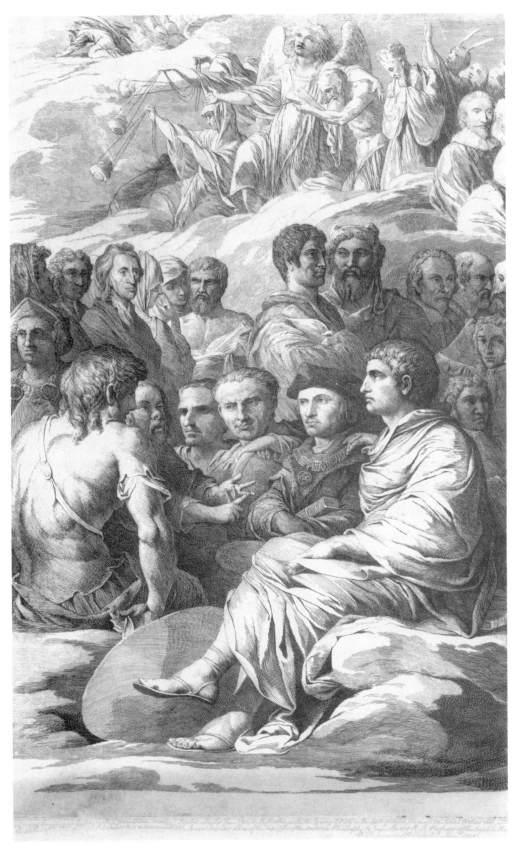

37. James Barry, *Glorious Sextumvirate*, second state, ca. 1798 etching and engraving (written date of May 1, 1795). Royal Society of Arts, London.

A lengthy paragraph extolling Swift's abilities to expose vice and to inculcate virtue follows this declaration that the satirist himself should be the seventh man, but Barry's own panegyric makes clear that an important reason for his inclusion in the group of the *Glorious Sextumvirate* was more specifically his writings exposing England's unfair exploitation of Ireland. Swift, who had been born in Dublin, to which he returned to become Dean of St. Patrick's, had vociferously opposed England's domination of Irish interests, and Barry evokes this legacy as well as his more general satire on mankind's follies.

Barry ends his discussion of Swift by saying he would indeed have added him to this group if he had had his likeness in time. As a consequence of the delay, Swift appears elsewhere in *Elysium*, grouped with poets and writers.[8] This explanation is less than convincing: one suspects that a portrait of Swift would not have been difficult to locate. In any case, Molyneux, whom Barry viewed solely in terms of his writings on Ireland, is the beneficiary, appearing in the painting in Swift's place behind and next to Marcus Brutus. His serious demeanor, with downturned mouth, is derived from the engraved frontispiece to the 1725 edition of the *Case*.[9]

In *The Case of Ireland's Being Bound by Acts of Parliament in England, Stated*, which was first published in 1698, Molyneux decried the Irish parliament's subordination to the parliament at Westminster, which did not hesitate to sacrifice Irish interests for England's gain. Of course, it should be remembered that the Irish parliament, limited as it was to the Protestant oligarchy, did not represent the nation, and through an iniquitous penal code, it actively suppressed the majority of the population. But Molyneux's arguments against the English parliament's unfair dominance, which treated Ireland as a colonial possession rather than as a sister kingdom, was to reverberate with Irish supporters of liberty of all religious persuasions long after 1698. In his work he argued that history and precedent supported the legislative independence of the Irish parliament, but more importantly for the future, he maintained that representative government was a natural right, an argument that was indebted to the writings of his friend John Locke, who appears near him in Barry's design.

In his *Account* of 1783, Barry focused on the reception of Molyneux's book:

> [N]ear M. Brutus is William Molyneux, of the kingdom of Ireland, with the case of his country in his hand. This book, though written with an almost unexampled precision, force, and integrity, was in King William's time (to whom it was addressed) burnt by the hands of the common hangman, to the great infamy of the faction who then predominated.[10]

Barry's source for the book having been burned is derived from the preface to the 1770 edition of *The Case of Ireland's Being Bound*, where this story, for which no historical documentation exists, is recounted as fact:

> At a Time when England was diffusing the Blessings of Liberty, to a prodigious national Expence, amongst the most remote People of the Continent, it must be a matter of just Surprize to the Irish, that far from receiving Assistance from English Legislature, towards repairing the Damages they had sustained, they saw their Independence as a Kingdom, unjustly violated, their Trade wantonly restrained, and Mr. Molineux's modest dispassionate irrefragable Proof of the Rights and Liberties of his native Country, profanely burned by the Hands of the common Hangman.[11]

The preface went on to describe how the ills befalling both the Irish and the Americans were the products of corrupt administrations rather than an expression of the English people themselves, who were characterized as "naturally brave, generous, and just."[12] It also portrayed Ireland as a nation where "Religious Biggotry is losing its force,"[13] thereby espousing liberty for Catholics as well as Protestants. Barry would have been sympathetic to the preface's application of Molyneux's message

to contemporary events, and he was soon to forge a personal relationship with John Almon, the book's publisher. In 1776, Almon, an ardent supporter of the radical politician John Wilkes, published the artist's print *The Phœnix, or the Resurrection of Freedom*, a work whose political message was so inflammatory that Barry omitted his own name.[14] The publisher and the artist obviously were in agreement in seeing the English government as corrupt and egregiously oppressive, even if Barry was the more cautious of the two in publicly expressing his convictions.

During the time Barry was completing his murals at the Society of Arts, Ireland was winning major concessions from the English government, which, engaged in a war with the American colonies, was more amenable to addressing Irish grievances, particularly in light of the Protestants having raised armed regiments of volunteers. On April 16, 1782, the Irish statesman Henry Grattan gave his celebrated speech on the triumph of Irish independence: "I found Ireland on her knees, I watched over her with a paternal solicitude; I have traced her progress from injuries to arms, and from arms to liberty. Spirit of Swift! spirit of Molyneux! your genius has prevailed! Ireland is now a nation!"[15] While Grattan's celebration proved premature, Barry's hope, as expressed in his 1783 *Account*, of a free Ireland that included Catholic participation was not entirely far-fetched:

> We may now fairly hope that Ireland will, at last, permit itself to be free; and that the great majority of the natives of that country (and the majority and the country are synonymous terms) will no longer have the bitter mortification of being prescribed the enjoyments of those constitutional rights (derived from the virtue of their ancestors, under the Henry's, John's, &c.) which, 'tis to be expected, will now be generously and wisely held out, even to aliens. The basis of our islands will be firm and wide, not alone in proportion to the encrease and the number of our people, but to (what is of still more importance) the high, generous, and manly spirit of those people, utterly estranged from whatever is abject and servile.[16]

Works such as the *Glorious Sextumvirate* were intended to help bring about this promising vision.

While at one time Barry may have projected Swift as the seventh member of the *Glorious Sextumvirate*, Molyneux, even in the painting itself, is the one actually accorded this honor. The early states of the large print detail of 1795 confirm his distinction, and in the preparatory drawing Barry inscribed Molyneux's name to ensure his identification with this exclusive brotherhood. While Molyneux had not died for liberty as had the others, at least his book had suffered martyrdom, having been burnt, at least according to Barry, by the common hangman. The pensive, balding man who replaces him in the print's final state is contemplating Molyneux in the neighboring *Lord Baltimore*. That is, he is contemplating not so much the actual man as he is the "spirit of Molyneux," which, as defined by Barry, encompasses the striving toward legislative independence and liberty for all the people of Ireland. Molyneux may have vanished at this point from the *Glorious Sextumvirate*, but for the discerning viewer his position as the seventh man is secure and accordingly so is his message of Irish liberty and justice for all.

Notes

1. [Jonathan Swift], *Travels into Several Remote Nations of the World. By Captain Lemuel Gulliver*, 2nd ed. (1727), vol. 2, 102–3.

2. Nicholas Rowe, *Lucan's Pharsalia*, 3rd ed. (London: n.p., 1753), vol. 2, Book IX, lines 972–73.

3. Ibid., vol.1, Book II, lines 592–93, 604–7.

4. Unlike Swift, Barry made a distinction between those who had been killed or executed for their support of liberty and those who had killed themselves to avoid falling into the hands of their oppressors. He remarked on "the fatal imperfection" of Cato's philosophy, which allowed him rashly to take his own

life, and he went on to say that he would like to think "something like this imperfection of stoicism was the subject on which Socrates was discoursing." See *Monthly Magazine* 16, no. 1 (September 1803): 106.

5. On May 2, 1798, Barry wrote to the Society of Arts in the third person that he would send it impressions of this three large details as soon as he had inscribed the margins: "when ye writing is put to the Plates he will send impressions of them to ye Society with his sincere & affectionate respects" (RSA, Barry Letter, Book 1, 136). Up until this time, they had obviously been without inscriptions. The second state's inscription reads: "This Group of the Celebrated Sexumvirate, Epaminondas, Socrates, J. Brutus, Cato, Sir Thos. More & M. Brutus, with the Scenery of Piety in the background, where all the Social virtues root, is taken from the picture of the State of Final Retribution & is recommended to the Serious Consideration of the disciples of the modern Philosophy by James Barry R.A. Professor of Painting to the Royal Academy. Painted, Engraved & Publis [*sic*] by J. B. May 1st 1795." This impression is in the collection of the RSA, London.

6. In June 1800 Barry presented to the Society four prints, including an impression of *The Glorious Sextumvirate*, and these engravings most likely embodied his final conception. The engraved caption reads, "This Colloquial Groupe of the Celebrated Sextumvirate, Epaminondas, Socrates, J. Brutus, Cato, Sir Tho' More & M. Brutus with that Scene of Pious Reference in the Back Ground, the only sure Root from whence Civil Liberty & everything Social, Graceful & Generous can derive Nutriment, Vigor & Expansion is taken from the Picture of the State of Final Retribution & is recommended to the Serious Consideration of the Disciples of the Modern Philosophy by James Barry R.A. Professor of Painting to the Royal Academy. Painted, Engraved & Published May 1 1795 by JB." Barry dates the print to the time of its inception rather than to that of its completion.

7. James Barry, *An Account of a Series of Pictures, in the Great Room of the Society of Arts, Manufactures, and Commerce, at the Adelphi* (London, 1783), 122.

8. For Jonathan Swift's placement in *Elysium and Tartarus*, see no. 82 in the key to the painting in W. L. Pressly, *The Life and Art of James Barry* (New Haven: Yale University Press, 1971), 296, fig. 149.

9. Philip Simms executed the engraving, which measures only 5 $1/6 \times 3$ inches. The face is thinner than it appears in Barry's print. However, in that regard the head in the preparatory drawing and the one in *Lord Baltimore* more closely resemble the 1725 frontispiece.

10. *Account*, 127.

11. William Molyneux [spelled "Mollyneux"], *The Case of Ireland['s] Being Bound by Acts of Parliament in England, Stated* (1770), vi.

12. Ibid., vii.

13. Ibid., xiv.

14. For a discussion of this print, see *Life and Art of James Barry*, 77–78.

15. Daniel Owen Madden, *The Speeches of the Right Hon. Henry Grattan* (Dublin: James Duffy, 1853), 70.

16. *Account*, 128–29.

Barry's Medal for the Society of Arts:
A Celebration of the Three Kingdoms

William L. Pressly

On JUNE 19, 1801, THE COMMITTEE OF THE POLITE ARTS OF THE SOCIETY OF ARTS approved a proposal to request five artists to submit designs by August 1 for dies for a new medal.[1] This medal was intended to replace the old one created by James "Athenian" Stuart, which the Society had been bestowing as an award since 1758.[2] The five artists solicited were James Barry, John Flaxman, J. F. C. Rossi, Robert Smirke, and Thomas Stothard. Barry, as did Flaxman and Smirke, declined to participate in this competition,[3] and the Society had to wait until 1806 before obtaining a new medal.[4]

On two occasions Barry gave lengthy accounts of his involvement with the design of the new medal. On October 25, 1801, he read a letter of that same date to the Society discussing the additions he had made to his series of paintings in the Society's "Great Room" during the summer recess.[5] Then he provided a second letter, dated November 26, 1801, for publication in the Society's *Transactions*, polishing and expanding material contained in the first.[6] In these accounts Barry made clear that when he had first been approached for a new design, he had not realized it was to replace Stuart's medal. Stuart, who had died in 1788, had been his first employer when in 1764 at age twenty-two he had arrived in London from Ireland. When he learned on meeting with the committee in late June 1801 that Stuart's original medal was being "utterly discarded without ceremony, without any previous discussion in the Society" and that furthermore he was expected "to enter the lists [of those competing to replace it], not with the great artists of Europe, nor even with those eminent natives of the country, but with such artists as our architects were in the habit of directing and employing for their ornaments and other subordinate internal decorations," he quit the committee "without making the communication he had intended."[7] What he had hoped to show were two drawings for the medal's obverse and reverse: "One a head of his Majesty, more than profile, the other a female head of the united kingdom of Great-Britain and Ireland, with the imperial shield suspended from her shoulder."[8]

The day after his disappointing meeting, Barry went to the Society's "Great Room," where he introduced his intended models into the lower left corner of his fifth mural, *The Distribution of Premiums in the Society of Arts*, "only changing the design for the king's head into that of Alfred, as he had no portrait of his Majesty."[9] Barry had initially embraced the idea of producing "an extra or second medal" for the Society in that it would give him the opportunity to display his thoughts on coinage that would from their "obvious utility and dignity . . . be infallibly adopted all over Europe."[10] Thus, these additions to his painting were more than his putting forth a design that circumvented official channels: they were the public rendering of improvements in coinage that he had been advocating for several years.

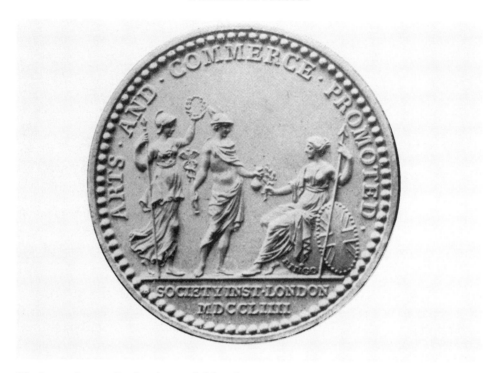

38. James Stuart, *Design for Medal for the Society of Arts*, 1757. Royal Society of Arts, London.

Barry had long been interested in the form and content of medals and coins. As his friend and biographer, Edward Fryer, wrote, "he was a great friend to numismatic learning,"[11] and over his career he intently scrutinized coins from a variety of ancient civilizations as well as Renaissance medals. In 1797, he had already tried his hand in designing a medal, when Joseph Planta, the secretary of the Royal Society, encouraged him to submit a design for one to be awarded for the best essay on light and heat, a fund having recently been set up for this purpose.[12] In July 1798 the government's committee of the Privy Council approached the Royal Academy requesting the advice of its members concerning how to improve "the State of the Coins of this Kingdom."[13] This request galvanized an enthusiastic Barry, but he quarreled bitterly with his colleagues over their response. The majority of the Academy's members, disenchanted with his difficult personality, ignored his efforts to participate, and Barry began his own correspondence with the committee on coinage and with its head, Charles Jenkinson, first Earl of Liverpool.[14]

On July 3, 1801, just days after he had made the additions of the painted medals to *The Distribution*, Barry again wrote to Lord Liverpool concerning numismatic improvements. Naively assuming that his earlier observations had been duly considered by the designer of the halfpenny and farthing, he was vexed that his instructions should have been misunderstood, acerbically complaining that "the head which ought to be most important and principal, is flat and without relievo, and triflingly buried in the centre of the coin, like a mite in a cheese, in order to allow space for an unnecessary mischievous circle of large letters."[15] In his descriptions of earlier coins and medals he made clear those design features that he considered desirable, singling out those fine heads executed in "bold noble relievo and greatness of manner."[16] A coin's lettering should also always be subordinated to the head's grand simplicity. In regard to questions of conservation, because the head should be executed in strong relief, it needed to be sheltered within a deep convex bed surrounded by a high rim.

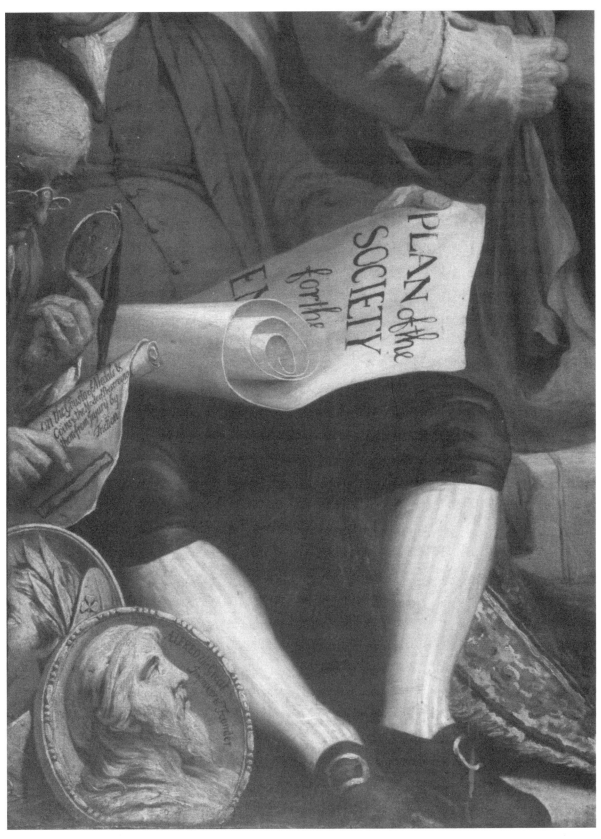

39. James Barry, Detail from *The Distribution of Premiums in the Society of Arts*, 1778–83 with 1801
additions. Royal Society of Arts, London.

The medals in *The Distribution* illustrate Barry's ideas on coinage. The obverse of King Alfred demonstrates a proper relationship between a head and its inscription. This head, in classical profile, grandly fills its space, with the inscription, "ALFRED the Great / Improver & Founder," hugging the right perimeter. Barry's defensive statement that he chose Alfred over George III, because "he had no portrait of his present Majesty with which he was satisfied,"[17] is unconvincing, but by using Alfred, he tied this painting more closely to its neighbor *Elysium and Tartarus*, where Alfred, "the deliverer of his country, the founder of its navy, its laws, juries, arts, and letters with his Dom book in one hand,"[18] is prominently positioned at the right of the cluster of illustrious legislators in the painting's foremost rank near its center.

The design for the reverse, which is cropped by the picture's frame, shows the head of Britannia wearing a laurel crown and bearing a shield with the Cross of St. Andrew on her back. The laurel crown links this image to figures in *Crowning the Victors at Olympia*, the third painting in this series. The shamrock at the top of the shield refers to the United Kingdom's newest links with Ireland. Barry had welcomed the Act of Union, which had on January 1, 1801, united Great Britain and Ireland in one Parliament with the expectation of Catholic emancipation to follow. As an Irish Catholic, he longed for the optimum potential of what the Union could come to mean. In spring 1801, he had petitioned the Society to allow him to place a painting commemorating this event over the fireplace on the east wall of the "Great Room" between the two paintings focusing on contemporary England, *Commerce, or the Triumph of the Thames* and *The Distribution of Premiums*,[19] but he had to withdraw this proposal after it met with determined opposition, some of which was surely motivated by disapproval over its subject matter. After the failure of this project, the shamrock in the painted medal was his discrete reference to the Union with its promise of a new political, social, and religious order.[20]

Barry intended that his additions should address directly the government committee on coinage. Above the obverse and reverse, he inserted an old gentleman closely observing a beribboned medallion while holding a scroll that reads, "on the Gousto of Medals & / Coins & the Mode of Preserving / them from Injury by / Friction." As he wrote to Lord Liverpool on July 3, this scrolled paper contains "the identical patriotic wish of his Majesty's Most Honourable Privy Council, so gracefully and exemplarily, though unsuccessfully, communicated to the Royal Academy."[21] In addition, beneath this inscription on the scroll is the cross section "of such a coin as was required [by this committee]."[22] In his letter, Barry invited Lord Liverpool to visit the "Great Room" to see for himself these additions,[23] and one suspects that the engrossed gentleman who holds the scroll is none other than Liverpool himself, who at the time was seventy-two years old. By adding this painted proxy, the artist ensured that, at least within the fictional space of the canvas itself, his models and his arguments would be carefully examined.

RETHINKING THE MEDAL'S DESIGN

Because the two sides of the medal added to *The Distribution* perform a variety of functions, such as harmonizing with the content of other paintings in the series and demonstrating numismatic principles, it is not surprising that the result fails to address practically the Society's needs. On reflection Barry soon conceived a new obverse, which in a modified form the Society was eventually to adopt.[24] Until now, this improved, final version, consisting of the heads of Minerva and Mercury, has only been known from Warner's print reproducing it, which he engraved for the frontispiece to volume 2 of *The Works of James Barry*.

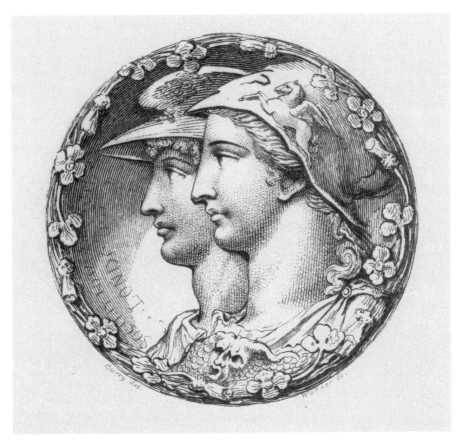

40. **Warner after Barry,** *Heads of Minerva and Mercury for a New Medal of the*
Society of Arts, **etching, 1809 [Frontispiece to** *Works of James Barry*, **vol.II].**
Royal Society of Arts, London.

Fortunately two drawings by Barry showing his final plan for the Society's medal
have recently come to light. Although boldly sketched, the first drawing contains all
of the medal's details, and it may be a rapidly executed work following the finished
design rather than preparatory to it.[25] This drawing is the carefully rendered, com-
pleted design and is the work engraved by Warner. Barry not only signed the paper at
lower right, but anticipating the creation of the medal itself, he provided for his name
to appear within the image as well, initialing a leaf of the shamrock at the lower right,
a detail that Warner was careful to honor in his engraving. The recovery of this draw-
ing demonstrates how much was lost in the engraving. Its subtle modulations were
beyond Warner's abilities, and Warner deliberately suppressed the exuberance of the
encircling wreath, whose foliage at times extends beyond the medal's circular frame.
Barry of course did not execute this drawing with an engraver in mind but as a design
to be followed by a medallist. But the drawing transcends this utilitarian purpose. The
inscription within the design, "SOCIETY........./LONDON...," is not fully legible,
perhaps to leave room for the Society to decide on a definitive wording but also surely
to minimize the part it plays in the overall effect. The drawing stands on its own as
a work of art. Obviously pleased with this more considered proposal, Barry requested
and received permission to introduce it into *The Distribution of Premiums*,[26] but he
never followed through on this initiative.

Barry described how this design was meant as an improvement on, and homage to,
James Stuart's medal of 1757:

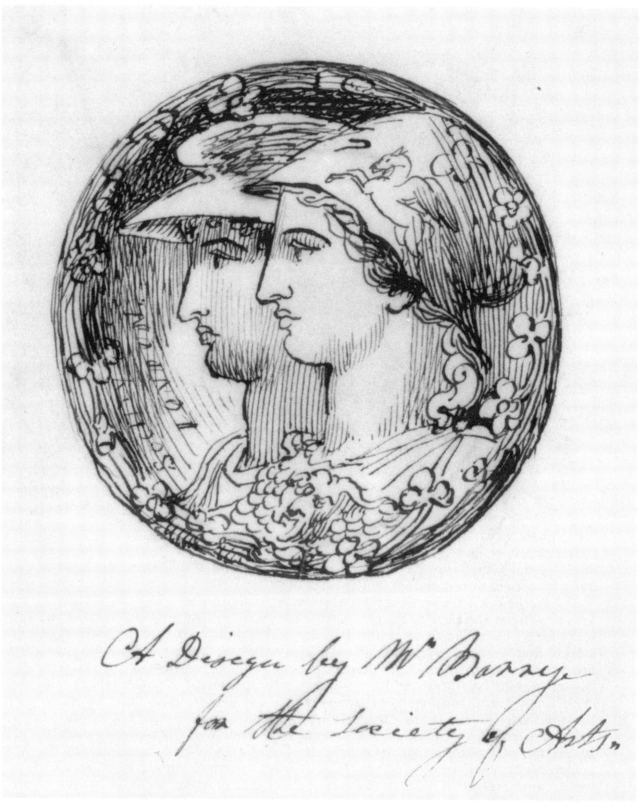

41. James Barry, Sketch for design for "Medal of the Society of Arts," pen and brown ink, 1801. Royal Society of Arts, London.

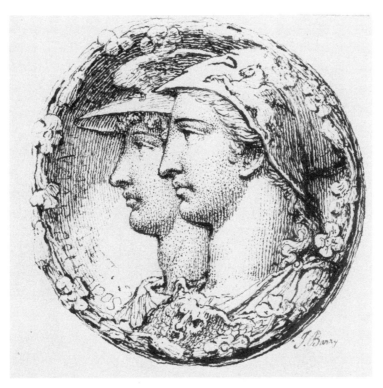

42. James Barry, Design for "Medal of the Society of Arts," pen and brown ink, 1801. Collection of Robert Tuggle.

Nothing can be more happily imagined than the idea [formulated by Stuart] consisting of Britannia aided by Minerva and Mercury, the classical tutelary deities of Arts, Manufactures, and Commerce; and this old device, like many other good old usages, cannot be amended by any change in the substratum. It requires nothing more in its essence, and will most happily coalesce and accommodate with all the acquisitions and improvements of the most enlarged and refined culture. For this purpose, a little more of *goût* and character in the figures, is all that is necessary; enlarging them so as to fill the space with more dignity, and taking away from their individual scattered appearance by the little graces and arts of a more improved composition. And as there is always a considerable dignity and consequence attached to magnitude, which is one of the constituents of sublimity, his suggested alterations would amount simply to this—to substitute, instead of the little entire figures of Minerva and Mercury, only two large heads of those deities; and he would omit the head of Britannia altogether; and by a wreath of the shamrock, rose, and thistle, boldly rising round the edge of the Medal, playing in and out in a graceful gusto manner, he would represent the present happily united Kingdom of Great Britain and Ireland, with a felicity at least equal to the owl, the horse's head, or the dolphins, on the Athenian, Punic, or Sicilian coins.[27]

On the obverse of his medal, Stuart employed three full-length figures: a seated Britannia at the right receiving Mercury, with his caduceus in one hand and a purse in the other, and Minerva, who holds a laurel crown in her left hand and her spear in her right. The overarching caption reads, "ARTS AND COMMERCE PROMOTED." The Society's full title, the Society for the encouragement of Arts, Manufactures, and Commerce, was too long to be suitable for inclusion. "Manufactures" does not appear in the inscription, nor does Vulcan join the other deities.

By focusing only on the heads of Minerva and Mercury, Barry did indeed achieve a sublimity that Stuart had not. The overlapping profiles look back to Classical precedent, and within the idealizing formula of abstracted outlines, Barry subtly distinguished between the two, even giving Mercury, as appropriate to a male, a more

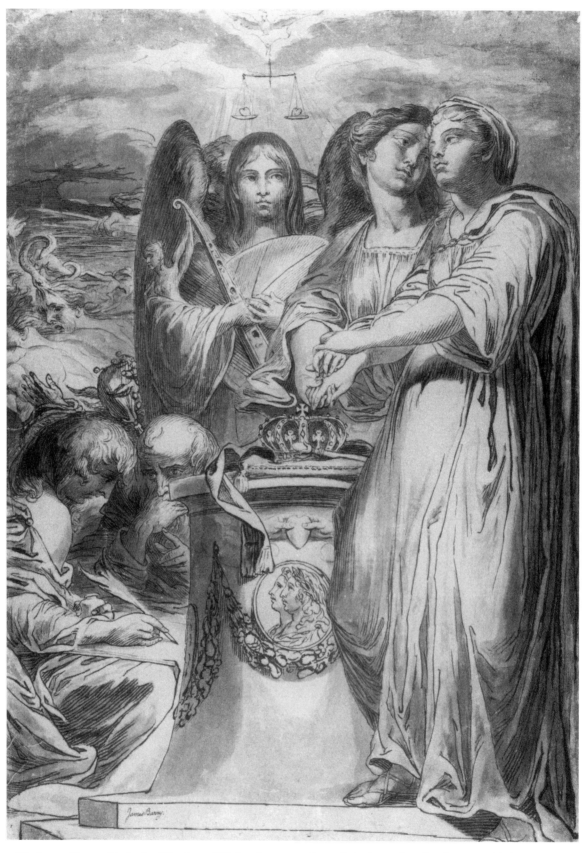

43. James Barry, Study for *The Act of Union between Great Britain and Ireland*, **pen and ink over black chalk, 1801.**

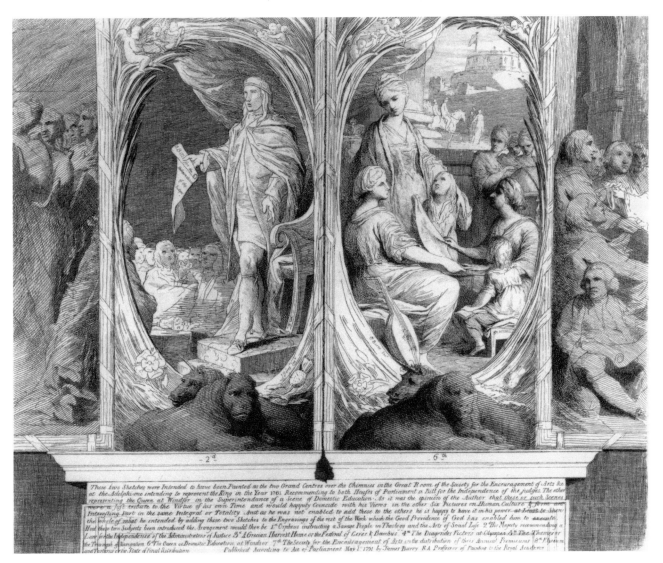

44. James Barry, *King George and Queen Charlotte*, etching and engraving, 1791. Copyright the Trustees of The British Museum.

pronounced Adam's apple. He had already employed overlapping heads in the double portrait of King George III and Queen Charlotte that he had inserted in his studies for his commemoration of the Act of Union. In one of these surviving sketches, the medallion of the royal couple, nestled within a garland, is centered on an altar, above which the personifications of Great Britain and Ireland pledge their mutual support. This arrangement of a male ruler's head trumping that of his consort is traditional, but in his medal for the Society Barry inverted the conventional ordering of the genders, placing the female deity above the male one. This shift also reverses the power relationship seen in Stuart's medal, where Mercury, representing Commerce, dominates: he occupies the center and is the one who interacts with Britannia. In his design, Barry gave Minerva, in her role as the patroness of the arts, preeminence. Mercury is identified by his winged hat, while Minerva, as is also traditional, wears her aegis adorned with the head of Medusa. Barry added to her helmet the figure of Pegasus. This winged horse had sprung from the blood of Medusa, and Pegasus's close association with the Muses, whose sacred spring had been created when his hoof struck a rock, made him an appropriate choice. In addition, Pegasus symbolizes fame through

artistic production, and in Barry's conception Mercury or Commerce provides a background for creative endeavors.[28]

In contrast to Stuart, Barry dropped Britannia, replacing her with another political symbol, one of his own creation. In his print, dated May 1, 1791, showing the two paintings which he then wished to add above the two "Great Room" fireplaces, he provided his portraits with elaborate frames that contain at their bases the rose representing England on one side and the thistle representing Scotland on the other. In the Society's medal, executed soon after the Act of Union, the Irish shamrock joins these two plants to weave a wreath around the medal's rim. Barry created a new dynamic that gives Ireland her full due. All are equal in this organic, vital image of the three kingdoms. In the composition commemorating the Act of Union, an angel clasps the Irish harp together with Britannia's shield. In the Society's medal, the intertwined plants encircling the rim symbolize a similar commingling but in a more distilled and subdued format that hopefully would not arouse the opposition that had been directed at the earlier composition. Barry's design for the Society's new medal not only proclaimed the fundamental importance of the promotion of the arts over that of any of the Society's other concerns but also saw this encouragement taking place within a new imperial order in which the three kingdoms of England, Scotland, and Ireland were bound together as equals.

Notes

1. RSA, Minutes, 19 June 1801.

2. Thomas Pingo, the engraver to the Mint, first struck medals from the dies after Stuart's design in 1757, see Sir Henry Trueman Wood, *A History of the Royal Society of Arts* (London: John Murray, 1913), 316 and the first medals were awarded in the following year, see D. G. C. Allan, *William Shipley* (London: Hutchinson, 1968), 75.

3. See RSA, Minutes, 3 November 1801, for the report concerning the response of the five artists. At that time the committee resolved to advertise for other submissions.

4. John Flaxman eventually created the new medal, following, on the recommendation of the Committee of Polite Arts, "the *principles* suggested by Mr Barry on this subject in the 19th volume of their Transactions," see RSA, Minutes, December 3, 1805). Flaxman's medal is reproduced in William L. Pressly, *The Life and Art of James Barry* (New Haven: Yale University Press, 1981), 294, fig. 148.

5. Barry's letter of 25 October 1801 to the Society of Arts is in Letter Book II entitled, "Letters from James Barry Esq & papers relative thereto since October 1798," in the archives of the RSA. It was published in *The Works of James Barry*, edited by Edward Fryer (London: T. Cadell and W. Davies, 1809), 647–61.

6. Barry's letter of November 26, 1801 to the Society of Arts is published in *Transactions of the Society of Arts* 12 (1801): xxvii–lxiii.

7. Letter of 25 October 1801, in *Works*, 2:648.

8. Ibid., 647–48.

9. Ibid., 648.

10. Ibid., 648–49.

11. *Works*, 1:310.

12. See Kenneth Garlick and Angus Macintyre, eds., *The Diary of Joseph Farington* (New Haven: Yale University Press, 1979), vol. 3, January 6, 1797, 740. Barry's design was not accepted. Smirke reported to Farington, "the idea is absurd." Unfortunately the design has not survived in the Royal Society's archives.

13. Letter of July 20, 1798 from Stephen Cottrell to the Royal Academy recorded in "General Assembly Minutes of the Royal Academy," July 27, 1798, 2:26–27.

14. In his diary Joseph Farington details Barry's skirmishes with the Royal Academy over this issue, and Barry himself lays out his side of the quarrel, along with correspondence, in his appendix to the second edition of *A Letter to the Dilettanti Society, Respecting the Obtention of certain Matters essentially necessary for the Improvement of Public Taste, and for accomplishing the original Views of the Royal Academy of Great Britain* (London: J. Walker, 1799).

15. Letter to Lord Liverpool, [July 3, 1801], reprinted in body of letter to the Society of Arts, October 25, 1801, *Works*, 2: 650. Barry gives the date for the letter in his letter of 26 November 1801.

16. Ibid., 651.

17. Letter of November 26, 1801, in *Transactions* 19, (1801): xxviii.

18. James Barry, *An Account of a Series of Pictures, in the "Great Room" of the Society of Arts, Manufactures and Commerce, at the Adelphi* (London: The Author, 1783), 130.

19. For discussions of Barry's attempt to introduce a painting commemorating the Act of Union into his pictures at the Society of Arts see William L. Pressly, "James Barry's Proposed Extensions for his Adelphi Series." *Journal of RSA* 126 (1978), part 2, 296–301, and *The Life and Art of James Barry*, 175–78.

20. The engraved head of Britannia with her shield is reproduced in *Works*, 2:474. This image, however, omits the shamrock. The rose, representing England, and the thistle, representing Scotland, would also have been elements on the shield, and while other vegetation can be dimly seen in the bottom of the shield as it is rendered in the *Distribution*, the shamrock is given prominence.

21. Ibid., 652.

22. Ibid.

23. Barry hopes that his letter to Lord Liverpool will entice at least one official to visit the "Great Room": "your lordship, or whoever you may send there, will see immediately, on the slightest glace at those models . . ." (ibid., 651).

24. See note 4. One presumes that Barry did not concern himself with designing a new reverse because he anticipated that its primary function would be as a ground for commemorative inscriptions.

25. The handwriting of the inscription beneath the image, "A Design by Mr Barry/for the Society of Arts," is not that of the artist.

26. See RSA, Minutes, November 25, 1801.

27. *Transactions*, 19 (1802): xxxvii–xxviii. He could not resist concluding these remarks with another salvo in his campaign concerning the nation's coinage: "It may be observed by the way, that this mode of rim, with an enlarged noble head of His Majesty, with the relieved and incused parts gracefully and happily diversified, and the inscription well secured within, would not be unworthy of the Royal Mint", *Transactions*, xxxviii–xlix.

28. For the occasion of the exhibition, *James Barry, 1741–1806: "The Great Historical Painter"* held at the Crawford Art Gallery in Cork in 2005–6, Peter Murray, the gallery's director, commissioned the casting of a medal based on Barry's design. This medal is illustrated and discussed in the article "James Barry's Medal for the Society of Arts: A realisation by Matthew Holland at the Bigbury Mint" by Dr. David Allan, *Newsletter of William Shipley Group for RSA History*, no. 7 (2006): 1.

Epilogue: Barry's Death and Funeral

David G. C. Allan

Persons unfamiliar with the administrative structure of the Society of Arts must have been confused by the fact that between 1800 and 1805 both the secretary and the assistant secretary shared the surname of Taylor. They were unrelated, the former being Dr. Charles Taylor, sometime editor of a new edition of Barry's *Account*, and destined to be a pallbearer at the artist's funeral, and the latter Mr. Thomas Taylor, celebrated as the translator of Plato and Aristotle, and fellow enthusiast with Barry for the Neoplatonist doctrines of Orpheus.[1] It was to fill the vacancy caused by Thomas Taylor's resignation, on account of ill health, that the Society held a meeting on February 6, 1806. Barry, as a life member, had the right to attend and vote and it seems he had promised to support Charles Coombe, son of his friend, Dr. Coombe.[2] It was a showery day and walking down to the Society's house in the face of winds blowing from the river, and sitting through the election meeting in what may well have been rain-soaked clothing, Barry caught a chill, which turned to a fever later that night when he dined at his usual eating place, a tavern in Wardour Street, which was a convenient stop on the way home to his house in Castle Street, near Oxford Road (the present-day Oxford Street). During dinner he lost consciousness but was fortunately discovered and revived by Counsellor Clinch, the brilliant young Irish lawyer who had just arrived from Dublin after a night spent in Chester. Clinch, who was a friend and admirer of Barry, and also knew Barry's neighbour, the architect Joseph Bonomi, immediately called a coach and had a message sent to Bonomi describing the predicament. When Clinch and Barry arrived at 36 Castle Street they found the keyhole of the door blocked with pebbles, so Clinch took the invalid to the Portland coffee house and went round to Bonomi's house. Bonomi's son sent for a locksmith but the door at Castle Street could not be opened. Clinch then returned to the Coffee House hoping to find lodgings for Barry, and one was eventually found in Mortimer Street, where Barry stayed until the morning of February 8, when he felt well enough to visit Bonomi, who lived nearby at 76 Great Titchfield Street. During breakfast the Mortimer Street landlady arrived to say that Barry would no longer be a welcome guest as his bleeding had drenched the bed. Unable to find alternative lodgings Bonomi took him in and sent for Dr. Coombe and Dr. Fryer. In spite of their efforts pneumonia proved fatal and Barry died after two weeks, on February 22, having received, it was rumored, the last rites from a Catholic priest.[3]

Although Barry's friends in the Society of Arts had subscribed to the purchase of an annuity of £120, to which the Earl of Buchan had promised a further £10 per year, none of these monies had come into the artist's hands, so in order to pay for a suitable funeral Sir Robert Peel, from whom the annuity had been bought, offered £120 for the funeral and a further £70 toward the cost of a monument.[4] On March 5, 1806, Sir Robert, who was a Vice-President, rose at a meeting of the Society to move a motion that Barry's body should be placed in the "Great Room" for the evening and night before his

funeral. The motion was carried unanimously and, accordingly, on Thursday, March 13,[5] his coffin was carried into the "Great Room" by the undertakers and surrounded by a screen hung with black, with massy candlesticks at the head and foot. It was reported that "a great number of members of the Society with their friends (none other being admitted) attended to bid a long farewell to the departed genius, whose corpse placed within the theatre of his fame, enjoyed that repose, to which while living, he was an utter stranger."[6]

At half past twelve in the afternoon of the following day the coffin was placed in a hearse, drawn by four horses, which departed from the Society's house, down the Strand and Fleet Street toward St Paul's Cathedral, followed by eighteen coaches in which were the chief mourners, Drs. Fryer and Coombe, and the pallbearers, Sir Robert Peel, Bart, VP, Caleb Whitefoord, VP, FRS, FSA, Richard Clarke, Chamberlain of London, VP, and Richard Powell, VP, MP, General Watson, member and Dr. Charles Taylor, Secretary of the Society. Numerous artists and members of the Society followed on foot and fell into ranks behind the procession, just as Barry himself had done when he attended the funeral of Sir Joshua Reynolds some fourteen years before. Barry's coffin was received on the steps of the west front of the Cathedral by the Reverend Dr Henry Fly, DD, FSA, Senior Minor Canon of the Cathedral, Rector of St Augustine's and Royal Chaplain and sub-Dean, where other artists and well-wishers had gathered. The party processed to a chapel in the northwest corner of the Cathedral (the present-day St. Dunstan's Chapel) and, with the bier placed in the centre of the chapel the solemn words of the burial service, as set out in the Book of Common Prayer, were intoned by Dr. Fly. The coffin was then carried into the crypt and placed in a deep grave in the south east corner, close to Reynolds's, and within about four feet of Sir Christopher Wren's.[7]

The inscription on the coffin plate was "James Barry, died 22nd February, 1806, in his 65th year" and the stone slab set into the crypt floor above the grave was inscribed:

The Great Historical Painter
James Barry
Died 22nd February 1806
Aged 64

To this was added the "chi-rho" symbol with the Greek letters Alpha and Omega on either side. Many of Barry's admirers, who had seen his great works at the Society of Arts, thought that Wren's famous epitaph could be adapted in Barry's case, and the Society in its corporate capacity declared that his "Great Room" paintings formed "A monument to perpetuate his memory."[8] However, in 1819 Dr Fryer and others put up a bust supported by a bracket inscribed:

Sacred to the memory
of
James Barry
who
to strong native powers of mind
added the intellectual riches,
(the only riches he ever needed or possessed)
Which sprung from
learning, philosophy and religion.
Hence,
both as a painter and a writer,
a lofty conception,
a moral tendency,

and a Grecian taste,
enobled, sanctified and adorned
all his works

———————

Born at Cork 1741
Died in London 1806[9]

Above the inscription were carved the same symbolic Greek lettering as had been put on the grave covering and below a monogram whose reference has yet to be determined.

NOTES

1. See L. S. Boas, "Thomas Taylor, Platonist (1758–1835) at the Society of Arts (i–ii)," *Journal of RSA* 115 (1967): 743–46, 818–23, 901–3.

2. RSA, Society Minutes, under date: the temperature on 6th February was minimum 42° maximum 51°, often cloudy and clear with showers and wind blowing from the west, see Metrological Office Library, T. Hoy, Mss. Diary, 6 February 1806, written at Syon House, Isleworth.

3. Joseph Bonomi to the Earl of Buchan, February 14, 1806, Royal Academy, *Jupp Catalogue* IV, 123–24. *Diary of Joseph Farington*, March 16, 1806.

4. D. G. C. Allan, "James Barry's Annuity: Acquisition of Papers," *Jnl. RSA* 105 (1957): 62–65. Obituary of James Barry in *Gentleman's Magazine* (1806), 229.

5. RSA, Society Minutes, under date.

6. *Gentleman's Magazine* (1806), 229.

7. Ibid.; James Northcote, *Memoirs of Sir Joshua Reynolds* (London: n.p., 1813), 377. For Henry Fly (b. c. 1744 d.1833) see his entry in J. Foster, ed., *Alumni Oxonienses 1715–1886* (London: Parker and Co., 1887–88).

8. *Gentleman's Magazine*, (1806), 229. *The Times*, March 15, 1805; S. T. Davenport, "Biography of James Barry RA," *Journal of [R]SA* vol. 19 (1870) 805–6; *Transactions of the Society of Arts* 23 (1806): xviii.

9. See Alison Kelly, "A bust of James Barry for the Society of Arts," *Journal of RSA* 123 (1975): 819–22.

Appendix

Susan burney's letter-journal entry for November 1, 1779, describing a visit to the Society of Arts on Tuesday, October 26, with her sister and stepmother.

Transcribed by Philip Olleson, Director, Susan Burney Letters Project, with notes by David G. C. Allan

Last Monday eveng [25 October 1779] Edward called, & found Miss Kirwan here, & Mr *Barry*, the painter, who came to fix a day for my Mother &c to see a great work wch he is now about—The next Morng was settled for it, & accordingly my Mother, Charlotte, & yours went Tuesday to Miss Kirwan's,[1] & thence were conducted by Mr Barry to his House, wch is next door to theirs—there we saw a representation of *Elysium*, & another of *Tartarus* wch he is now at work on—Thence he carried us to the Great Room belonging to the Society for Encouraging Arts & Sciences in John St Adelphi, where we saw those pieces which he has more finished, tho' no part of his design is yet compleatly executed. *The Progress of Society & Cultivation* is his subject, which is comprized in 6 distinct pieces. The Room for which it is intended is a very large one, & when it is compleatly finished he designs to exhibit it—the subject of the first Painting is Orpheus playing on his Lyre, not to attract Beasts, Trees, or stones, as Mr B. is desirous of setting allegory aside as far as it is in his Power, but to *humanize* the savage Inhabitants of Thrace, who are crowding round him & listening wth the most earnest attention—*Euridice* is among these—but is as yet but faintly sketched[2]—there is a great deal of Invention & Fancy in this Piece, & indeed in all the others, everything tending to explain & develop his subject—A Fierce Man clothed in the skin of a Beast is followed by a trembling Female who carries a faun at her Back wch he is supposed to have lately killed, to point out that in a state of Nature the most ignoble services are expected from Women. A Lion at a distance is marking as prey some savages who appear creeping from a cave,[3] in another place a Tyger is tearing a Horse, all tending to point out the universal Evils attending the want of cultivation, or union of civil society. The second Piece represents mankind in a much higher state of Civilization—it contains a Corn-rick, a Haystack, a Plough yoked with oxen, & many implements of Husbandry—He lays his scene in Greece—some beautiful women are dancing—Old People seated on the grass conversing—Athletics practising wrestling, 2 youths on Horseback run[n]ing a race[4]—& in a corner slaves[5] joining the general Festivity by indulging themselves in drinking. The 3d Piece, wch covers one entire side of the Room, (the Figures are almost all as large as life) represents the celebration of the Olympic Games—the Period chosen by Mr Barry is that during which Greece was perhaps at its highest point of Elevation—at the time of Cymon's recall from banishment & when Pericles so successfully encouraged & protected arts & sciences in Athens. At one end of the Piece set the Judges & distributors of the Prizes on a kind of throne, on wch are sculptur'd Medallions of Lycurgus & Solon, & Trophies hanging of the Victories gain'd at Marathon, Salamin, [*sic: recte Salamis*] &c—a foot racer is receiving an Olive Wreath from the hands of an Old Man[6]—The Victor at the Horse Race is a beautiful Greek youth, who appears just receiving a very

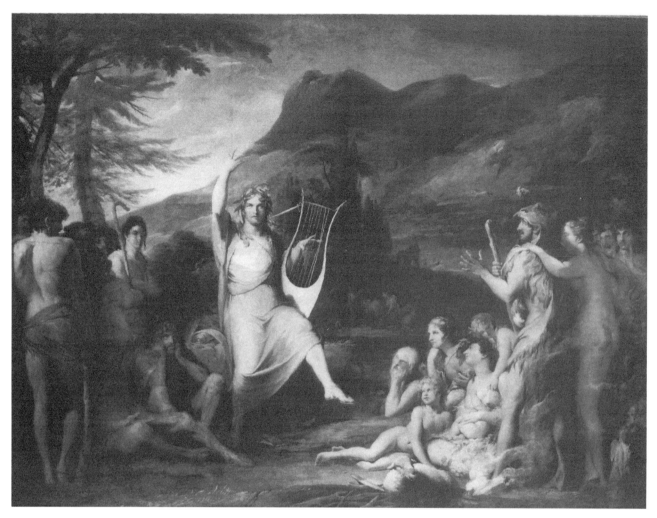

45. James Barry, *Orpheus*, oil on canvas. Royal Society of London.

fine Horse—& at the most distant end of the Piece is Hiero Tyrant of Syracuse in a su-
perb Char, preceded by Pindar w^th his Lyre supposed to be singing a celebrated Ode in
honour of his Patron's Victory.—A very fine figure, representing the Eloquent Pericles
is a very conspicuous object in the Piece, near him stands Cymon whom he appears
to be addressing, but whose figure is somewhat concealed by the Horse Racer—Many
celebrated Greeks stand in a group behind these, among which Aristophanes appears
pointing in derision at the length of Pericles Head, w^ch it seems from the descriptions
w^ch remain of him was very extraordinary, Pythagoras w^th *his finger on his Mouth*
&c. There are I believe above a hundred figures in this piece—all in some action, &
those design'd for particular Persons characteristically employed—M^r Barry has cop-
ied from real Portraits of all those whose resemblance still exist either from painting
or Marbles.—Whether He may not have committed some anachronisms I am not
able to determine—however it is really a very interesting Performance, & to *we fair
sex* appeared extremely well executed[7]—the two Pieces which are design'd to follow
this are to represent the *Triumph of the Thames*[8]—the first of them at the time of the
Spanish Armada—the 2^d about the time of the present King's accession—however of
these I have a very imperfect idea, & M^r Barry has not even sketch'd out his design.—
the concluding Piece is however far advanced—this we saw at His own House—it rep-
resents Elysium—In a Groupe sit the *younger Brutus, Sir Tho^s More, Cato, the Elder*

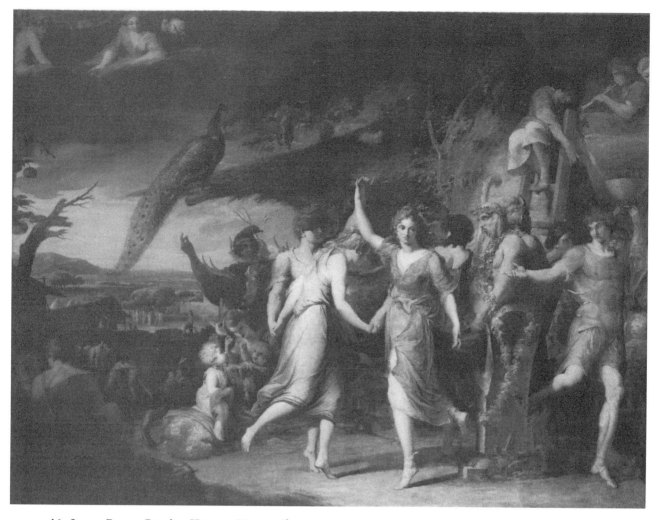

46. James Barry, *Grecian Harvest Home*, oil on canvas. Royal Society of London.

Brutus, Socrates, & *Epaminondas*—the idea of introducing Sir Thoˢ More in company wᵗʰ all these ancients Mʳ Barry says he borrow'd from some passage in Swift's works but I know it not—Locke, Boyle, *Shaftesbury* & many more compose another groupe—in a 3ᵈ appear 2 angels unveiling an Orrery to Sir Isaac Newton, Copernicus, Bacon, &c—above are Angels *incensing* the Creator, who however is invisible—but the idea seems a little catholic⁹—a groupe of Poets are merely sketched—the Bards of

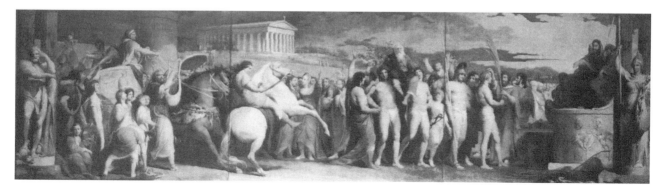

47. James Barry, *Olympic Victors* – all three panels in one view, oil on canvas. Royal Society of London.

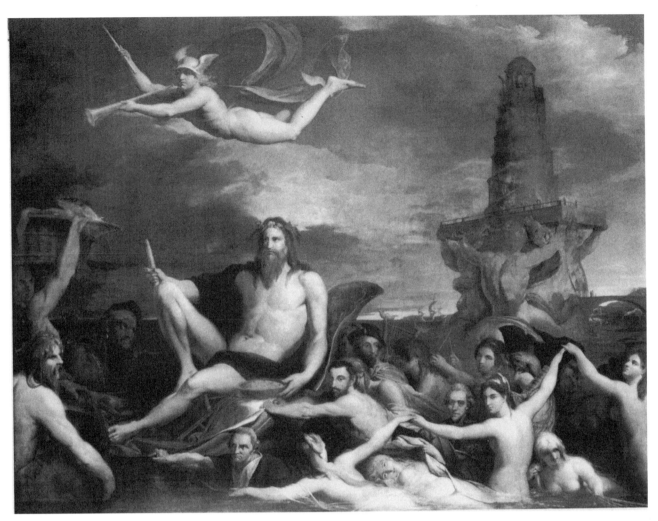

48. James Barry, *The Triumph of the Thames or Commerce*, oil on canvas. Royal Society of London.

all nations & ages will be here assembled from *Homer* down to *Gray*.—the Painters &
sculptors occupy another place, among whom are Phidias and Apelles.—to conclude
the scene a representation of Tartarus strikes one—not as you will believe in the most
pleasing manner in the world—fire is ascending from a Pit into which a *Warrior* is
tumbling headlong, a Gamester with cards in his hands[10]—a Miser wth a bag of money
grasp'd in his hand—a Nobleman whose face is not seen but whose Star & Garter
distinguish him &c—

I have already swell'd my account to so great a length that although it will give you
a very faint idea of the Executive part of Mr Barry's Design, you will probably be sick
of reading about it—but the truth is that few things offer themselves to me wch appear
worth writing, tho' as you wish for *Journals* I am not willing to pass unnoticed any
circumstances which I can recollect.

NOTES

1. Presumably the daughter of the Irish scientist Richard Kirwan (1733–1812) who, like Barry, was a
friend of Joseph Priestly.
2. Euridice is not mentioned in the *Account* (1783) but possibly the figure with a wooden crook to the
left of Orpheus is meant to represent her.

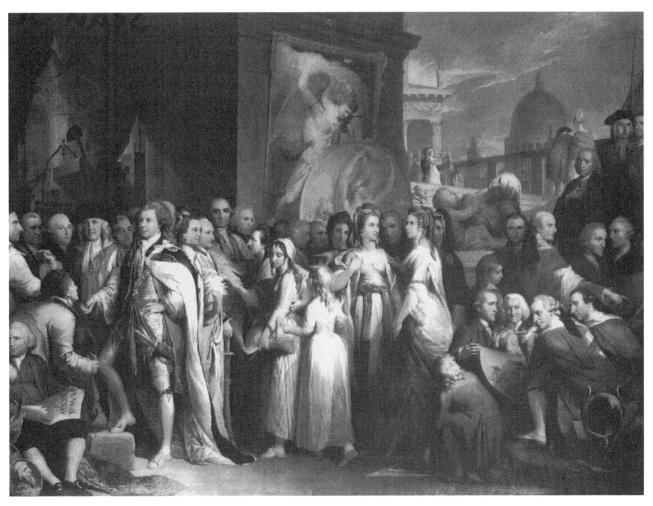

49. James Barry, *The Distribution of Premiums*, oil on canvas. Royal Society of London.

3. Evidently the group milking the goat had yet to be painted.

4. Not shown in the finished painting or mentioned in the *Account*. The back of a donkey appears where SB says she saw the youths on horseback.

5. "Inferior rustics" is the term used by Barry in his *Account* (1783).

6. SB leaves out mention of the Diagorides, presumably not yet painted.

7. Barry would have been less keen to let his men friends comment on the work.

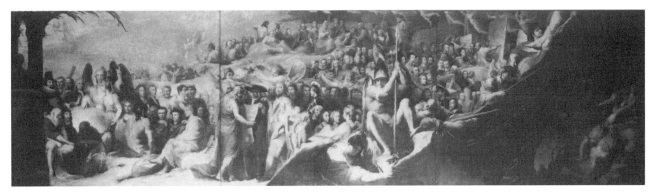

50. *Elysium*, oil on canvas. Royal Society of London.

8. Apart from the title used for painting no. 4 Barry departed from these suggested designs.

9. This would have seemed a typical Barry paradox, Protestant in not portraying God, Catholic in worshipping him with incense.

10. One card is visible in the painting, the other may have been hidden when the scandal monger was introduced (see 1783 and 1784 *Accounts* and D. G. C. Allan, 2005), *The Progress of Human Knowledge and Culture. A description of the paintings by James Barry in the Lecture Hall or Great Room of the RSA in London* (London: Calder Walker Associates, 2005), 32–33.

Professor Philip Olleson will include this letter in his forthcoming selection of Susan Burney's letters in a provisionally titled volume, *Musical Life in Late Eighteenth-Century England* which is due to be published in 2009/10. (Prof. Philip Olleson, Director, Susan Burney Letters Project, Philip.Olleson@nottingham.ac.uk.)

Bibliography

In 1986 the *Journal of RSA* changes its named to *RSA Journal*. For the sake of clarity each citation to that journal will use the name that was correct at the time it was published.

Abbott, John L., and David G. C. Allan, "'Compassion and Horror in Every Humane Mind': Samuel Johnson, the Society of Arts and Eighteenth Century Prostitution (i–ii)," *Journal of RSA* 136 (1988): 749–53, 827–32.

Ackermann, R, A. C. Pugin, and T. Rowlandson. *Microcosm of London*. London: Ackermann, 1808–9.

Adam, Robert. *Works in Architecture* (1779). Reprint, Dourdan: E. Thezard Fils, 1900–1901.

Aglionby, William. *Choice Observations upon the Art of Painting*. London: R. King, 1719.

———. *Painting Illustrated in Three Dialogues, Containing Some Choice Observations upon the Art. Together with the Lives of the Most Eminent Painters, from Cimabue, to the Time of Raphael and Michael Angelo. With an Explanation of the Difficult Terms*. London: printed for author, 1685.

Allan, D. G. C. "Artists and the Society in the 18th century." In Allan and Abbott, *"The Virtuoso Tribe." Studies in the Eighteenth Century Work and Membership of the Society of Arts*, edited by D. G. C. Allan and John L. Abbott, 91–119. Athens: University of Georgia Press, 1992.

———. "Barry and Johnson." *Journal of RSA* 133 (1985): 628.

———. "Barry's Adelphi Cycle Revisited." In *Proceedings of the International Conference in Cork and London*. Cork: Crawford Gallery, 2006.

———. "Bas-Relief Plaques in the Society's House: An Inquiry." *Journal or RSA* 119 (1970–71): 44.

———. "Chronology of James Barry's Work for the Society's Great Room." *Journal of RSA* 131 (1982): 214–21.

———. *The Houses of the Royal Society of Arts. A History and a Guide*. London: RSA, 1966.

———. "James Barry's Annuity: Acquisition of Papers." *Journal of RSA* 105 (1957): 62–65.

———. "The Laudable Association of Antigallicans." *RSA Journal* 137 (1989): 623.

———. "The Progress of Human Culture and Knowledge." *The Connoisseur* 186 (1974–75): 100.

———. *The Progress of Human Knowledge and Culture. A Description of the paintings by James Barry in the Lecture Hall or "Great Room" of the RSA in London*. London: Calder Walker Associates, 2005.

———. *William Shipley. Founder of the Royal Society of Arts*. London: Scolar Press, 1979.

Alumni Oxonienses: the members of the University of Oxford 1715–1886. Oxford, London: Parker & Co., 1888.

Anon. *Propositions for improving the manufactures, agriculture and commerce of Great Britain*. London: W. Sandby, 1763.

Attfield, Judy, and Pat Kirkham. *A View from the Interior: Feminism, Women and Design*. London: Women's Press, 1989

Bachelier, Jean-Jacques. *Memoire concernant L'Ecole Gratuite de Dessin*. Paris: Imprimerie Royale, 1774.

Baird, John D., and Charles Ryskamp, eds. *The Poems of William Cowper*. Oxford: Clarendon, 1995.

Barker-Benfield, G. J. *The Culture of Sensibility: Sex and Society in Eighteenth Century Britain*. Chicago: University of Chicago Press, 1992.

Barrell, John. *The Political Theory of Painting from Reynolds to Hazlitt: The Body of the Public*. New Haven: Yale University Press, 1986.

Barry, James. *An Account of a Series of Pictures, in the Great Room of the Society of Arts, Manufactures and Commerce at the Adelphi*. London: printed for author, 1783.

———. *A Letter to the Dilettanti Society*. London: J. Walker, 1798.

————. *A Letter to the Society for the encouragement of Arts, Manufactures and Commerce.* London: the author, 1793.

Bath Chronicle.

Berg, Maxine, and Helen Clifford, eds. *Consumers and Luxury: Consumer Culture in Europe 1650–1850.* Manchester: Manchester University Press, 1999.

Bermingham, Ann. *Learning to Draw. Studies in the Cultural History of a Polite and Useful Art.* New Haven: Yale University Press, 2000.

Berry, Christopher. *The Idea of Luxury. A Conceptual and Historical Investigation.* Cambridge: Cambridge University Press, 1994.

Bignamini, Ilaria. "The Accompaniment to Patronage. A Study of the Origins, Rise and Development of the Institutional System for the Arts in Britain 1692–1768." PhD diss., Courtauld Institute of Arts, 1988.

Blashfield, Edwin Howland. "Mural Painting in America." *Scribner's Magazine* 54 (1913): 362.

Blunt, Reginald, ed. *Mrs Montagu, "Queen of the Blues." Her Letters and Friendships from 1762 to 1800.* London: Constable, 1923.

Boas, L. S. "Thomas Taylor, Platonist (1758–1835) at the Society of Arts." *Journal of RSA* 115 (1967): 743–46, 818–23, 901–3.

Boime, Albert. *Art in an Age of Revolution, 1750-1800.* Chicago: University of Chicago Press, 1987.

Bond, Donald F., ed. *The Spectator.* Oxford: Clarendon Press, 1965.

Brewer, John. *Party Ideology and Popular Politics at the Accession of George III.* Cambridge: Cambridge University Press, 1976.

[Brown, John]. *An Estimate of the Manners and Principles of the Times.* London: L. Davis & C. Reymer, 1757–58.

Burtt, Shelley. "Private Interest, Public Passion and Patriot Virtue: Comments on a Classical Republican Ideal in English Political Thought." In *Politics, Politeness and Patriotism (Proceedings of the Folger Institute Center for the History of British Political Thought,* vol. 5). Edited by Gordon J. Schochet. Washington, DC: Folger Institute, 1993.

Butt, John, ed. *The Poems of Alexander Pope.* London: Methuen, 1965.

Campbell, Robert. *The London Tradesman.* London: T. Gardner, 1747.

Chambers, William. *A Treatise on Civil Architecture.* London: printed for the author, 1759.

Chippendale, Thomas. *The Gentleman and Cabinet-Maker's Director.* London: printed for the author, 1754.

Clayton, Tim. *The English Print 1688–1802.* New Haven and London: Paul Mellon Centre for Studies in British Art by Yale University Press, 1997.

Clifford, Helen. "Key Document from the Archives: The Awards of Premiums and Bounties by the Society of Arts" *RSA Journal* 145 (1997): 78.

Clifford, Timothy. *Designs of Desire. Architecture and Ornament Prints and Drawings 1500–1850.* Edinburgh: National Gallery of Scotland, 1999.

Climenson, Emily J. *Elizabeth Montagu, the Queen of the blue-stockings: her correspondence from 1720–1761.* London: John Murray, 1906.

Coffin, William A. "Robert Reid's Decorations in the Congressional Library, Washington D.C." *Harper's Weekly* 40 (1896): 1029.

Colley, Linda. *Britons. Forging the Nation 1707–1837.* London: Pimlico, 1994.

Collyer, Joseph. *The Parent's and Guardian's Directory.* London: R. Griffiths, 1761.

Coltman, Viccy. "Sir William Hamilton's Vase Publications (1776–1776)." *Journal of Design History* 14 (2001): 1.

Coutu, Joan. "'A very grand and seigneurial design': The Duke of Richmond's Academy in Whitehall." *British Art Journal* 1 (2000): 52.

Craske, Matthew. "Plan and Control: Design and the Competitive Spirit in Early Mid-Eighteenth Century England." *Journal of Design History* 12 (1999): 187.

Crown, Patricia. "British Rococo as Social and Political Style." *Eighteenth Century Studies* 23 (1989–90): 269.

Crucial Review, or Annals of Literature.

Davenport, S. T. "Biography of James Barry RA." *Journal of [R]SA* 19 (1870): 805–6.

De Bolla, Peter. *The Discourse of the Sublime Readings in History, Aesthetics and the Subject.* Oxford: Basil Blackwell, 1989.

De Certeau, Michel. *The Practice of Everyday Life* trans. Steven Rendall. Berkeley: University of California Press, 1984.

Defoe, Daniel. *The Complete English Tradesman.* London: C. Rivington, 1738

Dossie, Robert. *Memoirs of Agriculture and other Oeconomical Arts.* 3 vols. London, 1768–82.

Dunne, Tom, ed. *James Barry 1741–1806. "The Great Historical Painter."* Cork: Crawford Art Gallery, 2005.

Eagleton, Terry. *The Rape of Clarissa: Writing, Sexuality and Class Struggle in Samuel Richardson.* Oxford: Basil Blackwell, 1982.

Eger, Elizabeth, ed. *Elizabeth Montagu.* Introduction, volume 1, *Bluestocking Feminism: Writings of the Bluestocking Circle.* General editor, Gary Kelly. London: Pickering & Chatto, 1999.

Eger, Elizabeth. "The Nine Living Muses of Great Britain." In *Women, Writing and the Public Sphere 1700–1830.* Edited by Elizabeth Eger, Charlotte Grant, Cliona O'Gallchoir, and Penny Warburton. Cambridge: Cambridge University Press, 2001.

Eimer, Christopher. *The Pingo Family and Medal Making in Eighteenth Century England.* London: British Art Medal Trust, 1998.

Ellis, Markman. *The Politics of Sensibility: Race, Gender and Commerce in the Sentimental Novel.* Cambridge: Cambridge University Press, 1996.

Erdman, David V., ed. *The Complete Poetry and Prose of William Blake.* New York: Doubleday, 1988.

Fairclough, H. R., trans. *Horace Epistles.* New York: Heinemann, Putnam, 1926.

Félibien, André. *The Tent of Darius Explain'd: Or the Queens of Persia at the Feet of Darius.* Translated by William Parsons. London, 1703.

Fitzgerald, Percy. *Robert Adam, Artist and Architect. His Work and His System.* London: T. Fisher Unwin, 1904.

Foreman, Amanda. *Georgiana: Duchess of Devonshire.* London: Harper Collins, 1998.

Foster, Vere, ed. *The Two Duchesses, Georgiana, Duchess of Devonshire, Elizabeth, Duchess of Devonshire.* London: Blackie & Son, 1898.

Fryer, E., ed. *The Works of James Barry.* London: T. Cadell and W. Davies, 1809

Garlick, Kenneth, and Angus Macintyre, eds. *The Diary of Joseph Farington.* New Haven: Yale University Press for the Paul Mellon Centre, 1978–.

The Gazetteer.

Gentleman's Magazine. 1756, 1856.

Gould, Eliga H. "To Strengthen the King's Hand: Dynastic Legitimacy. Militia Reform and Ideas of National Unity in England 1745–1760." *Historical Journal* 34 (1991): 329–48.

Grant, Charlotte, ed. *Flora.* Vol. 4 of *Literature and Science 1660–1832.* London: Pickering & Chatto, 2002.

Graves, Algernon. *The Royal Academy. A complete dictionary of contributors and their work, 1769–1904.* London: G. Bell & Sons, 1907.

Green, Valentine. *A Review of the Polite Arts in France at the Time of Their Establishment under Louis the XIVth Compared with Their Present State in England.* Place. London: T. Cadell, 1782.

Grosley, Pierre-Jean. *A Tour to London, or, New Observations on England and its inhabitants,* trans. Thomas Nugent. London: Lockyer Davis, 1772.

Guest, Harriet. "'These Neuter Somethings': Gender Difference and Commercial Culture in Mid-Eighteenth England." In *Refiguring Revolutions: Aesthetics and Politics from the English Revolution to the Romantic Revolution.* Edited by Kevin Sharpe and Steven N. Zwicker. Berkeley: University of California Press, 1998, 173–94.

Gwynn, John. *An Essay on Design: Including Proposals for Erecting a Public Academy To be Supported by Voluntary Subscriptions . . . For Educating the British Young in Drawing, and the Several Arts depending thereon.* Dublin, 1749.

Hawley, Judith, gen. ed. *Literature and Science 1660–1834.* London: Pickering & Chatto, 2003.

Hayley, William. *Life of George Romney Esq.* London: T. Payne, 1809

Heckscher, Morrison. "Gideon Saint, an eighteenth-century carver and his scrapbook." *Metropolitan Museum of Art Bulletin* (1969): 299–311.

Hill, G. Birkbeck, and L. F. Powell, eds. *Boswell's Life of Johnson.* Oxford: Clarendon Press, 1934.

Hodgkinson, Terence. "John Locheé, Portrait Sculptor." *Victoria and Albert Museum Yearbook,* (1969): 152.

Holloway, James. *James Tassie 1735-1799.* Edinburgh: Trustees of the National Galleries of Scotland, 1986.

Hudson, Derek, and Kenneth Luckhurst. *The Royal Society of Arts 1754–1954.* London: John Murray, 1954.

Hume, David. *The History of England.* Indianapolis: Liberty Fund, 1983.

Hunt, Isaac. "Some Account of the Laudable Institution of Antigallicans." *A Sermon preached before the Laudable Association of Antigallicans.* London, 1778.

Irwin, David. "Art versus Design: The Debate 1760–1860." *Journal of Design History* 4 (1991): 219.

Jacques-Laurent Agasse 1767–1849 ou la seduction de l'Angleterre. London: Tate Gallery, 1989.

Jeremiah, David. "The Society of Arts and the National Drawing Education Campaign." *Journal of SA* 117 (1969): 292.

Johnson, Samuel. *The Idler*, no. 63 (1759). In *The Yale Edition of the Works of Samuel Johnson.* New Haven: Yale University Press, 1958–.

Johnson, Thomas. *One Hundred and Fifty New Designs.* London: Robert Sayer, 1761.

Kelly, Alison. "A bust of James Barry for the Society of Arts." *Journal of RSA* 123 (1975): 819–22.

Kelly, Gary, general ed. *Bluestocking Feminism. Writings of the Bluestocking Circle.* London: Pickering & Chatto, 1999.

Kingsley, Jonathan, Sr., *An Essay on the Theory of Painting*, 2nd ed., (1970).

LaRoche, Sophie von. *Sophie in London, 1786.* Translated by Clare Williams. London: Jonathan Cape, 1933.

Larson, Edith Sedgwick. "A Measure of Power. The Personal Charity of Elizabeth Montagu." *Studies in Eighteenth-Century Culture* 16 (1986): 197.

Leben, Ulrich. "Jean-Jacques Bachelier et L'Ecole royale gratuite de dessin de Paris." In *Jean-Jacques Bachelier (1724–1806): Peintre du Roi et de Madame de Pompadour* (Versailles: Museé Lambinet, 1999), 75–85.

Le Blanc, Mons. L.'Abbé Bernard. *Letters on English and French Nations.* London: J. Brindley, 1747.

Lefebvre, Henri. *The Production of Space* trans. Donald Nicholson-Smith. Oxford: Basil Blackwell, 1991.

"Les Bourgeois de Calais dans l'art britannique au XVIIIe siecle." *Les Bourgeis de Calais. Fortunes d'un Mythe.* Calais: Musee des Beaux Arts et de la Dentelle, 1995

Leipnick, F. L. *History of French Etching from 16th century to present day.* London: John Lane, 1924.

London Chronicle. 1761.

Lubbock, Jules. *The Tyranny of Taste. The Politics of Architecture and Design in Britain 1550-1960.* New Haven, Paul Mellon Centre for British Art, Yale University Press, 1995.

Madden, Daniel Owen. *The Speeches of the Right Hon. Henry Grattan.* Dublin: James Duffy, 1853.

Markus, Thomas A. *Buildings and Power: Freedom and the Control of the Origin of Modern Building Types.* London, New York: Routledge, 1993.

Miller, Lesley Ellis. "Innovation and Industrial Espionage in Eighteenth Century France. An Investigation of the Selling of Silks through Samples." *Journal of Design History* 12 (1999): 271

Molyneux, William. *The Case of Ireland['s]Being Bound by Acts of Parliament in England, Stated.* London: J. Almon, 1770.

Montagu, Edward Wortley. *Reflections on the Rise and Fall of Antient Republics Adapted to the Present State of Great Britain.* London, 1759.

Montagu, Elizabeth. Mrs. *Mrs Montagu, "Queen of the Blues," her letters and friendships from 1762 to 1800.* Edited by Reginald Blunt. London: Constable, 1923.

Monthly Magazine. 1803.

Monthly Review, or Literary Journal. 1760.

Morning Chronicle and London Advertiser. 1783–87.

Morris, Edward. "Letter to the Editor." *Burlington Magazine* 116 (1974): 672.

Mortimer, Thomas. *An Account of the Rise, Progress and Present State of the Society for the encouragement of Arts, Manufactures and Commerce, instituted at London Anno 1754.* London: S. Hooper, 1763.

———. *The Universal Director.* London, 1763.

Mullan, John. *Sentiment and Sociability. The Language of Feeling in the Eighteenth Century.* Oxford: Clarendon Press, 1988.

Myers, Sylvia Harcstark. *The Bluestocking Circle: Women, Friendship and the Life of the Mind in Eighteenth Century England.* Oxford: Clarendon Press, 1990.

Myrone, Martin. *Bodybuilding: Reforming Masculinities in British Art 1750-1810.* New Haven: Yale University Press, 2005.

———. *Gothic Nightmares: Fuseli, Blake and the Romantic Imagination.* London: Tate Britain, 2006.

Newman, Gerald. *The Rise of English Nationalism. A Cultural History 1740–1830.* London: Weidenfeld & Nicolson, 1987.

Northcote, James. *Memoirs of Sir Joshua Reynolds.* London: printed for Henry Colburn, 1815.

Oxford English Dictionary.

Peck, Harry Thurston. *Harper's Dictionary of Classical Literature and Antiquities.* New York: Harper & Brothers, 1898.

Percival, Alicia C. "Women and the Society of Arts in its Early Days." *Journal of RSA* 125 (1977): 266–69, 330–33, 416–18.

Plutarch. *The Philosophy Commonly called, The Morals.* Trans.by Philemon Holland. London: George Sawbridge, 1657.

Pocock, J. G. A. *The Machiavellian Moment: Florentine Political Thought and Atlantic Republican Tradition.* Princeton: Oxford: Princeton University Press, 1975.

———. *Virtue, Commerce and History. Essays on Political Thought and History, Chiefly in the Eighteenth Century.* Cambridge: Cambridge University Press, 1985.

Poems of William Cowper. Edited by John D. Baird and Charles Ryskamp. Oxford: Clarendon Press, 1980.

Pointon, Marcia. *Strategies for Showing Women, Possession and Representation in English Visual Culture 1665–1800.* Oxford: Clarendon Press, 1997.

Pope, Alexander. *The Poems of Alexander Pope.* Edited by John Butt. London: Methuen, 1965.

Pressly, William L. *The Artist as Hero.* London: Tate Gallery, 1983.

———. "James Barry and the Print Market: A Painter-Etcher *avant la letter.*" In *Art and Culture in the Eighteenth Century: New Dimensions and Multiple Perspectives.* Edited by Elise Goodman. Newark, Delaware: University of Delaware Press, 2001.

———. "James Barry's Proposed Extensions for his Adelphi Series." *Journal of RSA* 126 (1978): 296.

———. *The Life and Art of James Barry.* New Haven: Paul Mellon Centre for British Art by Yale University Press, 1981.

———. "Scientists and Philosophers. A Rediscovered print by James Barry." *Journal of RSA* 129 (1981): 510.

Public Advertiser. 1757, 1784.

Public Ledger. 1761.

Puetz, Anne. "Design Instruction for Artisans in Eighteenth Century Britain." *Journal of Design History* 12 (1999): 220.

Rapin-Thoyras, Paul de. *The History of England.* Translated by John Kelly, Joseph Morgan, and Thomas Lediard. London: J. Mechell, 1732–37.

Register of the Premiums and Bounties given by the Society of Arts 1754–1776. London, 1778.

Richards, Sarah. "A True Siberia. Art in Service to Commerce in the Dresden Academy and the Meissen Drawing School 1764–1836." *Journal of Design History* 11 (1998): 109.

Robbins, Caroline. "The Strenuous Whig: Thomas Hollis of Lincoln's Inn." In *Absolute Liberty. A Selection from the Articles and Papers of Caroline Robbins.* Edited by Barbara Taft. Hamden, Conn: Published for Conference on British Studies and Wittenberg University by Archon Books, 1982.

Rosoman, Treve. *London Wallpapers. Their Manufacture and Use 1690–1840.* London: English Heritage, 1992.

Rothstein, Natalie, *Silk Designs of the Eighteenth Century in the Collection of the Victoria and Albert Museum.* London: Victoria and Albert Museum, 1990.

———. *Woven Textile Designs in Britain from 1750–1800,* London: Victoria and Albert Museum, 1994.

Rousseau, G. S. *Enlightenment Crossings: Pre- and Post-Modern Discourse: Anthropological.* Manchester: Manchester University Press, 1991.

Rowe, Nicholas. Trans. *Lucan's Pharsalia.* London: J. and R. Tonson, 1753.

Rudé, George. *Wilkes and Liberty : a social study of 1763 to 1774.* Oxford: Clarendon Press, 1962.

Rykwert, Joseph and Anne. *The Brothers Adam. The Men and the Style.* London: Collins, 1985.

Sainsbury, John. *Disaffected Patriots: London Supporters of the Revolutionary America 1769–1782.* Kingston, Ont.: McGill-Queen's University Press, 1987.

Sekora, John. *Luxury. The Concept of Western Thought, Eden to Smollett.* Baltimore: Johns Hopkins University Press, 1977.

Shee, Martin Archer. *Rhymes on Art, or, The Remonstrance or The Painter in Two Parts.* London: John Murray, 1805.

Sheraton, Thomas. *The Cabinet Maker and Upholsterer's Drawing Book*. London: printed for the author by T. Bensley, 1793.

Simond, Louis. *Journal of a Tour and Residences in Great Britain during the years 1810 and* 1811. Edinburgh: Constable & Co., 1817.

Sir Joshua Reynolds: Discourses on Art. Edited by R. R. Wark. New Haven: Yale University Press, 1988.

Smith, Godfrey. *The Laboratory or School of Arts containing a large Collection of valuable Secrets, Experiments and Manual Operations in Arts and Manufacures*, 6th ed. London: printed by C. Whittingham for H. Symonds, 1799.

Snodin, Michael, ed. *Rococo: Art and Design in Hogarth's* England. London: V&A Museum, 1984.

Solkin, David. *Painting for Money. The Visual Arts and the Public Sphere in Eighteenth Century England*. New Haven: Paul Mellon Centre for Studies in British Art by Yale University Press, 1993

Spectator.

Spector, Robert D. *English Literary Periodicals and the Climate of Opinion during the Seven Years' War*. The Hague: Mouton, 1966.

Sprat, Thomas. *The History of the Royal Society of London for the improving of natural knowledge*. London: Royal Society, 1667

Stillman, Damie. *The Decorative Work of Robert Adam*. London: Academy Editions, 1973.

Sunderland, John. *John Hamilton Mortimer. His Life and Works*. London: Walpole Society, 1986.

———. "Mortimer, Pine and Some Political Aspects of English History Painting." *Burlington Magazine* 116 (1974): 217.

———. "Samuel Johnson and History Painting." In Allan and Abbot, *Virtuoso Tribe*, 183–94.

Swift, Jonathan. *Travels into Several Remote Nations of the World. By Lemuel Gulliver*, 2nd ed. London: printed for Benj. Motte, [1727].

Taylor, James. "Sea Pieces and Scandal. The Society of Arts' Encouragement of Marine Art, 1764–70." *RSA Journal* 144 (1996): 32.

Thunder, Moira. "Improving Designs for Woven Silks: The Contribution of Shipley's School and the Society of Arts." *Journal of Design History* 17 (2004): 5–27.

Transactions of the Society of Arts.

The Two Duchesses. Georgiana Duchess of Devonshire Elizabeth Duchess of Devonshire. Edited by Vere Foster, London: Blackie and Son, 1898.

Universal Magazine.

Wahrman, Dror. *The Making of the Modern Self: Identity and Culture in Eighteenth-Century England*. New Haven: Yale University Press, 2004

Wardle, Patricia. *Guide to English Embroidery*. London: H.M.S.O., 1970.

Ware, Isaac. *A Complete Body of Architecture*. London: T. Osborne and J. Shipton, 1756.

Wark, R. R. "The Iconography and Date of James Barry's Self Portrait in Dublin." *Burlington Magazine* 94 (1954): 153.

Watkin, David, *Thomas Hope and the Neoclassical* Idea. London: John Murray, 1968.

West, Gilbert. *Odes of Pindar*. 2nd ed. London: R. Dodsley, 1753

Whitehall Evening Post. 1761.

Woldbye, Vibeke, ed. *Flowers into Art. Floral Motifs in European painting and decorative arts*. The Hague: SDU Publishers, 1991.

Wood, Sir Henry Trueman. *A History of the Royal Society of Arts*. London: John Murray, 1913

———."The Society and Fine Arts." *Journal of RSA* 60 (1912): 108.

Yale Edition of the Works of Samuel Johnson. New Haven: Oxford University Press, 1958–71.

Young, Hilary. "Manufacturing outside the Capital: The British Porcelain Factories 1745–1795." *Journal of Design History* 12 (1999): 266.

———. "Silver, ormolu and ceramics." In J. Harris and M. Snodin, eds., Sir William Chambers: Architect to George III. New Haven: Yale University Press, 1996. 149–62.

Contributors

DAVID G. C. ALLAN is the author of the pioneer article "The Progress of Human Knowledge and Culture," *Connoisseur* (1974–75) and of "The Chronology of James Barry's work for the Society's 'Great Room,'" *Journal of RSA* 131 (1983), reprinted in D. G. C. Allan and J. L. Abbott, *The Virtuoso Tribe of Arts and Sciences* (1992), as well as editor of Barry's *Account* to which he has provided an introduction and keys (2005). He is Honorary Historical Adviser to the RSA and chair of the William Shipley Group for RSA History (founded 2004).

SUSAN BENNETT was formerly Archivist and subsequently Curator at the RSA (Royal Society of Arts). She is currently an independent researcher, in particular working on the life and times of an eighteenth-century amateur artist, Georgiana Jane Keate (1771–1850), and acts as Honorary Secretary for the William Shipley Group for RSA History (www.williamshipleygroup.btik.com).

HELEN CLIFFORD is currently a Senior Research Fellow in the History Department, University of Warwick. She has curated major exhibitions on historic and contemporary silver, and has published *Silver in London: The Parker and Wakelin Partnership, 1760–1776* (2004) based on her PhD research, as well as researching seventeenth- and eighteenth-century Luxury trades. Her articles relating to design history have appeared in *Burlington Magazine, Apollo, Business Archives*, and *Studies in the Decorative Arts*. She is the curator of the Swaledale Museum in Reeth, North Yorkshire.

CHARLOTTE GRANT is a Fellow and Director of Studies in English at Jesus College, Cambridge, following her position as Senior Research Fellow at the Royal College of Art, London. She works on literature and visual culture and on the role played by the RSA in promoting women as artists in eighteenth-century London. She is coeditor of *Women and the Public Sphere. Writing and Representation 1700–1830* (2001) and fellow at King's College Cambridge.

ANDREA MACKEAN completed her PhD in History of Art at the University of Manchester in 1999. Her thesis focused on the relationship between schemes of English decorative interior painting, the architectural and social locations of those works, and notions of public identity from 1600 to 1800.

JOHN MANNING has served on the English faculty of the University of Connecticut for nearly four decades. His work is devoted primarily to Shakespeare, Elizabethan drama, and early modern historiography. He is a fellow of the RSA and the Royal Historical Society. From time to time he resides in London for much of the year, having established a permanent program of studies here for Connecticut University students, which for more than twenty-five years has acquainted hundreds of young Americans with the work of the RSA.

MARTIN MYRONE is curator of eighteenth- and nineteenth-century art at Tate Britain. He is coeditor, with Lucy Peltz, of *Producing the Past: Aspects of Antiquarian Culture and Practice 1700–1850* (1999) and author of monographic studies of George Stubbs and Henry Fuseli. His major study, *Bodybuilding: Reforming Masculinities in British Art (1750–1810)* includes chapters on the Royal Society of Arts in the 1760s and the art of James Barry.

WILLIAM PRESSLY is a Professor in the Department of Art History and Archaeology at the University of Maryland. He has published the following books: *The Life and Art of James Barry* (1981), *James Barry: The Artist as Hero* (1983), *A Catalogue of Paintings in the Folger Shakespeare Library* (1993), *The French Revolution as Blasphemy: Johan Zoffany's Paintings of the Massacre at Paris, August 10, 1792* (1999), and *The Artist as Original Genius: Shakespeare's "Fine Frenzy" in Late-Eighteenth-Century British Art* (University of Delaware Press, 2007). He is currently at work on a book entitled *Writing the Vision for a New Public Art: James Barry's Murals at the Royal Society of Arts.*

ANNE PUETZ was Research Curator at the Courtauld Gallery, for the exhibition *Art on the Line: The Royal Academy Exhibitions at Somerset House 1780–1836*. She carried out extensive research into the role of the Society of Arts in the development of artistic hairing for the textile industry. She is currently active as an independent researcher and translator, and her PhD thesis was on the subject of British design prints in the period from the 1730s to the 1830s. She is the Adult Courses Programmer at the Courtauld Institute.

Index

As the terms "Society of Arts" and "Great Room" appear on many pages in this volume, they are not separately indexed. Likewise, as James Barry's name appears regularly throughout the book, only references to his works have been indexed.

Académie Royale, Paris, 41
Account of a Series of Pictures in the Great Room of the Society of Arts (Barry), 64, 83, 91, 92, 123, 129, 142
Ackermann, Rudolph, 79
Adam, James, 23, 81
Adam, Robert, 82
Adam brothers, 81, 82
Aglionby, William, 52
Ainsworth, James, 41
Almon, John, 129
Apollo Belvedere, 90
Archimedes, 114
Aristotle, 124

Bachelier, Jean-Jacques, 44
Bacon, Francis, 114
Bacon, John, 58
Bacon, Roger, 98, 103, 114
Bailey, William, 77, 83
Baker, Henry, 29
Baltimore, Lord. *See* Calvert, Caecilius
Banks, Thomas, 58
Baptism of the King of Cashel (Barry), 15, 23
Baptiste, 69
Barry and Burke in the Characters of Ulysses and a Companion Fleeing from the Cave of Polyphemus (Barry), 117
Barry, James: *Baptism of the King of Cashel*, 15, 23; *Barry and Burke in the Characters of Ulysses and a Companion Fleeing from the Cave of Polyphemus*, 117; *Birth of Pandora*, 25; *Birth of Venus*, 105; *Blessed Exegesis*, 101, 104, 106; *Bust of a young boy*, 106; *Commerce, or the Triumph of the Thames*, 67, 134; *Conversion of Polemon*, 116, 117; *Crowning the Victors at Olympia*, 21, 88, 90, 93, 134; *Distribution of Premiums in the Society of Arts*, 20, 32, 64, 73, 93, 117, 131, 132, 134, 135; *Education of Achilles*, 107; *Elysium, or the State of Final Retribution*, 21, 83, 85, 93, 98, 101, 103, 106, 107, 113, 114, 115, 116, 119, 128, 134; *Glorious Sextumvirate*, 113, 114, 119, 124, 126, 128, 129; *Grecian Harvest Home*, 90; *Job Reproved by his Friends*, 117;

Jonah, 105; *Jupiter and Juno on Mount Ida*, 25; *King George and Queen Charlotte*, 98, 113, 119, 139; *King Lear*, 25; *Lord Baltimore*, 114, 119, 124, 126, 129; *Mercury Inventing the Lyre*, 105; *Orpheus*, 89, 93; *Pensive Sages*, 101, 103, 104, 106; *Phœnix, or The Resurrection of Freedom*, 101, 129; *Progress of Human Culture and Knowledge*, 19, 25, 113; *Queen Isabella, Las Casas and Magellan*, 110, 113, 114, 116; *Reserved Knowledge*, 103, 113, 114, 119, 124; *Scientists and Philosophers*, 101, *Temptation of Adam*, 15, 23, 88
Bartsch, Adam, 105
Berg, Maxine, 34
Berkeley, George (bishop), 126
Bermingham, Ann, 69
Birth of Pandora (Barry), 25
Birth of Venus (Barry), 105
Blake, William, 58, 106
Blashfield, Edwin Howland, 107
Blessed Exegesis (Barry), 101, 104, 106
Boas and the Servant set over the Reapers, 27
Bodkin, Thomas, 88
Bolivar, Simon, 115
Bonomi, Joseph, 142
Boulton, Matthew, 81
Boydell, John, 25, 57, 105
Boyle, Robert, 126
Brown, John, 54
Brutus, Lucius Junius, 114
Brutus, Marcus Junius, 114, 119, 123, 124, 128
Buchan, 11th Earl of, 142
Bulkley, Mary Ann, 25
Burke, Edmund, 15, 23, 116, 117
Burney, Susan, 11
Bust of a young boy (Barry), 106

Cabot, Sebastian, 68
Caesar, Julius, 55, 123
Callipateira, 93
Callot, Jacques, 70
Calvert, Caecilius, 98, 114, 115, 119
Camden, Lord, 92
Casali, Andrea, 55, 58
Cato the Younger, 114, 119, 123, 124

Chambers, Hannah, 39, 70
Cheere, Henry, 41, 53
Clarke, Richard, 143
Cleopatra, 56
Clifford, Helen, 70
Clinch (counsellor), 142
Coffin, William A., 106
Colley, Linda, 66
Columbus, Christopher, 112, 114, 115, 117, 124
Commerce, or the Triumph of the Thames (Barry), 67, 134
Confucius, 124
Constable, William, 58
Conversion of Polemon (Barry), 116, 117
Cook, James (captain), 68
Coombe, Charles, 142, 143
Cooper, Anthony Ashley. *See* Shaftesbury, 7th Earl of
Copernicus, 114
Cosway, Richard, 39-40, 42
Cowper, William, 107
Craske, Matthew, 27, 43
Crowning the Victors at Olympia (Barry), 21, 88, 90, 93, 134
Cruikshank, Isaac, 117
Curtius, 55

Descartes, 98, 106, 114
Devonshire, Georgiana, Duchess of, 66, 116, 117
Dew, John, 40
Diagoras, 93
Dissertation on the Olympic Games (West), 91
Distribution of Premiums in the Society of Arts (Barry), 20, 32, 64, 73, 93, 117, 131, 132, 134, 135
Dossie, Robert, 31, 40, 69, 70
Drake, Sir Francis, 68
Dresden Academy, 43
Dublin Society for promoting Husbandry and other useful arts, 23
Durnford, Elias, 27

Ecole nationale supérieure des arts décoratifs. *See* Ecole Royale Gratuite, Paris
Ecole Royale Gratuite, Paris, 44
Education of Achilles (Barry), 107
Edward III (king of England), 55, 56
Edwards, John, 36
Eger, Elizabeth, 64
Ellis, John, 30
Elysium, or the State of Final Retribution (Barry), 21, 83, 85, 93, 98, 101, 103, 106, 107, 113, 114, 115, 116, 119, 128, 134
Epaminondas, 55, 114, 119, 124
Erskine, David Stewart. *See* Buchan, 11th Earl of
Essay on Design (Gwynn), 41

Félibien, 56
Flaxman, John, 40, 41, 131
Fly, Dr Henry, 143
Foulis, Andrew, 41
Foulis, Robert, 41
Foundling Hospital, 54

Fox, Charles James, 21, 110, 113, 116, 117
Fryer, Edward, 132, 142, 143

Gainsborough, Thomas, 98, 105
Galileo, 114
Gandon, James, 42
Garthwaite, Anna Maria, 31, 36, 37
Gastrell, William, 40
George III (king of England), 134
George (prince of Wales), 25
Gillray, James, 104
Glorious Sexumvirate (Barry), 113, 114, 119, 124, 126, 128, 129
Grattan, Henry, 129
Grecian Harvest Home (Barry), 90
Green, Valentine, 50, 51, 52, 53, 105
Greville, Lady Louisa Augusta, 73
Grosley, Pierre-Jean, 79-80
Grotius, Hugo, 126
Gunhilda (Casali), 55
Gwynn, John, 19, 41, 76

Hanway, Jonas, 68
Harvey, William, 126
Hayman, Francis, 54
Hebert, George, 40, 41
Herbert, William, 34
Hiero, 93
Hippocrates, 126
Hogarth, William, 53
Hollis, Thomas, 55,
Hope, Alexander Beresford, 32
Horace, 93
Hunt, Isaac, 66

Inquiry into the Real and Imaginary Obstructions to the Acquisition of the Arts in England (Barry), 19
Irwin, David, 88
Isabella (queen of Castille), 110, 112, 113, 115, 117

Jenkinson, Charles, 1st Earl of Liverpool, 132, 134
Jepthah's Rash Vow (Nollekens), 58
Job Reproved by his Friends (Barry), 117
Johnson, Samuel, 55, 64, 66, 82, 88
Johnson, Thomas, 34
Jonah (Barry), 105
Jonah (Michelangelo), 105
Jones, Robert, 40
Jupiter and Juno on Mount Ida (Barry), 25

Kames, Lord, 82
Kauffman, Angelica, 105
Kilburn, William, 34
King George and Queen Charlotte (Barry), 98, 119, 139
King Lear (Barry), 25

Landseer, Edwin, 40
Las Casas, Bartolome de (bishop), 110, 112, 113, 115, 116, 117
Le Blanc, Jean-Bernard (abbé), 52
Le Brun, Charles, 56

Lennox, Charles. *See* Richmond, 3rd Duke of
Letter to the Dilettanti Society (Barry), 64
Letter to the Society for the encouragement of Arts, Manufactures and Commerce (Barry), 92, 114
Lochee, John, 41
Locke, John, 124, 128
Lord Baltimore (Barry), 114, 119, 124, 126, 129
Lucan, 123
Lucretia, 56
Lycurgus, 93, 115

Magellan, Ferdinand, 110, 112, 113, 117
Martell, Isaac, 40
Marvell, Andrew, 101
Mary (queen of Scots), 115
Mendez, Christopher, 101
Mercury Inventing the Lyre (Barry), 105
Michelangelo, 92, 105, 124
Microcosm of London (Ackermann), 79
Millais, John Everett, 40
Milton, John, 25
Miranda, General Francisco de, 115, 116
Molyneux, William, 124, 126, 128, 129
Mondet, Abraham, 40
Montagu, Elizabeth, 20, 64, 66, 74, 81
Montfort, Lord, 58
More, Samuel, 26, 58
More, Sir Thomas, 114, 119, 123
Morrison, Alice, 42
Mortimer, John Hamilton, 58, 105
Moser, George Michael, 70
Moser, Mary, 40, 70
Mulready, William, 40

Naylor, William, 40
Newton, Isaac, 114
Nollekens, Joseph, 58

Opus Magus (Bacon), 98
Orpheus (Barry), 89, 93

Paris, Samuel, 40
Pars, William, 42
Pausanias, 92, 93
Peel, Sir Robert, 142, 143
Penn, William, 98, 114, 115, 119
Pensive Sages (Barry), 101, 103, 104, 106
Philpot, John, 40, 41
Phœnix, or The Resurrection of Freedom (Barry), 101, 129
Pindar, 92, 93
Pine, Robert Edge, 56, 57, 58
Pingo, Benjamin, 40
Pingo, Henry, 40
Pingo, John, 40
Pingo, Lewis, 36, 40
Pingo, Mary, 40
Pingo, Thomas, 40
Pingo family, 70
Pitt, William, the elder, 92
Planta, Joseph, 132
Plato, 93, 98, 124, 126

Plutarch, 107
Pope, Alexander, 67
Porsenna, 55
Postlethwayt, Malachy, 19
Powell, Richard, 143
Priam pleading with Achilles for the Body of Hector (Banks), 58
Prodicus, 92
Progress of Human Culture and Knowledge (Barry), 19, 25, 113
"Publicus," 68

Queen Isabella, Las Casas and Magellan (Barry), 21, 110, 113, 114, 116

Raleigh, Sir Walter, 68
Ramsay, Allan, 53
Raphael, 93, 124
Ravenet, Simon François, 57
Reid, Robert, 106
Reserved Knowledge (Barry), 103, 113, 114, 119, 124
Revett, Nicholas, 23
Reynolds, Sir Joshua, 19, 23, 25, 41, 53, 98, 106, 143
Richards, Sarah, 43
Richmond, 3rd Duke of (Charles Lennox), 29
Roffe, F. R., 89
Romney, George, 58, 60
Rossi, J. R. C., 131
Rowe, Nicholas, 123
Rowlandson, Thomas, 89
Royal Academy of Arts, 23, 25, 26, 32, 41, 50, 51, 58, 60, 70, 83, 105, 107, 132, 134
Runciman, Alexander, 105
Rush, Hannah, 70
Rutland, Isabella, Duchess of, 66, 117

St Martin's Lane Academy, 29, 53
St Paul Preaching to the Ancient Britons (Mortimer), 58
St Paul's Cathedral, 23, 25
Saint, Gideon, 34
Savile, Sir George, 92
Sayer, Peter, 36, 40
Scaevola, Mutius, 55
School of Athens (Raphael), 93, 124
Scientists and Philosophers (Barry), 101
Scott, Sarah, 64
Series of Etchings by James Barry, Esq (Barry), 100
Shaftesbury, 7th Earl of (Anthony Ashley Cooper), 124
Shee, Martin Archer, 76
Sheraton, Thomas, 81
Sherwin, J. K., 117
Shipley, William, 19, 27, 29, 30, 34, 41, 42, 44, 53, 69
Sissell, Richard, 36, 40
Smirke, Robert, 131
Smith, Adam, 76, 82
Smith, Charlotte, 69
Smith, Godfrey, 40
Smith, Charles Saumarez, 19

Smith, Joachim, 34
Smith, John Raphael, 105
Société pour l'avancement des Arts, Geneva, 42
Society of Antigallicans, 66
Society of Artists, 30, 55, 58
Society of Dilettanti, 41
Socrates, 55, 92, 93, 114, 119, 124
Solkin, David, 88
Sprat, Thomas, 67
Stothard, Thomas, 131
Stuart, James "Athenian," 23, 90, 131, 134, 135, 137, 140
Stubbs, George, 105
Sunderland, John, 55
Surrender of Calais to Edward III (Pine), 56
Swift, Jonathan, 114, 119, 126, 128, 129

Tassie, James, 41
Tatius, 55
Taylor, Charles, 142, 143
Taylor, Isaac, 89
Taylor, John, 58
Taylor, Simon, 42
Taylor, Thomas, 142
Templeman, Dr Peter, 73
Temptation of Adam (Barry), 15, 23, 88
Thales, 98, 101, 114

Timanthes, 93
Trustees' Academy, Edinburgh, 42

Vandermeulen, John, 58
Vauxhall Gardens, 54
View of the Priory of Warwick (Greville), 73
Vivares, Francis, 40
Vivares, Mary, 40
Vivares family, 70
Von la Roche, Sophie, 79

Wakefield, Priscilla, 69
Wark, R. R., 88
Warner (engraver), 134, 135
Washington, George, 115
Waterman, Elizabeth, 66
Watson, General, 143
Wedgwood, Josiah, 41, 81
West, Gilbert, 91; 92
Whitefoord, Caleb, 143
Whitton, Charles, 41
Willis, William, 42
Wollstonecraft, Mary, 64
Wood, Sir Henry Trueman, 43

Zeno, 124, 126
Zenocrates, 116